ADVENTURE UNLIMITED

Searching the Globe
with
Francis Raymond Line

Published by

WIDE HORIZONS PRESS
13 Meadowsweet
Irvine, CA 92715

Library of Congress Cataloging-in-Publication Data

Line, Francis R.
 Adventure unlimited : searching the globe with Francis Raymond
Line.
 p. cm.
 Includes index.
 ISBN 0-983109-05-7 (pbk.) : $8.95
 1. Adventure films—history and criticism. 2. Line, Francis R.
3. Adventure and adventurers. 4. Voyages and travels. 5. Motion
picture producers and directors—Biography. I. Title.
PN1995.9.A3L5 1988
791.43'09'09355—dc19 88-20666
 CIP

Dedicated to

HELEN E. LINE

*who shared in many
of these
adventures,
who edited all our
films, and who
inspired me every
mile of the way*

*With special thanks to
the people in many lands who helped
on these dangerous journeys*

and to

*the hundreds of men and women who
booked me on their
motion picture travel-adventure series
across America
and the thousands who attended those
film presentations*

CONTENTS

Foreword

This book is about the making of adventure motion pictures throughout the world and their subsequent presentation, in personal appearances, throughout the United States and Canada. No Foreword can better describe the success Line had in capturing his adventures on film than some of the letters written to him after such showings, of which the following are among many hundreds.

"We have had all of your programs. They have been so enthusiastically received by our members that we will unhesitatingly book everything you produce in the future." Kimpton Ellis, *University Club,* Los Angeles, California

"It gives me the greatest pleasure to thank you for the privilege of seeing what were undoubtedly the most marvelous and interesting pictures that have ever been shown in our club, which has boasted of seeing the best that has ever been offered. I think that this fact was attested to by the rousing spontaneous ovation given you upon their completion, an ovation such as our club has never before witnessed." H. L. Tanner, President, *Los Angeles Adventurers Club*

"May I take this opportunity of expressing our deepest appreciation of the (film you narrated) before the Washington, D.C. members of *The National Geographic Society*...truly a dramatic presentation. The story is closely knit, the color sparkling, and human interest more than adequate. Your vivid commentary enhances the picture's interest...we heard numerous expressions of delight from people of the most widely assorted tastes." Melville B. Grosvenor, *National Geographic Society,* Washington, D.C.

"If *Program Magazine* had orchids to hand out, or Oscars, it would award both to Francis R. Line...Not only would *Program* make these awards, so would his fellow lecturers in the motion picture field. When Francis Line was recently in New York his confreres went from one presentation of his to another...No praise too

high, no award too great, for the man who has produced the perfect film." James Pond, founder and editor, *Program Magazine.*

"Your color motion pictures are some of the finest we have ever shown." George Pierrot, Director, *World Adventure Series,* Detroit, Michigan.

Introduction

This is a book for all who like tales of high adventure. It is written, also, for specific groups of readers. For years, people have asked me to put my Arctic Lapland experiences into writing, as well as our story about the courageous little country of Finland. The first part of the book is especially for them. Others have been particularly interested in my filming of the crisis points in the far Pacific just as World War II was engulfing the world. The book's middle portion is for them.

Our years of adventures on the lecture circuit, both serious and humorous, plus the inspiring experiences of a lifetime of contact with peoples around the world, provide materials for everyone.

Enjoy the journey.

Francis Raymond Line

CHAPTER 1

The World Becomes Our Workshop

Shortly after midnight, in November of 1938, I wakened by chance and glanced casually out the window of our Ontario, California home. We slept upstairs; the window faced north, toward the mountains. My casual glance became a startled stare.

"Wake up. Look. Quick," I shouted to my wife, Helen. "Up there. Mt. Baldy. The whole mountain's in flames."

Mountain fires, particularly in late autumn before the winter rains, are dangerous. The tragedy of potential forest destruction and the threat to lives of both animals and people all flashed through my mind. But another consideration almost instantly crowded those thoughts into the background.

A few months before, Helen had given me a $25 motion picture camera. We had made two short local-lore movies, with pronounced success. This forest fire was a call to action.

"What a chance to use my new camera," I called to Helen. "How much film do we have on hand?"

In thirty minutes I was dressed, packed, and had driven the ten miles up toward the mountains, where a narrow winding road took off for Camp Baldy. Roadblocks and a couple of armed deputies stopped me.

"I need to go up and get movies of the fire." Sticking my head out the car window, I put my request to the officers.

"Not a chance," came their quick response. "Nothing but fire equipment gets through here tonight. You'd just be in the way. Here comes a fire truck now. See what I mean?"

At that instant a pickup truck roared up, red lights flashing in the darkness. A man leaned out to give some instructions to the deputies. He was a chief ranger from the Glendora headquarters.

I jumped out of my car. "Look," I shouted above the roar of the motor, "I've got to get pictures of that fire."

Perhaps he was just too busy to argue. Maybe he was pleased that someone wanted to film fire fighters at work. I never found

out. "Jump in the back," the chief ordered. "I've got to get going."

He went all night. We drove up to where crews were hacking and digging with axes and shovels, trying to make impromptu firebreaks. In some areas we skirted the flames. Then, in several places, we drove directly through them as they licked across the fire trails. Rocks had cracked under the intense heat, causing landslides. The sky was livid and—where the action was—the flames cast a red glow which was better than floodlights. I shielded my face from the heat, blinded my eyes against the smoke, and kept the camera grinding.

Next morning, armed with a special permit, I went back to Ontario for more film and returned to catch the fire action by day, this time with Helen coming along to help. We arrived just in time to film the crisis point of the whole fire. Nearly dead with exhaustion, the crews had had that blaze almost under control. Then a great blast of red-hot wind picked up those flames and carried them like dancing demons over the critical firebreak. They raced up the slope, and the whole mountain lay in their deadly path. We filmed it all.

The fire fighters, and we as well, didn't come far from being trapped. A spark set my shirt on fire. But it was all worth it. The newsreel men began arriving soon afterward, but they were just too late. Ours was the only complete record.

To get immediate film processing, I rushed with the fire footage over to the Eastman lab in Hollywood. When we viewed the scenes, and Helen gave them quick and skillful editing, we knew we had an epic on our hands.

In a way, this was the third epic of our brief amateur motion picture careers. During the first week after Helen had given me the camera, rather than shoot unrelated isolated scenes of our two children, we put our two-year-old Adrienne in six-year-old Barbara's red wagon and had Barbara pull her for the two blocks over to their grandparents' house. They encountered exciting childhood adventures along the way.

We edited the footage and showed it to Gardiner and Gertrude Spring. He was superintendent of Chaffey High School and Junior College. Having also just bought a movie camera, they were more than usually interested. They liked it greatly. "You've achieved real continuity," suggested Superintendent Spring.

Without quite realizing what had happened, we'd hit upon the technique of "making the movie tell a story."

That was just a test. Using the same technique, the same red wagon, and with Barbara and Adrienne again as the heroines, all of

us went out into the grape country east of Ontario. According to a huge roadside sign, we were in the "world's largest vineyard." The grapes were luscious purple, the leaves were shiny red, the Mexican harvesters were cooperative and photogenic. Our girls thrilled to see the purple clusters being deftly cut with the knives of the workers, the large boxes carried to the roadside, then hauled to the winery, where other workers stomped the fruit down with bare feet. Our two-year-old sampled grapes at every stage of the process until her rosy cheeks were nearly obscured with purple juice. Of course her rag doll had to have samples and Raggedy Ann soon became even more colorfully stained than her two-year-old mistress.

Adrienne Sees the Grape Harvest became an instant hit. Helen's Woman's Club asked us to show it at their next meeting. The Lions Club wanted to schedule it. All the color of those grapes and vines and all the excitement and interesting lore of those harvesting scenes and processes had been a part of the Ontario environs for years, but few of the women of the Woman's Club and almost none of the men at the Lions Club, had ever been aware of it all. The antics of a two-year-old girl and her rag doll in discovering all that beauty and interest, as she was being pulled in a red wagon through the grape vineyard, opened up a new world to the members of those clubs—a world in their own backyard which they had never known existed.

Stimulated by that adventure and its obvious success, we packed up the children and the rag doll and hastened down to the Pala Indian Reservation, about seventy miles away. The old Pala Mission was picturesque and aglow with historic fact and fancy. Some Indians, with whom we quickly struck up interesting friendships, showed us about. They were colorful too. But Mission and Indians were pale in comparison with the red peppers which were just then being harvested and spread out to dry. Red peppers on the vines, red peppers being picked, red peppers—whole carpets of them—spread out on the ground and rooftops. Great bunches and strands of them, resembling clusters of ruby beads, hanging on the porches of the simple little homes.

Helen edited that film. Not only the Woman's Club and the Lions wanted to see it but, as word traveled by the "grapevine" so to speak, the grape harvest and the Pala films were sought after by the Rotary Club, the Kawanians, the elementary and high schools, and the junior college. Our calendar was bursting at the seams with dates for future showings.

Then came the forest fire. All of those schools and clubs got not only the grape harvest and the Pala Indian film for the same

price (which was exactly zero, for Helen and I were donating our time for this new hobby of ours) but they saw the fire footage also. The Woman's Club wanted a repeat showing, with this new added feature. Clubs in nearby cities wanted to schedule the films. And in Glendora the fire chief insisted that we give a show for his men. That command performance—to coin a pun—added fuel to the flames. Nearly every night we were out somewhere showing our films, accompanying them with commentary. In those days movie screens and projectors were almost unknown quantities for clubs and most schools. We carried our own to every showing. But each week did not have enough nights. We desperately needed to make some kind of new arrangements.

"Helen, a bee is buzzing in my bonnet," I commented one day. "We need to do some tall planning."

We had heard about Burton Holmes and his travelogue lectures. He used large hand-tinted color slides. We had heard about one or two men who, with 35mm black and white travel movies, made their living lecturing around the country. At that time we had never heard of anyone who had done this, using the smaller 16mm film, which could be shot in living color. That is what we were using and showing, without charge, almost every night on our six-foot screen.

We discovered where to buy a ten-foot beaded screen and a strong 1200 watt projector, all of which could be transported by car, the screen tied to the top, the projector inside.

"We can't go on showing films and lecturing every night for free," I explained, and Helen agreed. "We and our calendar would both soon be exhausted. Let's make a full-length film we can charge for."

Without realizing what lay ahead, and with almost no knowledge of the then fledgling travel-adventure film lecture business, we were groping toward something that would occupy much of the rest of our lives, and would make the whole world our workshop. We were about to make a lifetime profession out of a backyard hobby. Barbara's little red wagon had metamorphosed into a chariot which would carry us to far scenes and high adventure.

"Where, Pray Tell, Is Lapland?"

That red wagon taught us a lesson. Every good adventure film, whether of two tiny tots on a trip to Grandma's or of a hazardous journey to Timbuktu, is helped enormously if an interesting mode of transportation is pictured. Continuity is established. Adventures, picturesque episodes, and local color can be woven into an

14

ongoing journey. A flowing story is created. The audience is carried along, eager to discover what lies around the bend. In a subtle way, each viewer participates in the action.

The grape harvesters and the Indians at Pala working in the peppers provided us with Lesson Number Two. Every good film needs deep human interest. People are important. Men, women, children, if shown in their intimate walks of life, capture people's imaginations.

We were reading now, night and day, cramming for the almost unknown life which was beckoning us.

Exotic transportation.

Interesting people.

In my reading I came upon the fact that the Lapps of Lapland are among the colorful people of the world, who live farther north than all but a few other humans. In winter—and their winters often last for ten months of the year—they travel by reindeer and pulka—a sort of hollowed out half-log which is pulled like a sled.

Exotic transportation. Interesting people. The Lapps in Lapland could provide them both.

But where, pray tell, was Lapland?

It is not a country, we soon discovered, but only a geographic expression. Lapland consists of the northern portions of Norway, Sweden, and Finland, extending slightly over into the Soviet Union.

Colorful, red-trimmed costumes, we read, are an integral part of Lapp life. Because of the long, drab winters, the people find relief in packing and condensing as many colorful activities as possible into just a few days surrounding Easter. The Lapps practice an exotic form of primitive Christianity, tailored to the exigencies of a hostile climate. At Easter time, our reading informed us, they travel by the hundreds from their remote isolated habitations into Karasjok, Norway, so-called capital of Lapland. Weddings, which have been put "on ice" for the long winter, are solemnized in the village church. Funerals, which also have been awaiting this occasion, are conducted. The pent-up drama of long and lonely winter months is all displayed at Easter. To the Lapps, it seems, this is a microcosm of the year.

But for our purposes there was one severe drawback. Easter, in that year of 1939, came on April 9th. And that date, on our already-crowded calendar, was little more than a month-and-a-half away. Travel from California to Lapland, in 1939, was not by jet. On our limited budget, it was not by propeller plane. It was by railroad across three thousand miles of America, by steamer across three thousand miles of ocean, by God only knew what means of

transportation from England up to Hammerfest, Norway, known as the world's most northernmost city. Then, as a strong possibility, the last of the journey would be maneuvered over a field of ice and snow.

We had several final free showings to give, packing to accomplish, and business arrangements to negotiate so we could leave our home and other affairs for possibly as long as half a year or more. I needed to buy a more professional movie camera and familiarize myself with it. We had books to read, maps to study, timetables to translate into concrete travel plans.

Also, it became increasingly important to study and interpret the daily news. Over in Europe a crazed little man with a Charlie Chaplin mustache was scrapping treaties, storming across borders with his newly-strengthened German armies, and otherwise shaking the foundations of a fragile peace which had held together since World War I. Adolph Hitler was on the move, and a "Stop Hitler" movement was forming between England and France. British Prime Minister Chamberlain, with his black umbrella, had gone to Munich and come back with an agreement which made the word "Munich" synonymous with vacillation or near surrender.

On March 23, 1939, we were as ready as we could get, to take off for Europe. Eight days earlier, Hitler had begun the dismemberment of Czechoslovakia. But our plans were all laid, our new course set, and our family of four—Helen and I, with six-year-old Barbara and two-year-old Adrienne—boarded the El Capitan Santa Fe streamliner for Chicago. The Great Depression was still casting its dark shadows across our land, mixing with those lengthening shadows from Europe. We had to travel inexpensively and El Capitan—a chair car train—was the answer. A close transfer in Chicago, another day coach journey through a night and a day, brought us to New York City for our last night in America.

New York's World Fair was to open in less than two weeks. We discovered that visitors were permitted to preview the grounds and exhibits.

"Do you think we should take the time?" I wondered aloud to Helen, as we wakened next morning.

It seemed foolish to rush off to a not-yet-opened World's Fair when so much of the real world—England and the Continent, and the Scandinavian peninsula, and Lapland—lay just ahead.

But our ship did not sail until evening. By subway and bus we trekked out to the fairgrounds on Long Island—and found the slogan which would enlighten our travels and adventures for the rest of our lives. Over the entrance to the Hall of Humanities was

inscribed, in great bold letters, a crisp phrase from the quill of Sophocles:

"Many wonders there be, but none more wondrous than man."

That became the motto to govern this trip, and all the rest of our filming journeys in the future.

We wanted to view grand scenery, visit foreign cities, explore exotic lands. But countryside and cities and scenic landscapes are only the background for the men and women and children who inhabit them. We were interested above all in the People of the Earth, in how they lived and what they did. It was to film and study the life of unusual and picturesque people that we were embarking on this trip. We would rather find out how a Laplander milks his reindeer or takes a bath than to shoot up three reels of film portraying the furnishings of the Swedish Royal Palace.

With a new motto to direct our world wanderings we journeyed back to Manhattan, taxied to Pier 42 on the Hudson River, boarded the Queen Mary, and by evening were cozily settled in a tiny, immaculately clean and entirely comfortable third class cabin for four. It was in the very bow of the ship; we had only to scurry up two flights of stairs to be on the ship's prow, to see her cut through the waters of the lower river, and watch the New York City skyline, then the Statue of Liberty, slip by in the gathering darkness. We were embarked on a new life.

Five days later—London.

Across eastern United States, late winter snows, swirling in blizzard proportions, had provided our American farewell. England had no snow, but the weather was freezing. Learning that we had just left snowbound America, a dour British gentleman remarked sadly: "I don't know why they ever bothered to discover and settle that place."

Our plan was to locate a modest flat where Helen and the girls could stay while I made the journey, alone, to winter Lapland. Upon my return, we planned to put the girls in a highly recommended private school. Helen and I would do more filming in Europe, and return to Lapland for summer pictures.

Two precious days were required to locate a flat. It could be heated only by feeding shillings, one after another, into a meter, and even then the flat stayed cold. This contributed to our feelings of loneliness as I kissed Helen and the children good-bye and took a boat train for Harwich and the channel crossing to Denmark. The month of March had gone out like a British lion, and April was well upon us. Easter Sunday was only a week away. Lapland seemed eons of miles distant into the uncertain future.

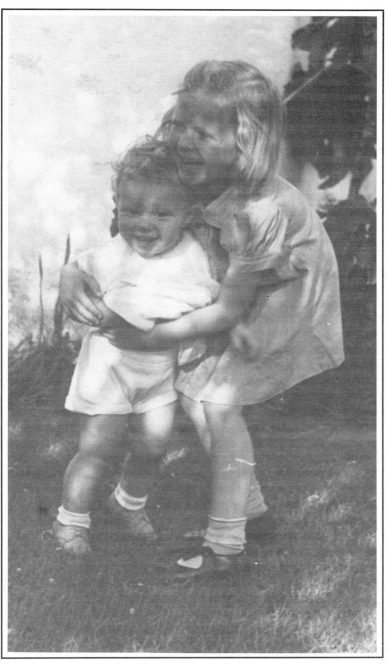

Making home movies of their daughters, Adrienne and Barbara, led the Lines into a lifetime profession.

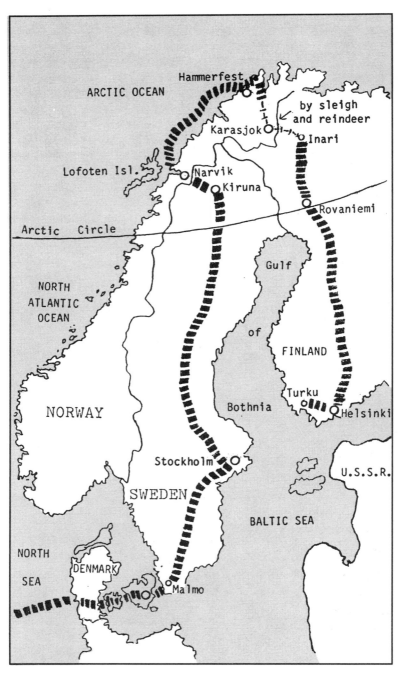

ARCTIC OCEAN

Hammerfest

by sleigh
and reindeer

Karasjok

Inari

Lofoten Isl.

Narvik

Kiruna

Rovaniemi

Arctic Circle

NORTH
ATLANTIC
OCEAN

Gulf

of

FINLAND

Bothnia

Turku

Helsinki

NORWAY

Stockholm

SWEDEN

U.S.S.R.

BALTIC SEA

NORTH
SEA

DENMARK

Malmo

Line's route to Karasjok, Norway, center of colorful Lapp Easter ceremonies.

CHAPTER 2

Northern Lights in the Arctic

An electric train, glistening red, whisked me across Denmark, making the hops between the three Danish isles by train-ferry, as we sat comfortably in the cars. There was a stopover in Copenhagan, then by steamer I made the crossing to Malmo, Sweden, and was in the Swedish capital city, Stockholm, before I had had the chance to learn even two words of the Scandinavian languages.

But lack of linguistic knowledge was proving no handicap, so far. Almost everywhere I turned, someone was able to help me out with good English.

In Stockholm, there was a chance to admire the classic architecture of the city hall and to ascend an outdoor elevator shaft leading to an exotic restaurant suspended, so it seemed, high in the air, with a fine view over the city.

Good luck was following me every step of the way; I discovered that a train—electrified much of the distance—ran northward from Stockholm, penetrating to the country's northern tip, above the Arctic Circle. The thousand mile journey would cost just $14.00, plus $1.25 for a sleeper. It was night when we departed, and I soon found myself in a Swedish sleeping compartment unlike anything I had every experienced. There were three narrow bunk beds, one above the other, and two other passengers with whom I would share these facilities. They were both large, burly Scandinavian gentlemen bound for central Sweden to sell snowplows, and I made no objections—which might not have done any good—when they arbitrarily assigned me the upper bunk, close to the car's arched ceiling. Had there been a window for seeing out I would have skipped a lot of sleep in the hope of getting glimpses, even in the darkness, of this storybook land through which the train was whisking me with the speed of wind. Since a window was not available, I slept like a baby. Until the first signs of dawn.

Even before daylight I was up, dressed, and out of the compartment, where I could feast—not on breakfast, which didn't

interest me at all just then—but on the glory of a completely new world slipping silently and swiftly past us.

Most of central Sweden was heavily forested, with numerous lakes and rivers. The lakes, great areas of frozen white, looked eerie with their one or two solitary ski tracks across them. The ice of the rivers was piled high with fresh-cut timber, awaiting the spring thaw and the timber drive.

Each time our train stopped, more interesting wonders were revealed. The baggage trucks at the stations were huge sleds. Boys and girls of all ages—men as well—flocked about the train on skis. All were bundled up in colorful clothes. The air was filled with the steam from people's breaths.

As we continued northward the forests rapidly became smaller and more sparse. The timber had dwindled to brush when the train suddenly slowed and the whistle sounded. There, on a vast field of snow, was planted a large white sign, printed in three languages with the words, "Polar Circle."

In late afternoon we reached Kiruna, an interesting Arctic city tucked away in the northernmost part of Sweden. Our train sped on, circling west now toward Norway and the Norwegian coast, where the Atlantic blends into the Arctic Ocean. We entered the mountains and passed Lake Tornetrast, one of Sweden's finest, with its shores hugged close by white-fanged mountain peaks. At the tiny Norwegian border town of Riksgransen, an immigration inspector and a customs man came through the train. The latter, I believe, thought my three-lens movie camera must have been a machine gun. He was worried, and went away shaking his head, mumbling something about revolvers.

At the border, the train started its descent toward the Atlantic coast. Some Norwegian youngsters had left a window open. I went to close it. But it remained open the rest of the way—for below me, visible in the dusk of twilight, was the Narvik fjord. Lake Tornetrast had been breathtaking. But the sight of the fjord eclipsed everything. Here was open water from the Atlantic—soft blue and mystic in the dusk. Frigid white peaks were everywhere, like dog teeth against the sky. Our train wound back and forth. Every view was different. One's first sight of a Norwegian fjord should always be like this—approached from inland, without warning. It hits one between the eyes.

Full darkness came. I stayed by the window. The other passengers were reading, or napping, or visiting. But if there is anything

whatsoever to see, I *have* to see it. The rewards have always been worthwhile. And here, far above the Arctic Circle, the habit paid off in a way that has made me forever thankful that I am an addict of "window shopping" for scenes of grandeur.

"Look," I suddenly called out, to no one in particular. "Look at that sky. What is it? It's fantastic."

A Norwegian young man who was sitting nearby came over to determine the cause of my excitement. But even before he had the chance to utter a word, I was lurching into an explanation of my wild delight.

"It's the northern lights," I almost shouted. "I saw some in Michigan once. But not like this. I can't believe it. Look. The whole sky is shimmering. It's alive."

A "sky alive" described it well. There, through the darkness which wrapped itself about the window, a dancing, shimmering ballet of luminous color was filling the northern sky. As a result of my reading, one of my hoped-for objectives on this journey was to see a display of northern lights. But I hadn't ever imagined they would be like this—like some legendary watercolorist, splashing colored designs in wild abandon across this far northern slice of the hemisphere.

The young man at my side mentioned that we would soon be at Narvik—journey's end. I only nodded—and kept my gaze on that spectacle in the sky.

Forests, in places, cut off my view. Gradually the display dimmed, then faded, and disappeared. If this trip accomplished very little more, here was a reward which had already made it worthwhile. This had been a treasure store which I would never forget. My education in wildly aesthetic wonders was expanding.

So, also, was my education in political geography. My youthful companion, a Norwegian sailor who spoke excellent English, informed me that Norway was scarcely twenty-five miles wide at this point. He began to tell me about Narvik, port city on this fjord leading out to the North Atlantic Ocean. Although his English was excellent, the words with which he described the town, in a sailor's terms of derision, had been dredged from the sewers and left nothing to the imagination.

The small hotel near the railway station, to which my sailor friend directed me, was somewhat in character with his description of the city. But the sleep I had was filled with dreams of flashing northern lights and dancing snowy peaks.

23

In Stockholm I had found that the Arctic express which had transported me into this Scandinavian northland would make a rather good connection with a small coastal steamer, plying the waters poleward, to Hammerfest, known as the farthest north city in the world. Bright and early I was on that steamer and we began churning through the rough waters surrounding the Lofoten Islands. Small fishing vessels tossed in the great waves along our path, and low but ominous snow-clothed mountains lined the Norwegian shoreline.

There was a stop at Tromso, with time for me to look about the city and film a statue of Roaul Amundsen. It was from Norway that he had launched his polar exploration.

"But wait," I said to myself. "This is Tromso, close to the *Arctic* Ocean. But Amundsen was an *Antarctic* explorer." Only later did I have time to research this matter and become acquainted with one of the strange tales of early expeditions—of how Amundsen, on his journey from Norway to seek the North Pole, abruptly changed his mind, headed for the Antarctic, and was the first man to set foot on the South Pole.

From Tromso, it was northward again, into the Arctic Ocean, with the bleak shoreline becoming more desolate, except for a few clusters of fisherfolk's homes which became visible just before dark.

Far into the night I watched as our steamer plowed northward, until drowsiness forced me to bed. Long moaning blasts of the ship's steam whistle wakened me. At 4:30 A.M. we tied up to the wharf at Hammerfest.

This was Good Friday. Stabbing cold surrounded us like a blanket. The wharf, the streets, the entire city seemed deserted. Only some crying sea gulls, a flock of scolding crows, and a raging snowstorm were on hand to greet me. No one whatsoever was available to supply any information as to how I might continue on inland to Karasjok in time for the festivities of Easter. Through the storm I found my way to the Grand Hotel, but no one was astir there either.

In the office, a large blackboard listed the rooms which were either filled or vacant. Choosing a vacant one, with a good ocean view, I wrote the notes of my journey until the city was awake. Karasjok was only 150 miles inland. This was Good Friday. I had two full days to make my goal by Easter.

Snow and Ice and Fjellstues

By 8:00 A.M. the city was astir. My first inquiry brought quick response. The whole interior of the Arctic region, my informant said, was frozen and snowed-in. Only on skis could the trip be made. That would take days, even for one who knew how to ski. "Get to Karasjok by Easter?" someone exclaimed. "It's impossible; utterly hopeless."

That was one of the most discouraging situations of my journey. There I was, at the top of the world, with nearly 9000 miles of hard travel behind me, and a bare but impassable 150 miles barring me from my Karasjok goal. Somehow, someway, I had to get to Karasjok by Easter dawn. Otherwise, the success of the strenuous journey might be jeopardized.

It took almost the entire day to locate someone with whom I could communicate effectively in English and who at the same time knew the back country. But the search was worth it. The man I found was a godsend. His help was invaluable. He proved to be a linguist. We explored every possibility and conceived a plan which offered a bare chance of success. Next morning—Saturday—I started out anew.

A tiny steamer was to leave about 10:00 A.M. for Repparfjord, twenty-five miles closer to my goal. It was a cold day but I perspired freely while waiting until eleven o'clock for the boat to start. Off at last, the vessel nosed through narrow channels fringed with snowy peaks.

Three times we stopped at fishing villages; each place was just a house and shed, with large drying-racks for the fish. In three hours the steamer panted wearily up to the wharf at Repparfjord. The place was marked boldly on my map. It proved to be a great Arctic metropolis of two houses and some storage sheds. But the dot on the map boasted an automobile, as my benefactor in Hammerfest had suspected. Showing him the notes and map, on which my linguistic friend had marked my route and hoped-for destination, the car owner agreed to drive me as far as conditions would let him. That was the all-important thing for me.

Altogether, we progressed twenty miles, through a wonderland of white. At times there was only snow—vast, rolling stretches of it, unbroken by twig or tree. At times the white drifts loomed several feet above the car on either side. At last we could go no farther. A Lapp man and woman and a Lapp youth emerged from a small hut to see who we were. "Karasjok. This American needs to get to Karasjok," my auto driver began explaining, in a

combination of languages. I brought out my map and the notes my Hammerfest friend had written. Result: the Lapp youth, with a wretched pony and sleigh, carried me on to the so-called village of Kistrand, and several miles past it. Then we came to the house of a Norwegian who had what passed for a small truck. Out came my maps and my written instructions. For nine dollars the owner of the truck agreed to attempt the drive down to the fjellstue of Skoganvarre.

The good man earned his money. For a ways the road was open, but I would never have taken a vehicle of my own over the raw, jagged chunks of snow, across the slippery ice, and through the churned-up drifts which we encountered. At length the road disappeared completely and we took off over the surface of a river and skimmed along for miles. Farther back, where the river had narrowed, I had seen cold black churning water through broken gashes in the ice. I hoped that my driver wasn't so intent on earning his nine dollars that he would risk his life—and mine too.

The weather was bitterly cold. With luck, we would arrive about dark at Skoganvarre—as far as any car could possibly go. From there I would have to travel by night—if I could get transportation. There were several families of Lapps living in Skoganvarre with horses and sleighs, my friend had said. They might be able to help.

While I was in the truck my constant fear was that we would encounter conditions entirely impassable and my journey would be brought to an end. If only I could reach Skoganvarre and get the use of a sleigh to continue on.

But then I began to wonder. In the closed truck, in the daytime, I was freezing cold. What would the weather be like in an open sleigh in the dead of night? But I was soon to discover there was no need to worry.

We reached Skoganvarre Fjellstue just at dusk. A fjellstue is a rest house for travelers, erected by the state in these northern areas where hotels do not exist and towns are scarce. There were many Lapps all about. Out with my maps and notes again. Sure enough, one of them—a big black-haired burly fellow—was ready and willing, for a price, to take me on my journey through the night, toward Karasjok.

My face showed my concern over the cold, but the Lapp just smiled. These people haven't lived in the Arctic hundreds of years for nothing. Disappearing somewhere, he returned in a moment with a large sack and began hauling out its contents. First deer-fur leggings which he pulled high up over my legs and thighs. Then

26

huge soft fur boots, which the Lapp proceeded to stuff with fine marsh hay until each of my feet resembled a gunboat. Then a voluminous fur peske, or coat, in which he enveloped me by slipping the thing over my head. It dragged the floor and I looked like a cinnamon bear just escaped from a zoo. Lastly, woolen mittens and a four-cornered star-shaped hat which pulled down over the ears. I could see now that it wasn't going to be a question of freezing to death; the question was, would I suffocate?

Actually, that night ride in the open sleigh with my Lapp companion was one of the memorable experiences of my life. It was cold, very cold, and tiny icicles formed in my nose. I could understand the warning that had been given me, not to wash my face before starting. The face is the only exposed part; it could easily freeze. The rest of me was warm as toast.

Twilight lingered for a long time and I peeped out above my furs in wonder at the ever-changing scene. For a while our way led through unbroken pine forest in a semimountainous area. Then we swung down and out onto the surface of a river and jogged along mile after mile. I lay in the bottom of the sleigh and snuggled into my furs. They smelled strongly of reindeer and perhaps the odor acted as a sedative. Or perhaps the tinkling bell on the horse's harness lulled me. At all events, I went to sleep, to be awakened with a start when we pulled up in the dead of night at a tiny hut.

It was a lonely fjellstue. There would be time, my Lapp motioned, for some coffee and a couple of hours of sleep. Going inside, he started a roaring fire on the earthen floor, poured coffee from a tobacco sack, produced a bottle of curdled reindeer milk, and put the pot on to boil. Then from his sack he took two hunks of deer meat, cut them up, and put them in a frying pan. Soon it was ready to eat.

We each spread deer furs in a corner and lay down for a nap. But two other travelers—Lapps going in the other direction—arrived and we all visited while they prepared their meal. Then at last the four of us, all in the one tiny room, nestled into our furs, snored lustily, and slept.

I awoke at 3:00 A.M. and called to my Lapp friend that we must be on our way. Quickly we hitched up and were off. It had started to snow. Soon we were garbed in a white blanket of flakes. We were traveling through heavy pine forests; at length we started to descend. A river valley lay before us. Breaking around a curve, I saw a cluster of houses down below.

"Karasjok," waved my friend. He swung his horse merrily down a hill and along the frozen riverbank to the door of the

fjellstue. I looked at my watch—just seven minutes after six on Easter morning. My race against time from California had been successful. I had arrived on schedule.

CHAPTER 3

Kodachrome Clothes, and a Wedding

The fjellstue which had been our midnight resting place on the all-night ride to Karasjok had been a crude one-room hut, little more than a shelter, without windows or furnishings of any kind. Fjellstue, in Norwegian, means "mountain hut."

When our sleigh pulled up at the fjellstue in Karasjok, I rubbed my eyes—or I would have, if my mittened hands had permitted it. If my Lapp driver-guide could have spoken English he would have been smothered with questions. This long red-painted structure on a gentle slope overlooking the frozen river was an attractive inn—a hotel, or so it seemed to me. I had known that Karasjok had numerous visitors in summertime and apparently the Norwegian government, with these accommodations, was striving to make them welcome.

My Lapp guide awakened the household and a charming Norwegian hostess showed me to a room. It was Room Number One, a large double corner chamber which I soon discovered was the best in the house. I didn't ask the price, but resolved that it might be better to change to a less pretentious room later on.

Subsequent inquiries provided my second surprise. The established fjellstue price, it seems, prevailed here, just as for the simplest mountain hut that has an attendant. My room cost thirty-seven cents a day, and meals would range from thirty to forty cents.

Surprise number three came almost immediately. As soon as I was properly quartered, the fjellstue household members went back to bed. Karasjok, it developed, was not an early morning community—at least not in winter. No wonder my night guide had been in no hurry to rouse himself in the middle of the night in order to get me here at 6:00 A.M.

Personally, I was thrilled to be on hand at an early hour. Sleep could come later. Before Karasjok was astir, I would have time to

survey my surroundings and get the lay of the land, preparatory to picture-taking.

The fjellstue was across the wide river from the village. Carefully I made my way over the slippery ice and was soon in the "main street," a narrow snow-covered rural dirt lane between fences, with one lone goat wandering along the path. There was a store and a steepled white church near a couple of two-story Norwegian-style homes. Most of the scattered Lapp houses were of hewn logs, unpainted, a few of the older ones revealing highly skilled workmanship, where the log ends were fitted and joined.

First signs of life came in the form of a vigorous welcome from the village dogs. Soon half a dozen of them, in various directions, were signaling the arrival of a stranger. The barking echoed along the deserted rural lane, but the welcoming committee quieted down when they saw I meant no harm.

It was sometime after eight o'clock before a few Lapp men began moving about in their barnyards. An hour later two Lapp women, colorfully attired, appeared from the edge of the surrounding forest, picking their way over the snow toward the steepled church. Then two more women. Then a group of Lapp men. Soon, from all directions, men, women, and children—singly, in couples, in whole family groups—were streaming across the snow toward the place of worship.

From the eaves of the church, and of the nearby houses, slender icicles were suspended like decorations. A stray ray of the morning sun broke through some clouds, touching and melting those pendants of ice, making them gleam and sparkle like jewels.

I liked what I saw of this village. Easter Sunday was officially getting under way.

Who Are the Lapps?

The Lapps are the world's enigma. Today they inhabit the rather ill-defined section of northern Norway, Sweden, and Finland, extending into the Soviet Union, known as "Lapland." But where they came from and how long they have lived in Lapland is hard to say.

Authorities at one time classed them as a Mongol race. They are not. They are of the white race. They were once thought to be Slavs. This is not the case. They are as much a distinct people as the Germans or the Italians or the French. In my reading before coming to Lapland I learned that the Vikings, settling in Scandinavia

fifteen hundred years ago, had found the Lapps already established in the north.

Through the years I have researched more widely, with ever expanding ramifications. A scholarly book, copyrighted by Abnordbok, Gothenburg, Sweden, titled *People of Eight Seasons, The Story of the Lapps* has been helpful. A Roman historian, Tacitus, in the year 98 AD, wrote that he had heard about the Lapps. Other writers in early days described how these northern peoples used snow "slides" or skis. Another historian has the Lapps inhabiting this northern land at least as early as the beginning of the Iron Age, 500 BC. This well-researched book tells of a culture existing here during the Earlier Stone Age, before 3000 BC. One writer even "propounded the somewhat astonishing hypothesis that the ice-free coastal strip along the Norwegian Sea...had been populated by humans throughout the Ice Age." He speculates that these were the forbears of the Lapps. Some pre-historic skis were actually unearthed in Lapland, dating back to 2500 BC.

Whatever their origins, the Lapps are a peaceful people. I found them to be extremely likeable. While their exact origin may never be known, perhaps it does not matter.

I soon found that the Lapps themselves are colorful. Since their land, in winter, is barren and white, they have used their attire as a means of enriching their lives. This is especially true of the women. Describing a Lapp woman's dress would not give an adequate idea of its color unless I said that she looks like a walking rainbow.

Tight-fitting caps, or bonnets, worn by all the women and older girls, are bright red. Their shawls are patterned with red and green, and sometimes yellows and blues. Their heavy outer garments are trimmed in red. Their ankles are wrapped with red binding to keep the snow out of their boots. Red tassels are suspended from the men's hats and from their boots. Both men and women wear colorful belts. Red trimming adorns the infant cradleboards, and decorates children's sleds.

The religious ceremonies of the Lapps are colorful for the same reason as their clothes—to brighten up somber lives.

In the early afternoon of Easter Sunday I witnessed a resplendent wedding. But one even more colorful, I discovered, would take place late next day—on Monday, their "second Easter." This was well for me, since I soon found there were other religious activities needing my immediate attention.

Morning worship on Easter Day was nothing more than an elaboration—two-and-a-half hours long—of a regular Norwegian

Lutheran service. A brief evening worship also was held at the Lutheran church, but it wasn't rich enough in emotionalism for many of them. Nor was it extensive enough. The Lapps are long-suffering. They had their own tiny meeting place and at five in the evening I went in with all the rest. The room was the size of a small country school in America, and soon it was jammed. More kept coming and the shoving was almost unbearable. At first the women sat on one side and the men on the other, but there was such an overflow that a complete scrambling eventually took place.

Two ministers up in front, on a raised platform, read Bible passages—one minister in Norwegian, the other in Lapp. At intervals the congregation sang—long dirges a quarter of an hour in length. Mountain Lapps from distant places kept arriving and they demanded standing room inside. There was shouting and much shoving. When darkness came, candles and lamps were lit. Occasionally one of the ministers would blow his nose without benefit of kerchief.

At 7:00 P.M.—after two hours—I went out for dinner and returned about 8:00. In the interval the real excitement had begun. Some of the Lapps—but not all by any means—were in a frenzy. Up at the front of the room they were dancing and weeping and laughing. Men and women—mostly the older ones—would go up and hug the ministers. Then they would come down into the aisle and dance and shout and cry. I left at 10:00 P.M., after the services had progressed for five hours.

During my first day in Karasjok, I stuck to European clothes and was a curiosity wherever I went. Then I bought a complete Lapp outfit and immediately became one of the people. Luckily, I discovered a Norwegian who spoke a little English. He told me that I was as typical a Lapp as he had ever seen. Most of the Lapps are just over five feet in height, as I am. I fit in perfectly.

I wanted to observe how the people lived, so would barge into a house, repeat the usual greeting of "Bouris, Bouris," (the only words of their language I knew) and make myself at home. They would serve me with coffee, sometimes chuckle a little, and then go on about their business of nursing the baby or feeding blood-pudding to the dogs.

If circumstances required it, I would get out some brightly colored beads (from Woolworth's three-pence and sixpence stores in London) and make a presentation to the woman of the house. After that, picture-taking was easy.

Feasting at a Wedding

Monday—the second Easter. It was late afternoon, time for the wedding of a young woman who, I learned, was especially well-loved among the Lapps. The bridal procession formed in front of a hewn-log Lapp home some five hundred feet from the church. At a strategic spot, halfway between church and bridal party, I set up my camera and tripod. It was as though I gave the signal for the procession to begin. No sooner was I established in my chosen location than the colorful column headed toward me.

Bride and groom led the way, followed by their attendants, a dozen couples, all young men and women, marching side by side. Streaming across the white snow, with their red-trimmed attire—the women with red bonnets and flashing shawls—it was the stuff for which color motion picture film was invented. Thirstily, my camera drank it all in.

Bride and groom had nearly reached me. Scarcely thinking what I was doing, I picked up my tripod and repositioned it directly in their path. The entire procession stopped, as I took close-ups of the bride. Now there was another touch of red. The blush on her cheeks nearly matched the hue of her bonnet. The manner in which the ruddy-cheeked groom smiled down on her lovingly, as all this was going on, made me realize that my brazen picture-taking would not get me into trouble. Again I perceived that the Lapps are a gentle and likeable people.

Removing myself from their path, the procession continued toward the church. The bridal party entered first, then nearly half the village followed.

The other half of the village (or so it seemed to me) for whom there was no room in the church, waited outside on the snow. From the point of view of human interest, this waiting crowd was as intriguing as the wedding itself—teenage Lapp girls giggling and whispering, probably wondering what their weddings would be like, aged women gossiping, youngsters playing in the snow, babies being cared for by attentive mothers. It was a variegated outdoor overflow congregation.

In half an hour the ceremony was over and the procession marched out, but now the bride wore a sparkling bauble-bedecked crown, with iridescent ribbons attached to it, which streamed down her back to mix with the hues of her shawl.

The richness of color created by that congregation of Lapp men and women streaming out of the church and spreading out across the white snow was a chromatic experience that made me

33

forever thankful I had arrived in Karasjok on time. The landscape was stained and dyed with crimson. It was like a child's imaginative, uninhibited finger-painting, with the red paint pot spilled gaily all over the sheet.

Up the village path to waiting sleighs the wedding party moved and, midst the shouting of well-wishers and the ringing of sleigh bells, they all drove off.

Many of the onlookers were drifting toward a centrally-located house nearby. I followed, and went inside with the rest. The Lapps showed great interest in me and we laughed and conversed (mostly by signs) as I was beleaguered by several men bringing me coffee and cakes.

After this had progressed for a time, one man had a brilliant idea, brought on perhaps by some questioning signs which I was making. I was trying to find out where the bride and groom had gone.

Leading me outside, he soon flagged down a sleigh and said something to the Lapp man who was driving. Merrily, with sleigh bells jingling, we headed off over the snow and, after a few miles, arrived at the home of the bride.

That coffee and cake affair in the village had just been for the overflow crowd. Here was the real wedding feast. It had already begun, with forty guests packed into a tiny room. I partook of the food too—reindeer meat, potatoes, fine sweet bread. And for dessert, to cap the climax, a great platterful of tiny Sunkist oranges from California. The Sunkist stamp was on each one. Almost more than anything else, this convinced me that the wedding I had filmed was an auspicious event. These oranges had been purchased for this special occasion from Norwegian traders, who had brought them up from the south.

I was dressed completely in Lapp clothes but, with large movie camera and tripod in hand, I was nearly as much the center of attraction as the bride. Light was fading fast so we interrupted the feast long enough to go outside for close-up pictures of the bride, the groom, and the entire wedding party.

The vivid festivities of the Easter season were among the episodes which I had journeyed nearly nine thousand miles to experience and to film. They were worth it. Darkness overtook us as the filming and the feasting were finished.

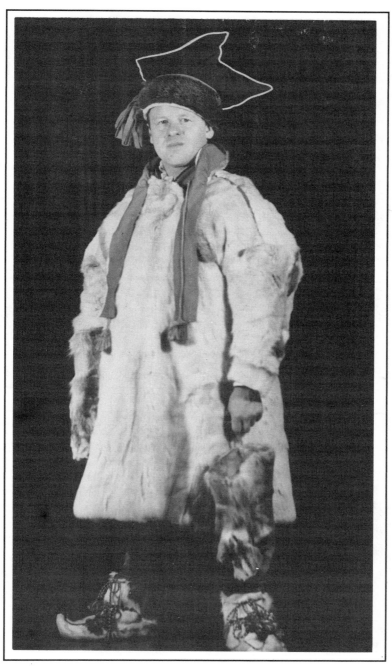

The author in Lapp garb. Boots are often stuffed with marsh hay for warmth.

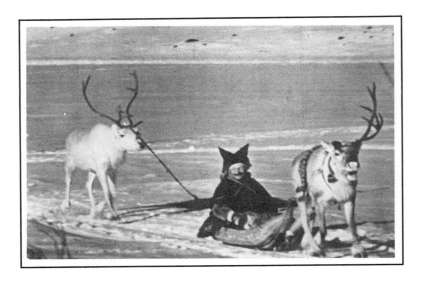

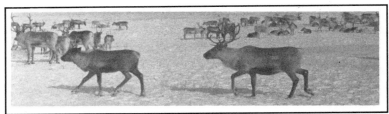

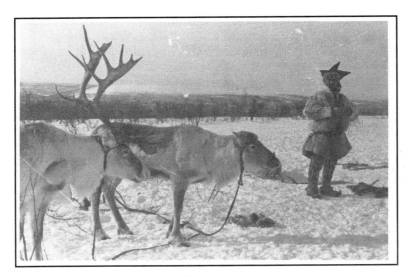

Upper: Line's guide riding in a pulka.
Lower two: Prime grazing land. The reindeer paw through snow for forage.

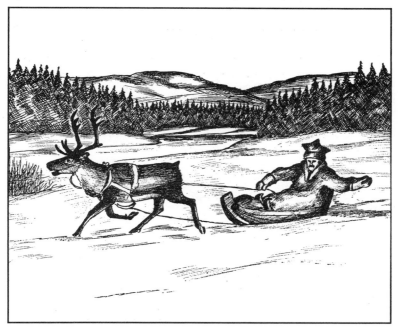

Upper: This boy tends herd over the symbolic wealth of Lapland.
Lower: Lapp postcard showing reindeer and pulka.

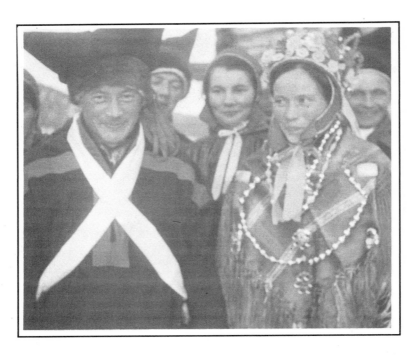

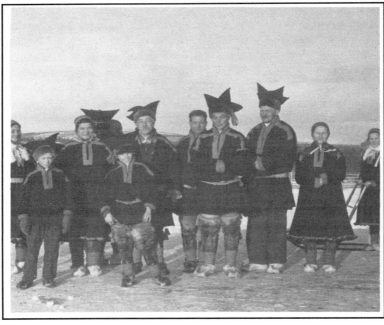

Lapp bride and groom, and a few of the wedding guests.

CHAPTER 4

Reindeer Roundup

Lapland is reindeer land. I was soon to discover that human inhabitants could not exist without the deer. They are the Lapp's principal means of transportation, food supply, source of fur and clothing, and symbol of status and wealth.

Having become well acquainted with one family of Mountain Lapps, I bargained with them off and on regarding a trip by reindeer and pulka up into the low mountainous country to see their reindeer herd. That trip, with me driving a half-wild deer from my uncertain seat in the tiny pulka, was my true initiation into Lapland.

Pulka driving combines all the thrills and pleasures of tobogganing, horse racing, and the rodeo. A pulka—the conveyance by which the Lapps do virtually all of their cross-country traveling in winter—is a tiny round-bottomed sled or toboggan somewhat resembling an elongated foottub, barely large enough to hold one person. It is hitched by leather thong to the deer, which is controlled by a single rein extending backward at the animal's side, or often between its legs. I became adept in the business, and learned well the first rule of pulka-driving: "Don't leave go of the rein."

Preliminary reading on Lapland had convinced me that the novice could not escape many a spill in his first attempts as a pulka driver. I quite naturally assumed that my deer would be hitched behind my guide's and "trailed along" to begin with. But not so.

"Here is the rein," the guide indicated, and that was all there was to it. My animal started out at a fast pace. Almost immediately we encountered a sharp incline where the trail led down to the frozen bed of a river. A pulka has no brakes and the deer broke into a terrific gallop to keep the conveyance (and me) from surging forward between its legs.

But the animal couldn't go fast enough. From up ahead my guide signalled me to drag my feet. Thus was taught to me the first

great lesson of the Arctic—how to use one's feet in steering a pulka or checking its speed.

That first hill was maneuvered without a spill and quite proudly I can boast that never afterward did I fall out of a pulka.

Of course I did nearly everything else which a skilled driver would never do. Once while braking down a hill, my leg became caught under the pulka and I thought it would snap off before I could get it loose. Several times, on mad charges downgrade, I narrowly missed colliding with trees. And once I didn't miss. That was on a level stretch. My animal suddenly veered into the forest and a tree was the first thing we encountered. Forcibly, too. All these things happened to me, but never once did I actually fall out.

Soon after gaining the riverbed we met a reindeer outfit coming in the opposite direction. Our animals shied and balked; a reindeer is frightened at the least occurrence. In the confusion, I got ahead of my guide and he tried to repass me. A deer detests being overtaken. And there, on the frozen river, we made the fastest time of my travels in Lapland—twenty-five or thirty miles an hour for a short stretch. Hoofs pounding, snow flying, hearts (both of animal and driver) beating wildly—it was a supreme moment. My face was so caked with flying snow that vision was almost impossible. All I could do was clutch tightly to the rein until the race was over and my guide had finally passed.

The deer is a remarkable animal, with speed, stamina, and adaptability. Their usual gait is a trot, but often they break into a gallop, and sometimes resort to leaps and bounds. The deer's hoof is a marvel of adaptation. It is wide and looks like a gunboat on the deer's slim leg. And if the snow is soft, the animal can expand it still farther. The rear of the hoof consists of sharp prongs which can be put down flat for snow, or dug in for ice. Every few miles our deer would stop to eat the snow, the only drink they required. Often they eat and paw their way down to gray moss, which is their winter food.

All signs of trees, or even shrubs, were now gone; we were north of the Arctic timberline, traversing a sheet of white snow which seemed as wide as the world. In the distance, on that white expanse, appeared a large speck, surrounded by a cluster of much smaller specks. They proved to be a wigwam-type tent, surrounded by a great herd of reindeer. With a merry swirl we circled up to the isolated shelter and were greeted by a young boy, who seemed barely in his teens. This was the herdsman.

All of us were soon inside. The tent was opened at the top and smoke from a fire on the bare ground lazily rose and disappeared

through the hole. Reindeer pelts surrounding the fire made excellent seats and a bed. The place was snug, warm, and comfortable.

Quickly the herdsboy brought in a kettle of snow, hung it over the fire, and threw into it half a dozen hunks of bloody raw reindeer meat. The snow melted, the water boiled, and the meat simmered in a bubbling scum of powdery dirt on the water.

Coffee was brewed. It was good. I took mine black, for I still was not used to curdled deer milk. My Lapp guides had brought good Norwegian bread and margarine from Karasjok. Soon I was eating with such enthusiasm and abandon that I got too close to the flames and scorched my peske, or outer garment. Men and boy laughed merrily at my clumsiness and with a hunting knife one of them speared out another piece of meat for me to devour. When the meal was over we went outside where I had a visual lesson in Lapland economics.

Several hundred reindeer were scattered within a few hundred yards of the tent, many of them pawing and eating through the three-foot snow cover to reach the moss below. Strange as it seemed, this was prime winter grazing land.

These animals represent the wealth of Lapland. In his neighbor's eyes, the owner of such a herd is rich. A large herd is a status symbol, and with good reason. From the deer come the pelts and fur for clothing, and the meat and milk for food and drink. The hide is cut in strips for leather thongs. From the blood, a type of pudding is made. The deer stomach is filled with milk in the making of cheese. Reindeer hairs are hollow; they float, and are used for stuffing life preservers.

The true Lapps, I learned, even depend on the reindeer for all designations of month and season, rather than using a calendar. Calving time means that the month of May has arrived; the shedding of fur means summer. There is the month when the horns of the reindeer are in velvet, the month when the deer must start for the coast, the period when the animals get restless and head back inland again. It is solely because of the migrations of the reindeer that the Lapps are nomads; they would normally prefer a sedentary life. Time means little to a Lapp, but everything to the animals they tend, so the reindeer has become the true calendar of the Arctic. The fact was being reinforced in my mind that, without reindeer, human life could not exist in this Arctic land.

My guides wanted to take a couple of the animals back to Karasjok, so they could be trained for pulka driving. The herd seemed docile but when one of the men unloosed his rope, whirled

it, and lassoed one of the creatures, a mighty battle began. The lasso had caught the animal around the foot. In a series of violent jumps and charges, the creature freed it. The other man succeeded in getting his rope around a deer's antler, which resulted in a tussle that outdid a bulldogging contest in a western American rodeo. The animal lunged and plunged, snow was churned into the air, the Lapp man at times found himself being dragged bodily as he clung to the rope—until suddenly the deer's horn broke off.

It was late afternoon before two reindeer were successfully lassoed, tied behind the pulkas, and preparations made for the journey back to Karasjok.

As we glided out over the great snowfield, I took a long look back at the young herdsboy standing outside his tent, surrounded by the reindeer. A lonely task, but an important one. He was guarding an economic and symbolic treasure—the wealth of Lapland.

"Two Lapps from America"

Karasjok's winter population consists of some eight or nine hundred Lapps, made up of villagers who live in substantial but small hewn-log houses in the town itself, and of Mountain Lapps, who occupy rude homes across the river, about a mile away.

In spring and summer a general exodus occurs. Many Lapps from the town itself go with their cattle and horses to summer camps, up the Karasjoki River, where better grazing can be found during the short summer months.

The Mountain Lapps are the true nomads. Each spring they follow their reindeer herds down to the coast, returning to their Karasjok homes in the autumn.

Neither of these departures had yet occurred and in that population of nearly a thousand I made an intriguing discovery. One Lapp, and only one, so far as I could determine, was able to speak English. I was having a particularly difficult time making my sign language understood by the girl at the fjellstue who was preparing my food for breakfast. Glancing out the window, she gave me an apologetic smile and wave of the hand, dashed out the door onto the snow, and came back with a fine looking middle-aged Lapp, who had been passing by just at that moment.

"I'm Clement Boyne," he greeted me, in excellent English. "You are from America? I've been all over America. I know it well. Welcome to Lapland."

What I had for breakfast, and whether I even ate it or not, I can't remember. I pounced on this English-speaking Laplander

and began plying him with questions of every description, as though he were the only person I had met or talked to in a year. Clement Boyne was a godsend.

"Many years ago, your government hired me to take a herd of reindeer to Alaska. I went to Point Barrow and taught the Eskimos how to raise reindeer in that land."

For years he lived in Alaska. At last, his task accomplished, Boyne had returned to the United States just before Christmas and had secured a job in a Seattle department store as a Laplander Santa Claus. His combination of Eskimo and Lapp fur garments, combined with his authentic "North Pole" experiences, made an immediate hit with the crowds. He traveled from city to city in America, considerably extending the Christmas season each year, as department stores tried to out-bid each other for his services.

He had left Karasjok as a young man; he was middle-aged upon his return. He longed for a chance to speak English and we became such close friends that we were seldom parted during the rest of my stay. Together, we visited scenes and areas I had already filmed and with his help I obtained additional shots. He helped me obtain pictures of obscure religious services. He went with me to the homes of the Mountain Lapps. Preparations were already under way for the spring reindeer migration to the coast. With Boyne's help I filmed the activity—skins and meat being hung out on the outer walls of the huts, pulkas being repaired and made ready, clothing being made or mended.

One day as Boyne and I were walking along a reindeer trail near the edge of Karasjok, a Lapp man, standing by his small hewn-log home, pointed to us and said something to his wife.

"He's saying: 'There are those two Lapps from America,' " Boyne explained to me. "With you wearing Lapp clothing, you look as much like a Lapp as I do. That man thinks you are one of us."

Spring, according to official timing, and even according to the calendar set by the reindeer, was supposed to be close at hand. But the elements were confused. The days became colder, and the nights became nightmares. At one time, the thermometer touched seventy degrees below zero, Fahrenheit. My camera lenses froze; I could not turn them when I needed to. I oiled them—to no avail. The fingers of my right hand became raw, and even bloody, as I attempted to turn the grooved lens discs. In desperation, it became necessary for me to get up far before dawn and, in my fjellstue room where the temperature was at least bearable, turn each lens

back and forth time and time again, so it would be workable during the day.

The freezing cold merged into more temperate weather. Scene by scene, episode by episode, the story of the area, the activities of the people—even the intimate details of life in the homes of some of my friends—were captured by my camera. Late one afternoon, as the shadows began to lengthen, I climbed a small hill and had a sweeping view of much of the village, and the life that had become familiar to me.

The main cluster of homes, with the church and the store, were nestled in a curve of the river. On the icy surface of the river itself occasional horse-drawn sleighs were passing up and down to the accompaniment of jingling sleigh bells. One such sleigh was loaded high with marsh hay, destined for one of the barnyards that I had filmed. Another sleigh groaned under a load of wood. The winter days, when other work cannot be done, is the time for stocking firewood.

Those sleighs had to use care to avoid holes in the ice, which had been chopped through for winter fishing. Through one of them, as I looked, a teenage girl, her crimson-trimmed attire standing out against the icy white background, was dipping water into a pail, to be carried home for their drinking supply. Past the girl shot a sled, for a boy—taking off from the very hill where I watched—had tobogganed down the slope and out onto the icy river. He, and a companion with another sled, trudged back up the hill, then both of them slid down again. Realizing that I was watching them, and filming their achievement, they had made a running start, and coasted almost across the river's surface to the far shore.

On that far shore, a small crude ferryboat—deserted and discarded—lay where it had been hauled up just before the river had frozen over last fall. In a month or so the ice would begin to thaw and for a time there would be no way to cross the river at all. But once the ice was gone, the old ferry would again be put in use for the two or three months before freezing weather came again. Winters follow winters in close succession here in Lapland.

CHAPTER 5

Reindeer Trek across Lapland

Time for my departure was approaching. Since I was now familiar with the route, the return trip by way of Hammerfest might have been easy. But that would have become just a twice-told tale. In my reading before this whole adventure started, I had uncovered the prospects of a more exciting and rewarding way of heading back into civilization. Although he had never undertaken that journey personally, my Lapp friend, Clement Boyne, recommended it highly. I would go by reindeer and pulka, eastward instead of west, out through this wild country of northern Norway over to the Finnish border, then continue through the northern reaches of that new nation to a junction with the Great Arctic Highway, which extends from the Arctic Ocean down to Rovaniemi, Finland, on the Arctic Circle.

Clement Boyne helped me engage a good Lapp guide, who had a pair of reindeer to transport us by pulka. All interpreting had to be done before departure.

It was decided that, by making an early morning start, we could cover most of the distance to the Finnish border the first day and put up for the night at a Lapp hut which my guide knew about. The country from there would be wild and mountainous, infested with wolves, most feared predator and enemy of the deer. It seemed best to start that part of the trek by daylight.

My indebtedness to Clement Boyne had been so great, and our friendship had become so intimate and real, that we both found it hard to make our farewells. Next morning, with no one any longer able to interpret for me, I went out to join my guide, and found that for some reason he had made a change of plans. He had sent his son instead—a young, inexperienced and unimaginative fellow, who had almost no ability to comprehend sign language, which would be our only means of communication.

This change of plans was hard to take, but there was almost nothing I could do. It became even harder to take when I soon discovered that our reindeer—at least mine—was unaccustomed to pulka driving and was, in fact, as yet only partly tamed. It soon became apparent that my young companion's animal was equally ill-trained. Once, in desperation, he even had us swap reindeer and pulkas, but both creatures were still just as difficult to manage. In that fashion we began our journey into the mountain wilderness toward that Lapp hut where we would spend the first night, then on across Finland to Inari, and the junction with the Great Arctic Highway.

Down toward the Finnish border we went, and bid good-bye to all civilization. Our route led along a mountain stream and where the ice was uncertain or broken we had to find a way along the banks. My journey by pulka up to the large reindeer herd had been to the north of Karasjok, across a barren expanse of snow. There, we had been above the timberline. But this trek toward Finland took us through areas of deep forests. Trees seemed to be everywhere and often it was difficult to snake our way through without hitting one of them. Darkness came but we did not stop. Escaping mix-ups with trees became even more difficult. I grew worried. Couldn't my guide find the Lapp hut? Was he lost? He could not understand the sign language with which I endeavored to converse and ask questions. At one point he did stop and, from a sack tied to his pulka, pulled out some marsh hay and began stuffing it into his boots. He motioned for me to do the same.

For this I was thankful. The night was growing bitterly cold. Lapland days are often unpleasant but the nights are severe. After a long climb we began coming to occasional descents. In the darkness, the deer charged blindly through the forest. Black shapes of trees seemed to be everywhere. Drifts of snow powdered into our pulkas as we charged through them.

Nine, ten, eleven o'clock—still we went on and I began to wonder how long a novice—unused to this sort of thing—might be able to endure the cold.

Out of the night came the barking of a dog. Ordinarily, the sound of barking dogs does not cause my heart to well up in thankfulness. But that distant barking, somewhere ahead in the snow-filled darkness, sent chills of anticipation through every vein of my body. We entered a clearing; on the far side was a light. We swung up to a backwoods house. Some Lapps stuck their heads out to see what was the matter and a long lingo of unintelligible confab ensued. Result? We spent what was left of the night in that hut.

46

When daylight came I found that I had been a guest, in what amounted to a one-room house, with eight Lapps. There was a small utility room, without door, and I had graciously been allowed to sleep there. By 8:00 A.M., the family was astir. The weather outside is too severe, at night, for dogs, and they had slept on the floor of the main room, with the family and my guide.

There was a fireplace, with black iron cooking utensils and black pot for coffee or tea. Breakfast consisted of bread, coffee, and strange flabby meat, cut up with a huge hunting knife.

As the main door was opened, allowing the dogs to get out, stinging snow of a blizzard whipped into the room. Not until then did I realize that perhaps my guide had known of the approaching storm, and had tried to get as far as possible before it overtook us. This place that we had reached was certainly not the Lapp hut where we had planned to spend the night.

Outside now, the dogs were fed a pan of animal blood. My guide and I restuffed our boots with hay. By means of smiles and signs I thanked my hosts profusely, paid them for their kindness, and we were off.

That day, heading into the blizzard, brought difficulties hard to imagine. Numbing cold penetrated to my mittened fingers; stinging snow hurt my face. At times our trail hugged a low mountain where the snow was two feet deep. It flew up and filled the air in showers as we plunged down hills. My pulka became laden with the stuff. If worked into my mittens and boots.

We crossed many great lakes. With but a single rein, there is no way to steer a deer other than to get him started in the right direction. On the great white sheets of snow covering the lakes, our animals refused to go as we wished. They would become wild and charge about the snow area without any sense of direction. Only when they had worn themselves out could we get the beasts in hand.

As the author of *People of Eight Seasons* describes the average unruly reindeer: "They race off after their own noses; and when the rein checks them and tries to control them, they start off hither and thither in all directions in the snow drifts."

By early afternoon we came to a tiny log hut, and stopped for something to eat. In the main room, about twelve feet square, was an extended family of nine Lapps, all but one of whom lived there. Cooking utensils hung on the walls or in the fireplace; beds were on the floor.

Only one other habitation lay along our path during the remaining daylight hours, and there we stopped to feed and rest our deer. A Finnish farm family lived here—not quite as poor as the Lapps of the night before, but obviously hard-pressed for a livelihood in these stark surroundings.

A man was lying in bed in a corner upon our arrival, and a woman was getting in firewood. Hearing a gurgling from a pile of furs on the floor, I discovered a delightful little baby. A young girl, perhaps three or four years old, was equally sweet. The mother of these children, and of another baby boy whom she nursed every few minutes, could have been attractive too—but her face was stolid. Probably it was because of my intrusion.

The man got up. As we became better acquainted, by means of smiles and signs and laughter, the young mother smiled, too. Both mother and father showed great affection for the children. Both mother and little girl beamed appreciatively at the beads and trinkets that I gave them.

The blizzard almost completely abated before nightfall. We traveled late and after dark swung southward, finally reaching a good-sized Finnish farm. There I had a room all to myself, with coffee before going to bed, and a good breakfast before leaving next morning.

"Don't Leave Go the Rein"

The next day was clear and fine, but it brought the worst experience of the trek. I was half a mile or more in the wake of my guide, who was out of sight somewhere ahead. Suddenly my deer stopped, frightened by a wolf or some forest denizen, then unceremoniously it jerked the pulka at right angles to the trail and bolted off through the forest. Finally I stopped the beast and maneuvered it back to the trail but there the crazed animal started out at a gallop in the wrong direction.

It was several minutes, this time, before I could bring the frightened deer to a halt. When that feat was finally accomplished, the only thing to do was to get out and endeavor—with what patience I could muster—to veer the creature around, end for end, in the right direction.

Apparently such a procedure wasn't to the deer's liking. Quite suddenly, like a horse breaking from the starting gate at a racetrack, it bolted forward. I made a leap for the pulka—a feat which I had successfully accomplished on the run many times. But this time I missed.

Do you remember the code of Lapland—"Don't leave go of the rein." Well, there wasn't much chance for me to forget it. My valuable movie camera was in the pulka. Furthermore, that pulka and deer represented my only means of transportation. An interminable trek by foot through deep snow to civilization wasn't to my liking. But—prime consideration of all—the rein was tied around my hand and wrist in a double splice. Leave go I couldn't. The code was easy to follow. But that deer was not. After the first leap, I was prone on the ground, gliding sleekly through the snow at my deer's fastest and choicest pace. How far I tobogganed that way would be hard to say. Measured by the pain in my arm it seemed a mile. By yardstick it probably would have measured less than a tenth that far. The empty pulka was dangling along behind the deer and I succeeded, after getting hold of it, in pulling myself in. Whereupon, the ornery creature, probably seeing that the fun was over, stopped altogether and began calmly eating snow. When finally my guide appeared on the scene—having noticed my absence—my runaway deer was as quiet as a kitten drinking milk. But my arm was sore for days.

Toward mid-afternoon on the fourth day I heard, in the distance ahead, strange sounds, like the slow beating of drums. Entering a clearing from the dense forest through which we had been traveling, I made out, on the far side of the open space, two Finnish woodsmen felling a tree. The sounds of their ax blows split through the silent world about us.

Those were the first real signs of civilization. We came to several Finnish farmhouses, then ahead I saw the small cluster of hewn-log structures indicating the inn and its outbuildings of Inari, just a few miles from Finland's Great Arctic Highway. My reindeer trek across Norwegian and Finnish Lapland was at an end. Almost reluctantly I bid good-bye to my guide, as he started the return trip to Karasjok. That night, at the Inari Inn, I slept in a bedroom all to myself under downy covers in a soft comfortable bed. But there were signs that this was still a frontier land. We had lamps for light in the dining room, and my bedroom was lighted by candle.

My hostess was a lovely Finnish lady who spoke good English. She had once lived for a time in Canada.

Courtesies on this journey will never cease. This new-found friend told me that Inari was actually still about twenty kilometers from the Great Arctic Highway. She would accompany me down

to Ivalo, at the highway junction, to see that I got a good start back to civilization without difficulty.

Before we left, there was time to see the great frozen lake on which Inari is located, and to film the wild ice in the river feeding into it.

My gracious hostess was an encyclopedia of information about this land. One reason she accompanied me to Ivalo, I discovered, was because she was hungry for a chance to speak English with someone from the outside world.

"It is lonesome up here at times," she told me, "but when I go out for a holiday I always get homesick. I must return to Inari."

The road was rough and bad, but it afforded fine views of the lake. At one point it was necessary to honk a herd of some thirty reindeer out of the way.

"There are many wolves in this area," my inn hostess explained. Rather than attacking the herds of deer, she said, they usually isolate one, then run it until it is tired. "Once," said my friend, "the postman left his reindeer untended and the wolves got it."

There was an hour-and-a-half wait at Ivalo for the Great Arctic Highway bus—the bus that runs from Petsamo on the Arctic Ocean, to Rovaniemi on the Arctic Circle. "I hope we can meet again," I said to my newfound friend, as the bus prepared to depart. This hope of mine was expressed without any real thought that it might one day become a reality. The conditions under which such a meeting was actually to occur were stranger than fiction, and lay a long way into the future.

Almost at once, as soon as the bus departed, with me aboard, I was sorry that my Inari hostess was no longer available. I thought the bus was heading in the wrong direction—toward the Arctic Ocean instead of southward toward the Arctic Circle. Apparently too long in the wilds had confused me.

But reassurances came promptly. No one on the bus spoke English, but we soon stopped at a roadblock, to be greeted by a Finnish customs official. Then I knew we were headed in the right direction. I had been in Finland for several days, but all of Lapland—whether in Finland, Norway, or Sweden—is outside of customs regulations.

In an enormous white flour sack—procured at Inari—I had crammed my complete Lapp outfit—fur peske, four-cornered hat, felt outer garments, leather boots, mittens. When I pulled them out for customs inspection, the officer and the Finnish and Lapp passengers on the bus all had hearty laughs. Even though I could not

speak with them in their language, a bond of friendship with my fellow passengers was established.

Half a day later, just at the edge of Rovaniemi, through a veil of snow which was turning to rain, I saw the sign, in four languages, "Arctic Circle." My Lapland Arctic adventure had ended.

Four days later I was back in London with Helen and our girls.

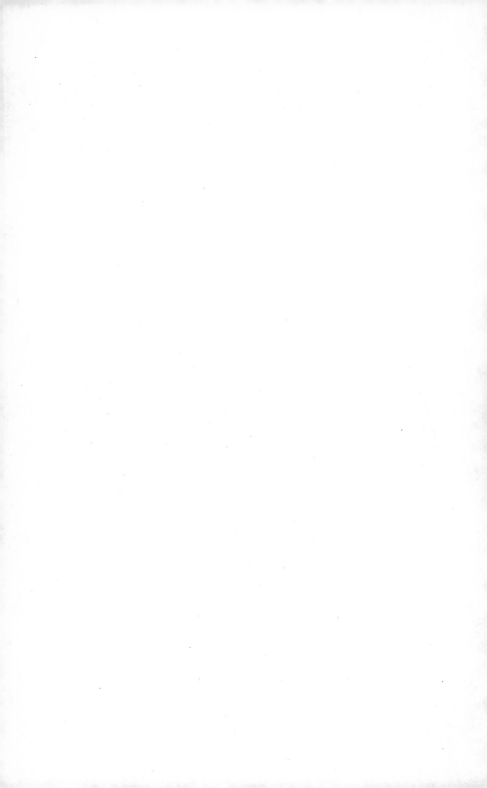

CHAPTER 6

Sixty Thousand Lakes in Finland

In returning to London from winter Lapland I had made the unusual bus trip down Finland's Great Arctic Highway and had journeyed the entire length of that country. In visiting a number of her fine cities, including Helsinki and Turku, I had felt admiration welling up within me for this nation which was so old and yet so new.

Helen and I planned to return to Lapland together for summer filming. That trip would take us through Finland. Why not make a full-length film on this land, we began asking ourselves. Even before leaving home, realizing that Helsinki was scheduled to host the 1940 Olympic Games, such a thought had been in the back of our minds. While passing through Helsinki from Lapland I had procured guidebooks, maps, and extensive literature. In our small London flat we commenced burning the midnight gaslights, devouring this exciting Finnish material as though it were a mystery novel.

While still in America we had heard about a private English school which was one of the finest in the English-speaking world. It was Kittiwake, on Britain's south coast, lovingly administered by Margaret Silcock. We had made plans by mail to leave our two children, Barbara and Adrienne, at this school during our summer journey to Lapland. And on our way to summer Lapland, we now decided, we would spend several months producing a film on Finland.

In her own language, Finland is known as "Suomi." The Finns call their country "Suomen Tasavalta,"—"the land of a thousand lakes." Actually she has more than 60,000, including Lake Ladoga, largest in Europe. Of the lower half of Finland, approximately twenty-five percent of its area consists of lakes. Many of them, so we read, were connected by rivers, or sometimes canals; steamers plied them to carry freight, deliver mail, and provide passenger service to isolated areas. Some of the rivers had

mighty rapids which the adventurous could navigate or "shoot" in specially constructed river craft. We discovered in our reading that we would be able to journey through much of the Finnish nation by way of its lakes and rivers. We could make a film which would not only document the advanced social conditions and farsighted industrial and architectural aspects of this old-new nation, but we could flavor it all with episodes of high adventure.

Sixty thousand lakes. Connecting rivers. Mighty rapids. We decided to name our new-planned color motion picture *Finland Waters, A Story of Adventure in a New Nation.* Our journeyings by water would give the film continuity—a thread on which to hang episodes of adventure and human interest.

The romantic approach to Finland is across the Baltic Sea through the archipelago surrounding the Aland Islands, last home of the windjammers. Following this route, wending through thirty thousand islands bunched like grapes until it was impossible to realize we were actually crossing a sea, we came to Turku.

It was necessary to visit and film three of Finland's principal cities before starting our adventure by water. We soon found that Turku, the first of these, was more than a preface to the country. It was the whole first chapter. In one breathless whirl we were barraged with an ancient castle, a 13th century cathedral, horse-drawn droshkies (cabs), a chattering, gossipy marketplace, and a lively slice of modern Finnish life.

The wrinkled old market women, faces as varied and interesting as the heterogeneous products they sold, had real camera appeal, but the best photographic subjects were the trimly-attired young streetcar conductresses.

Turku was like that—a city of contrasts.

As we came to Tampere, the country's chief industrial center and the second on our city list, we had expected normal factory conditions. Instead, we found factories with fine statuary in well-kept lawns before nearly every plant, and advanced social conditions which were the hallmark of Finland and Sweden.

Women as well as men—mothers as well as fathers—worked in the factories; special play areas, beautifully equipped, were located throughout the city where children might be left for the day under the care of girls in training for the teaching profession.

Best experience of all in Tampere had to do with Hellin Heiskala, our guide and interpreter, secured for us by a branch of the government. When our filming was over, she invited us out to her little home—a small red wooden structure by a forest at the

edge of town—where we met her two-and-a-half year old girl, Heli, or "little Hellin." This beautiful lady was a university graduate who spoke seven languages. She was an occasional tourist guide, and was the person in charge of a children's radio program which was broadcast throughout much of the country. Her husband, Finland's leading aviator, was known locally as the "Lindberg of Finland."

Although we had no conception of it at the time, Hellin and little Heli, and her ever-enlarging family, would become world renowned, and play important parts in our own lives in the years to come.

The third city to be explored was the greatest of all—Helsinki, the nation's capital, where outstanding architecture immediately came to our attention. Arriving by rail, we were deposited at the train station, one of the fine buildings designed by Finland's world-renowned architect, Eliel Saarinen. He was also to play a significant part in our later lives.

After visiting the Diet, called by many travelers the finest parliament building in the world, and after admiring and filming the unusual churches, all the way from the Greek Orthodox Cathedral to a workingman's church which resembled a skyscraper, we went out to the Olympic Stadium, whose towering shaft had caught our eye as we entered the city by rail. The Olympic Games, so everyone thought at that time, were less than a year away. Finland was a land devoted to athletic prowess. In much of our spare time we watched athletic contests, drills, aesthetic Scandinavian dancing, and field events of many kinds.

Getting Our Two Cents Worth

Finland's cities offered us much culturally, but our exciting adventures, we had assumed, would come later. In a way that was true. But in these three metropolitan areas we experienced adventures of a different sort.

The first was monetary in nature, a phenomenon of the pocketbook. We discovered that, economically, at the time of our visit, Finland was a tourist paradise.

Many countries in Europe, where the dollar had an unfavorable rate of exchange, were expensive. Not so in Finland. A Finnish mark was worth two and one-ninth cents. It bought a streetcar ride of any length, with two transfers if needed; it was good for a shoeshine, an ice cream cone, or several miles of railway travel.

To quote in American terms, taxi minimum fares were twelve cents, excellent meals cost a quarter, modest hotels were one dollar for two persons, while twice this price obtained a double room in the very best places.

Those meals and hotels require elaboration. Our breakfasts were served to us in bed—an old Finnish custom and one not at all hard to adopt.

For lunch and dinner one sits down to food displays which are artistic and gastronomic achievements. "Sit down" is not the proper expression, for in many establishments the food is served buffet style. One table in the center of the "Ruokasalissa," or dining room, beams invitingly with its salads, cheeses and hors d'oeuvres. Another is bedecked with breads, butter, milks, coffee, and dessert, while a third groans under the weight of the entrees. For one of our noon meals there were thirty-two different fancy dishes on the salad table alone—and the whole meal cost twenty-eight cents.

Finland is indeed a tourist paradise. A paradise in all respects but one—her language. A little sample is the word "siskomakkara-keitto," which we were told was a type of soup. Just to pronounce it sounds a bit like slurping bouillon.

In a railway station, when we came upon a sign reading "Matkalavaravakuutuksia" we didn't know whether it was a place to buy tickets, procure a meal, or take a train. A sign on a door in the parliament building in Helsinki reads "Tyovaenasiainvaliokunta." We discovered that "sanomalehtitoimisto" means "newspaper office."

Helen could not make heads or tails out of a notice over a park bench on which she sat to consult her Finnish-English dictionary. She found it said: "Wet Paint."

All this may be well enough for the people who are born to such a language, but it does seem a bit unjust to strangers to call the travel office a Suomen Matkailisayhdistys. There are a few compensations, however. We saw a Finn jam his finger in a window and he said "Ouch," just as we would. At a Helsinki church service we heard the minister close his weird-sounding prayer with a familiar "Amen." It was one of the few words in the service we could understand.

A ridiculously favorable rate of monetary exchange; a chamber of linguistic horrors—those provided the first two of our unusual Finnish adventures. The third had to do with bathing.

The sauna is the Finnish steam bath and the word "amazing" is all that can describe it. My initial experience with one came just

56

after I had reached civilization at Inari after crossing winter Lapland by reindeer.

Two Finnish youths led me out over the snow to a red log building, took me into the dressing room, and then to the hot steam room itself, where I perched myself on an elevated bench up under the rafters. In a corner stood a great boiler filled with hot rocks, and over these one boy poured pails of water. That room became unbearable. Dante's inspiration for his literary masterpiece must have been one of these Finnish sweat baths. According to instructions, I frantically soused cool water over my body and face and beat myself lustily with small birch branches. But the cool water turned hot just from contact with the air. I had withstood cold and hardships and had endured blizzards, but after three minutes in that executioner's chamber, I bolted out the door onto the cooling snow. Stark naked. It was several minutes before the boys could coax me back. The room had cooled somewhat, but after scrubbing thoroughly I went out and took a snow rubdown. Afterward I learned that those fellows had sized me up for a tenderfoot and purposely made the room so hot that they themselves could scarcely bear it.

That was my first experience with the sauna. My second took place at the resort hotel Finlandia, situated between the lakes at the famous ridge of Punkaharju.

After dinner, a sign was posted in the hotel lobby announcing this to be "sauna" night—it apparently being the practice to "steam up" only twice a week. Helen at once decided to try it, but I demurred. One parboiling, it seemed to me, was enough. In thirty minutes she returned, grinning from ear to ear.

"What seems to be the matter?" I asked.

"Never mind," came her mysterious reply. "All I can say is, you don't understand the fine points of a Finnish sauna."

In three minutes an appointment had been made with the porter. Another ten minutes and I was in the steam room.

The temperature was not hot in the least—just 165 degrees Fahrenheit and completely comfortable. The innovation came in the fact that, instead of performing my own beatings with the birch twigs, in marched a most attractive young maiden to take full charge of the task. She really beat hard, and after fifteen minutes of that, she motioned me down to the scrubbing floor. Handing me a tumbler and a great frosty pitcher of ice-cold cider, she procured soap and water. To the accompaniment of an icy drink, I was scrubbed from head to foot.

The cheerful young lady then proceeded to the rinsing, using pail after pail of successively cooler water. Finally she wrapped me in a great bedsheet of a towel and pronounced the ablutions complete.

The person must have been thinking of Finland who said that travel is an education in itself.

CHAPTER 7

Monks, Milk, and Lumber Mills

Finland Waters. At last we were ready to launch into the theme we had chosen for our film. As a warm-up we started out with a visit by water to an unusual colony of individuals, whose habitation can be reached only by a boat trip across Europe's largest inland body of water. We journeyed out to an island in Lake Ladoga to become acquainted with the monks of Valamo. For several hours our little steamer churned the rough surface of a lake which was 150 miles across, with the Russo-Finnish international boundary line passing directly through it. (Scarcely more than one year after our visit, Valamo, as a result of the Russo-Finnish War, would become Soviet territory.)

The monks of Valamo adhere to the Christian teaching that all who come their way should be given food and shelter. In the last century so many travelers visited Valamo that a separate building had to be erected to house them and it was here, for a nominal charge, that we stayed.

Our room was long and narrow, with partitions nearly a foot thick. Our bed was hard, and the pillows like rocks. We had to do our own room service, but we enjoyed it all the more because of these facts.

The food served to us was good. I received special permission to eat with the monks themselves. At noontime we filed into a dark room and took our seats on wooden benches to eat a meal consisting of raw carrots, almost black bread, and beans. For dessert there was a second helping of beans, with an added sauce.

At strange hours, night and day, the monks held religious ceremonies in their beautiful chapel. We attended one such service at two o'clock in the morning and discovered that these aged men had voices comparable to those of the Don Cossack Russian Choir. Many of them had been chanting six and eight times daily for forty or fifty years. They have had much practice.

The monks do most of their own work. Those of the higher orders conduct the services and do the chanting, while those of the lower orders engage in the more menial tasks.

When it came time to depart, they helped us down to the dock with our luggage. They put our bags on board. A monk cast off, and there was one at the pilot wheel, steering the little vessel through the channels and out again over the wide waters of Lake Ladoga back to the Finnish mainland.

The clear, almost mystic chanting of the monks of Valamo, with the sounds echoing through the quiet solitude of the great church, and carrying even out across the waters of the lake, carried in our memories throughout the rest of our Finnish journey.

Next day that journey started in earnest as we boarded the small steamer Punkaharju II, to head northward by lake and river through the heartland of the Finnish countryside. The Finns were prosaic in the naming of their boats. Along this waterway we saw Punkaharju I, II, III, IV, V, and VI.

At occasional places along the way our little vessel would pull up at docks on the shores. A passenger would be taken on or let off, or some goods loaded or discharged. Catches of fish were staple cargo. Another stop. Out goes the gangplank, and some empty milk and cream cans are unloaded. These small steamers play an important part in bringing communication to the people who inhabit these isolated areas.

First important city along the way was Savonlinna, a beautiful place, where we chanced to arrive on market day. The square down by the water's edge almost resembled a human anthill, people everywhere, and with dozens of small carts being pushed or pulled home, full of produce after the morning's shopping.

Climbing a tower in the center of the city, we saw again the type of terrain which gives the nation its name, Suomi—land of rivers and swamps and lakes.

Heading northward again, this time on the Punkaharju I, we passed intimate scenes—boys fishing from the shore, women washing by the water's edge, holiday makers out for an airing.

Especially did we see the saunas, small smokestacked huts where the Finns enjoyed their steam baths. The Finns attribute much of their buoyant good health to these saunas and to the great use of milk in the diet.

Dairying is the nation's second industry, with signs of it all along the way. At one farm we disembarked (catching Punkaharju V later in the day), to study and obtain moving pictures, first hand, of the dairy processes. The person in charge was a twenty-two-

year-old girl, whose parents were both dead. She directed the work of the whole self-contained estate, with its blacksmith shop, bakery, laundry, and dairy. Her attractive rosy cheeks were the result, not of make-up, but of the healthy hue brought on by hard work.

On Punkaharju V we continued northward, passing fine stands of timber and making occasional stops at isolated docks.

Lumbering is Finland's first industry; seventy-five percent of the nation's exports consist of lumber or lumber products. There are three main stands of timber—pine, spruce, and birch.

When I had come down from Lapland in winter I had seen lumbermen cutting the trees. Now we saw the logs being floated down to the mills. Some were going singly, others made into huge rafts, while still others were tied in great bunches and towed behind lake vessels. In every manner and means they were heading down the waterways toward the mills.

Lumber was piled everywhere—lumber for most of the countries of Europe. Finland, in proportion to its size, has more timber than any other European nation.

Shooting the Oulu Rapids

With our journeyings on the boats Punkaharju I, II, III, IV, V, and VI, plus a number of other lake and river vessels, we had concluded with one form of transportation by water through Finland. But there was still a new type open to us. For a third of a century, lumbermen in the center of the nation have been transporting tar down to the ports of the Bothnian Gulf along the rapids of the Oulu River. For this purpose a special type of boat has been constructed, and helmsmen have been trained in the art of shooting these rapids. It is now possible to make the journey in craft similar to the old tar boats. We decided on the trip, but first walked down the river some distance to see just what kind of rapids we would have to shoot. The frothing current, churning over rocks like a herd of wild horses, almost frightened us, but we obtained fine pictures of the area we would be navigating. When the trip started, we made two amazing discoveries. First, the tar boats—just three feet wide but forty feet long—are admirably constructed for the tasks which they have to perform. And we found that the helmsmen really knew their business.

Time and again our tiny vessel would head toward a rock. It would seem that a catastrophe could not be averted. But at the last instant the boatman would steer the craft clear and avoid disaster.

At one place the river was filled with logs. Many times our little vessel would get astride of one. Sometimes several would be under the boat at the same time. We would think that surely the craft would turn over, but always the skill of the helmsman was able to save us from any accident. Last portion of the journey was the roughest of all and we had a spine-tingling landing, with the tar boat catapulting angrily around a rough curve and missing an old wooden pier by inches as we shot under a suspension bridge and drew up alongside a little landing stage.

The entire adventure consumed nearly a day. In all that time there was no severe accident. At least not until the end. Just as we were docking, I saw a pretty girl whom I wanted to photograph. In my haste to jump out, I tipped the craft half over, until it dipped water. But I did get the movie footage.

A little Alice-in-Wonderland train, with a solitary car hitched to its poky old engine, was waiting to pick us up. It fairly galloped over the final stretch to Oulu, the birch-laden tender and the single car dancing gleefully to the rugged rhythm of the tracks. Here on this train were nearly as many thrills of rough riding as we had experienced on the riverboat.

The greatest joy of the trip lay in the companionship of those who accompanied us—seven persons comprising five nationalities—French, German, English, Finnish, and American.

At the Arina Hotel in Oulu, on the Bothnian Gulf, Helen and I entertained most of our international group for the evening, then went down to the midnight train to see them off, for we were all traveling in various directions. Our friendships had been short but sincere and there was real wistfulness as we stood on the platform saying "Auf Wiedersehen," "Au Revoir," "Cheerio," "Hyvasti," and "I'll be seeing you!" Representatives of five splendid nations and we were all friends. To think that there is a possibility of our all being involved in a war amongst one another!

Oulu is a drab town with a pearl set in its center. The Arina Hotel, opened just two months, was one of the finest we had enjoyed in Finland and we lingered two days just to bask in the luxury. The great dining room was a splendid achievement in decorative restraint. Each evening an orchestra played and one night it rendered a medley of American folk songs just for our benefit. We have always liked "Dixie" and such tunes, but they are like rare old lace when heard eight or nine thousand miles from home.

Our close proximity to the Arctic Circle, and to the longest day in the year, is allowing the sun to play strange tricks, to which it has been impossible for us to adjust. The last week, midnight has been

less than one hour removed from the sun's rising and setting. It never becomes even faintly dark. Hotels and restaurants draw huge curtains over the windows at 9:00 P.M. and turn on the electric lights, giving their patrons a rest from too much daylight.

The rosy glow in the sky in the middle of the night may be the last flush of today or the first blush of tomorrow. No one can tell. And the sun rises in nearly the identical spot in which it sets. Confusing place, this northland.

Confusing and exhausting. Traveling is supposed to be a relaxing sort of task, but we have never worked as hard at home as on this Arctic trip. One just does not think of going to bed before 12:00 or 1:00 A.M. And with so much to do, and with the sun flashing in your eyes each time you turn in bed, six o'clock seems late for rising.

Confusing and exhausting perhaps, but intensely interesting.

Sauna-diploma

We hereby certify that

Mr. Francis Line

has, in the honourable tradition of Kalastajatorppa,
bathed at a temperature of

120 °C./ *248* °F.

in Hotel Kalastajatorppa's more modern, perhaps even hotter,
version of the fisherman's shore sauna.

Munkkiniemi,

16.6.1972.

witnessed by

Eri Ritschkoff. Hellin Östring

HOTELLI
HOTEL
Kalastajatorppa

*On a later visit to Finland, Line received a "Sauna Diploma" proving
that the temperature was 248° Fahrenheit.*

CHAPTER 8

Festival of Lights

Many Finnish hotels have the pleasant custom of hoisting the national emblem of each new guest who arrives. We were the first Americans to register at the hotel in Rovaniemi; in our honor, up went the American flag.

This was the city, directly on the Arctic Circle, where I had ended my Lapland Arctic adventure, just as spring was turning the deep winter snows to slush. Now it was June 23rd, eve of St. John's Day, and the city was crazy with excitement. Longest day of the year (almost). The Arctic Circle, where—on this one day—the sun does not set, even at midnight. Townspeople, tourists, and travelers, backwoods settlers from the forests of northern Finland— Rovaniemi was crowded with celebrants. Crowded, too, with entertainment—street fair and circus, clowns, even a third-rate American cowboy doing roping stunts.

At 11:00 P.M. all eyes turned toward Ounasvaara Hill, and the thousands who jammed the streets began trekking toward its summit.

The hilltop was studded with massive rocks and on these the throngs stood in clusters facing the light. All day there had been clouds but, like a real miracle, at half an hour before midnight the clouds parted and revealed the sun. Not only were we seeing it at midnight but that was the only time of day it had been visible. From a band concealed somewhere in the rocks came the strains of Sibelius's tone poem, Finlandia. All heads were bared as the Finnish flag was raised aloft. Midnight came, and the sun—just touching the horizon—slowly began its ascent of another day.

Helen was overwhelmed; tears streamed down her face as she listened to the music, which was like a review of our entire Finland trip—rippling forests of birch, surging streams, mysterious backwoods life, with its friendly people who had helped us along the way. All these things flowed through her mind and were contained

in the music. A woman standing near her asked: "Are you Finnish?" Helen replied: "At this moment I am."

St. John's Eve—the Festival of Lights—had been celebrated after the manner of the Arctic.

The Great Arctic Highway, extending from Rovaniemi northward to Liinahamari on the Arctic Ocean—down which I had traveled a portion of the distance to terminate my winter trek to Lapland—this Arctic Highway journey would be Helen's and my last adventure in Finland. At the city's outskirts, the bus driver kindly stopped so we might film the sign, in four languages, "Arctic Circle."

From that point northward the highway cut for miles through heavy forest. Here and there in small clearings were the log huts and rude sheds of Finnish settlers, invariably painted red. Each tiny clearing meant toil—a struggle to push back the forest; each little home meant that a family of hardy pioneers was doing its bit to extend civilization into remote places.

It was nearing the first of July and spring plowing had just begun. The first frosts commence in August. Only with the aid of continuous sunlight can there be any hope at all of growing a crop in two months.

As we passed the isolated farms—fragmentary specks of human endeavor in a wilderness of forests—we marveled that people could choose to live in such remote locations.

Bus travel on the Arctic Highway is not a rushing affair. The buses are actually the mail conveyances, which carry passengers only as an accommodation. Each time we came to a farmhouse there would be a stop to leave or pick up mail. The farmers would bring down their tiny cans of cream to send out, and receive "empties" in exchange.

In addition to mail stops, each hour or so we would pull up at some farmhouse in which the housewife had turned her sitting room into a "ravintola." There would be ten minutes for coffee or milk, or half an hour for a full meal. We would lay out a few pennies as payment and be off.

At such places, gaily-attired Lapps, who lived far back in the forests, would come down to stand around and stare at the strange-looking bus passengers who were invading their land. Occasionally the Lapps, as well as others who lived in the backwoods, traveled on the bus. In almost every case they became car sick. Paper sacks for sick passengers were standard bus equipment. The road was not excessively winding but there was scarcely a time when some passenger was not ill. For Americans who are born to

auto travel—virtually using the steering wheel for a teething ring—it is hard to realize that a novice can be quite as distressed in a swiftly-moving car as in a ship at sea. Many of those sick folks were having their first auto rides.

Reindeer blocked our progress on two occasions, then leaped off into the forest as the driver blasted his horn. We saw many of them back in among the spruce and birches, heads alert as they watched this strange yellow demon on wheels rushing through their domain. Once, on a distant hill, there was a whole herd—like sheep on Scottish moors.

BANG! and the yellow demon slid to a stop with a punctured tire. All the passengers alighted—then all began a wild batting and slapping. Mosquitoes!

The country became more mountainous and the road more winding as we forged onward into Petsamo, the area which until 1920 was part of Russia. (Following the Russo-Finnish War, shortly after our trip, part of it again was annexed to Russia.) Mixed pine and birch gave way to birch alone, which became more scrawny each mile we traveled, until at last only the scrub-covered rocky fells of upper Lapland met the eye. Sparkling salmon-laden streams surged down the low mountains on every hand. Lakes were cupped in the lowlands, and moss-crusted rocks were tossed about in grand disorder. Just at 11:00 P.M.—but with the sun still high in the sky—we swung down a slope to the Petsamo fjord and into the little fringe of settlements which border its shores. They were more Russian than Finnish, with the fat domes of a Greek Orthodox church in the center of each tiny cluster of houses that made up a town. Then, just at the edge of the harbor of the fjord, sat the Liinahamari Inn with the highway running on down to the very shore, ending in a pile of rocks by the salt waters from the Arctic Ocean.

Filming the Midnight Sun

I stood on a mountain crest high above the Arctic and surveyed the world below me. It was midnight, with a flashing crystal sun shooting white light over all the earth. My climb to the mountain-top had been glorious—that first stretch along the tumbling stream in the late evening, that mad scramble over the rock-strewn falls, those ticklish jumps from boulder to boulder, with one jump almost disastrous.

It was July, yet large fields of snow were still battling it out in a life-and-death struggle with the sun. But the sun, working double

shifts, was winning out. Foaming rivulets of the melted snow went careening down between the rocks as though in frantic retreat; wide pools of icy water lay concealed under the spongy moss as though in belated hiding from the enemy. This battleground between sun and ice was grand in aspect, yet hard to travel. By jumps and leaps I had made headway toward the summit.

A promontory. A quick turn around a rock cliff. There ahead, on my way up, I saw two mountain peaks turned upside down. The thing seemed eerie. More Alice-in-Wonderland stuff. A brief moment of study was necessary in order for me to realize that this was a reflection—one of the finest I had ever seen—with the two peaks and their patches of snow all done in duplicate on the surface of a mountain lake. The sky was clear and white, without color, and the clear yet strange light of midnight so confused me that the whole thing was unreal. It was a perfect subject for photography. It was for something such as this that I had taken this hike—to film one of the beautiful spots in the Arctic by midnight light.

Exhilarated by the beauty of it all—with the summit just ahead—I leaped the boulders recklessly. They were encrusted with moss. The space between them was moss-covered and soggy. My camera equipment was clumsy. A rock slipped. Or I slipped. Or something. I turned an ankle and a somersault at the same time.

A fine patch of moss, with a puddle beneath it, broke my fall. I was unhurt. My camera was unscratched but my trousers were soaked and my watch broken—stopped at twenty-five minutes to midnight. The bow of my glasses had snapped in two. Quite lucky on the whole.

The summit was close at hand and although I was now without a watch, there is no doubt I made it before midnight. There have been so many "best moments" on this trip that one shouldn't keep adding to them. But this night on the Arctic summit near Liinahamari in north Finland must have a place on the list.

There, far below, was the Arctic Ocean. Liinahamari harbor is on a fjord so this was my first sight of the actual Arctic itself. It was the only one of the "seven seas" that I hadn't seen. Just to think! There to the north, on the other side of this ocean, was American soil—Alaska. Not far, comparatively, but that connection with America will be useless until polar aviation becomes a reality.

But in the other direction—off across the Arctic and the Atlantic toward the west and south—there was a connection which meant something. For across that vast stretch of water flows the Gulf Stream. Like a Nile carrying fertility into a barren land, that strange current in the ocean gathers some of the warmth from our

American continent and bears it to the far northern shores of Norway, Finland, and Russia.

Finland's southern ports on the arms of the Baltic are frozen in winter months—navigable only with the aid of ice-breakers—but Liinahamari, nearly one thousand miles northward, is ice free year-round, thanks to America's Gulf Stream. This northern exit offers an outlet to Finland in case of a Baltic blockade in time of war. (A few months after our visit, as a result of the Russo-Finnish War, Finland had to relinquish this area, with its strategic harbor.)

As I looked to the west I could see the peaks of Norway. The frontier was only seven miles distant. And the Soviet Union just six miles in the other direction. This northern area of Finland—Petsamo it is called—is in reality just a narrow corridor jutting northward to the Arctic waters.

Narrow, but mighty in interest. There below were the lakes beyond which Helen and I had hiked, the day before, to a village of Skolt Lapps. That had been an important adventure. Farther down—too far to see—was Boris Gleb, a village of Russian Lapps which we had visited. And beyond that, two of the greatest waterfalls in Finland—small Niagaras hidden in the Arctic. We had spent half of one night hiking to them, then spent hours just gazing at the splendor.

And beyond all that was Finnish Lapland, then Finland proper off below the Arctic Circle. From my Arctic pinnacle I looked and thought and "daydreamed" at midnight. We would be leaving Finland now in just three more days. What a country it had been.

Doing a makeshift repair job on my tripod, I took a full reel of colored movies by the light of the midnight sun, then started down. It was nearly 4:00 A.M. when I reached our little inn. The place was bolted securely and it took a lot of pebble-throwing against Helen's window before she awakened and let me in. A few days later, in a small motorboat, we went down the Paatsjoki River, across the Norwegian frontier, to Kirkenes. A fjord steamer carried us up around North Cape, where we were at approximately the same latitude as Point Barrow in Alaska, then down to Hammerfest, from where it was just a day's journey into Karasjok, the Lapp capital I had visited at Easter time. I was glad to see my Lapp friends again, and they, too, rejoiced at my return.

Heavy summer rains greeted us at Karasjok, and we had to wait a couple of days before attempting a boat journey up the swift Karasjoki River, where we wanted to visit a Lapp summer camp. During this time, we had opportunities to observe and film the contrasts between the summer and winter life in this interesting land.

While awaiting the storm's cessation, we visited a number of my old friends. Many were out at the coast with their reindeer herds, others were far up the river tending cattle, but of those still remaining in Karasjok, all were glad to see me. As we walked along the grassy lanes which served for streets, even those whom I didn't know personally would smile and beam in recognition. At Easter time I had taken snapshots of scores of these people, and on this second visit we brought back pictures by the dozen to distribute amongst them. These snaps were the first photographs of themselves some of the Lapps had ever possessed.

At last the storms abated and we headed up the Karasjoki. Our first objective was a Lapp summer camp, where the cattle and horses are taken for better grazing during the hot months. The huts of the camp were of sod, many of them unlighted except for a smoke hole in the roof. Some of them were lined with colored comic sheets from Norwegian and Finnish newspapers. It was strange to see Jiggs and Maggie, Mutt and Jeff, Little Henry, and similar characters in this out-of-the-way place. And all printed in foreign languages.

After filming one abode and its occupants, I offered a trinket of jewelry to one of the girls. Whereupon another girl ran up and gleefully exhibited a pair of blue glass beads. At once I recognized them. They were a pair which I had given to a woman back in Karasjok the winter before. A series of trades had finally brought them into the hands of this girl far up the river. With movie camera recording the scene, we gave her another pair—this time some green ones. With no sense of incongruity, she slipped them on with the others.

Back to Karasjok and Hammerfest, then by steamer down along the Norwegian coast, on to Denmark, and across a corner of Germany, en route to England to reunite with our two young girls. Our departure for America was scheduled on the Queen Mary's sailing in September.

But during our two days in Germany we heard some news which altered our plans considerably and possibly saved our lives.

CHAPTER 9

War Threat Alters Our Plans

In March of 1939, eight days before our departure from home on our European adventure, Adolph Hitler had begun the dismemberment of Czechoslovakia. Upon my return from winter Lapland I found that England was preparing for a threatening future. In letters and notes at that time I wrote:

"A.R.P. is sweeping London. Air Raid Precaution is the city's most important activity. Gas masks were issued long ago. But now, real measures of actual protection are being provided. Every factory is arranging bombproof air raid shelters for the workers. Thousands of individual shelters have been distributed to the homes, and every householder who is without one is being urged to construct a safe shelter for his family. Each day's papers carry a page devoted to the subject, with other instructions on how to darken windows for 'black outs,' and how to strengthen the basement as a shelter. The government has issued a booklet on the emergency food supplies each family should keep on hand.

"Every block in London has an air raid warden who can take charge in an emergency. The schools are ready to evacuate their children at a second's notice and flee with them to the country. As transients, we are under the supervision of the American committee, and have filled out proper questionnaires as to what help we will need in fleeing London if need arises. All means of transportation have been planned in advance.

"We decided to make a film, for children, on England and Holland. In order to get attractive photos of the rural English countryside, we took an auto journey back into the most remote parts of the isle. There, almost completely obscured, vast airfields and hangars are being laid out. All this is going on doggedly, determinedly, quietly. If Hitler plays the fool and plunges the world into war, England doesn't want to be caught napping.

"People hereabouts have a chance to see some of the effects of Hitler's purges and conquests. London is filled with immigrants.

Nearly every school has Czech, Austrian, and Jewish children who have fled Hitler; certain sections of the city are crowded with refugees. We have become well acquainted with a girl who just recently fled Czechoslovakia. Until Hitler took the country, she had never realized she was Jewish. But there was a trace of non-Aryan blood, so she came under the ban of hate.

"If England is reacting to the threat of war, then such is doubly the case in Holland. We discovered this as we and our two young daughters went there to continue working on our children's film on England and Holland.

"The country's main concern seems to be that she may become a battleground, caught between the vast armies of Germany and Britain.

"Upon entering the country with our movie camera, we were constrained not to take pictures of bridges, canals, dikes, dunes, or harbors. Every important bridge is mined—ready to be shattered at a moment's notice—and on nearly all of the large bridges we observed patrols of soldiers. Most of the trees along rural roads, so we were told, are likewise mined so they can be blown up to obstruct the highways in case of emergency.

"All roads leading to Germany have been 'tank-proofed'—constructed, that is, in such a way that great steel spikes can be raised up above the concrete every few rods. And, as an ace up her sleeve, Holland has her dikes as the most potent weapon of all. Her army, it is conjectured, could at best hold off an enemy no more than forty-eight hours. But, by blowing up certain of her dikes, she could in that time flood two-thirds of the country with a foot of water. Enemy troop movements would thus be almost completely impossible. Such action would be a desperate course to take, but one for which the tiny country is fully prepared if emergency arises.

"Many of the Hollanders feel the strain. One of them, learning we had come from California, said: 'You must be crazy. If I could only gain the safety of California, I would never leave it for a minute.'

"When crossing the North Sea back to England, we talked with many refugees on the ship—mainly Jews leaving Germany. One such family—a highly educated man and his wife, with four bright-eyed children—was fleeing because their children's lives were in danger—not from soldiers but from other children. Stones were thrown at them whenever they entered the streets. Propaganda which causes such acts will certainly have cankerous effects for generations to come. And in the meantime this fine scholarly

family must leave home, penniless and without a place in the world to go. England cannot absorb all these peoples, yet she is offering them temporary refuge."

The private school in the south of England, where our children stayed during Helen's and my summer trip to Finland and Lapland, was in one of the precise areas where London children would be evacuated in case of bomb threats. So we had felt they would be safe during our absence; actual war still seemed remote.

Fortunately we made our film on Finland, and revisited Lapland, without threats of war materializing.

But as we entered Germany from Denmark, on our return to England from summer Lapland, we began to wonder. The country and its people were tense.

Pictures of Hitler were everywhere. Photographs of him, paintings, statues, plaster casts were displayed in stores, hotels, stations. An enormous framed photo of "der Fuhrer" hung above the bed in our Hamburg hotel. The streets were filled with marching boys and girls, some of them little tots six and eight years old. The idea was to create a completely militaristic youth, instilled with Nazi ideals. It was impossible to tell what the older Germans thought of the Nazi regime, but the young people and college youth (educated according to the Hitler formula) were rabidly behind the Fuhrer.

It was difficult to find out anything about Germany directly from the people themselves. We tried to quiz a number of persons but met with no success. In a determined effort to find someone who would really talk, we at length discovered a Canadian youth who had been studying in Germany for a year but was just leaving. He had learned much and, as we rode with him toward the border, we conversed in whispers for several hours.

From all he had heard and learned, our Canadian friend was convinced that a severe crisis, with war as an eventuality, would come by September. That was just one month away. When finally we crossed the border out of Germany he gave a lusty shout of joy and declared: "Now it can start anytime."

That sobering conversation with our Canadian acquaintance was the most important talk of our entire trip. Taking him at his word, we rushed back to London. Our return passage to America was booked on the Queen Mary for September, but we were able to get it put forward to the ship's August departure.

Down to Kittiwake we went to pick up our children. A large bombproof cellar, with tunnel leading from it to the school, had been erected there. We owned a part of that tunnel and bomb cellar, since all parents had been assessed for their construction.

That night our return train pulled into London on Platform 15 of Victoria Station. We looked at the large station clock and noted the time—8:04 P.M. A little more than two hours later, Platform 15 had been wrecked by a bomb. Windows of the train on that platform were shattered, and the large clock had stopped at 10:20 P.M. It was an I.R.A. bomb; German sympathizers were suspected.

Our August departure on the Queen Mary was its last civilian sailing for six years. By September, England and Germany were at each other's throats.

World War II began on September 3rd.

Helen Line in handmade Finnish costume.

The Lines' daughter, Adrienne, dressed as a Dutch boy.

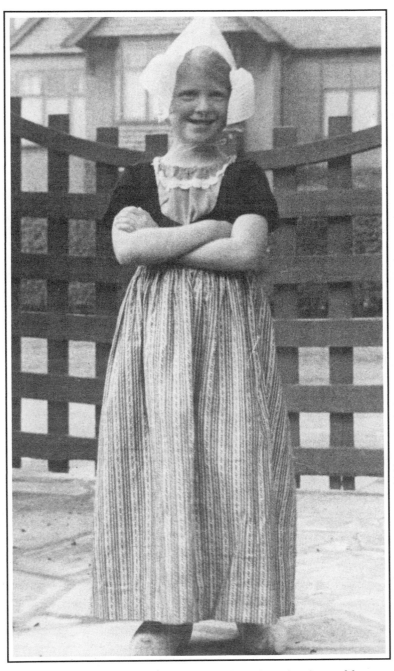

Barbara loved Holland. She and her sister took part in motion picture of that country made by the Lines.

SEPTEMBER

3

SUNDAY

● AT 11 O'CLOCK yesterday morning Britain declared that a state of war existed between this country and Germany.

The front page of England's DAILY EXPRESS carried this historic news flash on September 4, 1939.

CHAPTER 10

First Rung on the Ladder

Having produced three full-length films—on Lapland, Finland, and England and Holland—we were now professionals in the travel-adventure film lecture business. It was a field that, so far as 16mm color motion pictures were concerned, was so newly begotten there was almost no one but us to rock the cradle.

The minute we arrived home, however, helping hands began reaching out to get the cradle in motion. In our own city of Ontario, Dean Charles Booth of Chaffey Junior College requested our first showing, and would pay a fee of twenty-five dollars. The laudatory letter he wrote us afterward told us that our initial effort had been a success.

We had gotten the cradle rocking. To use a more graphic metaphor, we'd taken our first step up the ladder.

In our home area, four or five showings of our various films came in rapid succession. Apparently, favorable word was spreading fast.

Further dates in Southern California had to be put off for a month because I had, by mail, arranged for nineteen showings in my former home state of Michigan, where half a dozen newspapers had carried a series of articles written by me concerning Lapland, Finland, and our other adventures in Europe.

Every presentation went well, but my greatest personal satisfaction came with the November 19th showing of *Lapland Adventure* in the auditorium of the high school in Howell, Michigan, where I had graduated. Howell's population was only 2500, but every one of the auditorium's 1000 seats was taken. Extra chairs were put in. Several dozen persons had to be turned away.

More important, as an opening wedge leading to significant national engagements, were presentations of two of our films, on successive weekends, at my alma mater, University of Michigan, in Ann Arbor.

Most important opening wedge of all, however, was a private showing to less than a dozen persons. The great Finnish architect, Eliel Saarinen, as well as his architect son, Eero Saarinen, had come from Finland and were professors at Cranbrook Institute of Art just north of Detroit. The father had designed some of the fine structures shown in our film; the son would one day win St. Louis, Missouri's first place award, with his design of the great St. Louis arch. Having written the elder Saarinen about our Finnish film, he had asked if I would want to show it privately in his home.

I wanted very much to do so. Father and son, their wives, and a few close friends were present, including George Booth, of *The Detroit News* Booths, and a patron of Cranbrook. As a result of that private showing, new friendships were formed, Prof. Saarinen at once booked the film for a public engagement at Cranbrook Institute, and he gave me a personal letter of glowing recommendation. A short while later he did something of far greater importance.

My private showing for the Saarinens had been on November 27, 1939. Just three days later—taking advantage of the fact that all eyes were focused on Germany's war with England and France—Russia attacked its tiny neighbor of Finland.

Finland was respected and loved in America. She was virtually the only nation still meeting her war debt obligations from World War I. Russia's armies marching across Finnish borders sent shock waves across the world.

Finland was in desperate need. At once an American Finnish Relief Fund was organized, with former president Herbert Hoover as chairman. Saarinen wrote Hoover about our film and a copy went to the Los Angeles office for Finnish Relief. Whenever a spare date was available, from that time on, we showed *Finland Waters* free of charge, to raise money for the struggling nation which was under attack by Russia.

Our regular business did not suffer. We had probably the only color motion picture in existence on Finland. Bookings were snowballing. But, as a result, there were snow blizzards of paperwork, contracts, and interminable correspondence. We heard about the Mae Norton Agency, and she heard about us. Soon she was handling our Southern California engagements.

Ed Ainsworth came to one of our Lapp lectures and gave us a boost in his *Los Angeles Times* column, *Along El Camino Real,* reaching hundreds of thousands. "Francis (Lapland) Line of Ontario," he called me.

We gave *Lapland Adventure* for a dinner meeting of the University Club of Los Angeles—a prestigious engagement, as we later discovered.

In a five week period I had had thirty film programs in Southern California and Michigan. Christmas was an off season. But on January 3, 1940, came a showing of *Finland Waters* for The Los Angeles Adventurers Club. It was a courtesy presentation; no one ever receives a fee there. But it was one of the most important shows of my new career, with far-reaching and long-lasting effects.

The written letter to me from the president was the first reward:

"It gives me the greatest pleasure to thank you for the privilege of seeing what were undoubtedly the most marvelous and interesting pictures that have ever been shown in our club, which has boasted of seeing the best that has ever been offered. I think that this fact was attested to by the rousing spontaneous ovation given you upon their completion, an ovation such as our club has never before witnessed."—H.L. Tanner, President, Los Angeles Adventurers Club.

As a second result of that film showing I was asked to join the club, which I did. This eventually led to invitations to show my films before—and become a member of—The New York Adventurers Club, The Circumnavigators Club, and The Explorers Club of New York. I was able to become acquainted with such members as Lowell Thomas, Commander MacMillan, Peter Freuchen, and dozens of the world's well-known explorers and adventure personalities.

The third spin-off from the Adventurers Club showing was the most far-reaching.

In two short months we had achieved much greater success in our new field than we had dared to hope for. We'd climbed several important steps on the ladder. But our engagements had all been localized in Southern California, or in my former home state of Michigan. The "big time" in this business was in the Midwest and the East—St. Louis, Kansas City, Chicago, Detroit, Pittsburgh, Philadelphia, Washington, D.C., New York.

The large illustrated lecture series in those cities booked their attractions a year—sometimes two or even three years—in advance. No matter how timely our Finland film might be, these large courses could not book it, even if they knew it existed. As yet, most persons outside of Southern California or Michigan, upon

hearing the name Francis Raymond Line, would probably confuse it with a steamship line. That occasionally happened. The large American lecture courses were not much interested in newcomers.

Just one such course—the most prestigious of all—operated on a different plan.

"There's one place where you can really get your foot in the door." That was the remark, from a Los Angeles Adventurers Club member, after my showing there. He went on to explain.

"The National Geographic Society holds an illustrated lecture series in Constitution Hall. Washington, D.C., you know. The place seats four thousand. They pack it every time. Their fee is tops."

"But...," I began to interrupt.

"No 'buts' about it," my informant continued. "The Geographic is the only outfit in America that isn't interested in big names. They want only one thing—quality. Your film has it. It's a cinch. They're constantly seeking new talent."

Off went a letter, special delivery, to Melville Bell Grosvenor, son of the magazine's editor, and director of the Geographic's lecture course. And back came an immediate reply. Could we send our Lapland and Finland films to them, at once, for preview and evaluation?

No, we could not do that. But we could do something even better. Already I had booked engagements for the late winter months in Michigan. Helen and I would just continue on to Washington, and give the Geographic previews of our films in person.

The middle echelon of National Geographic employees, we found, was made up of some of the most agreeable and down-to-earth individuals we'd yet discovered in this field. Three of Melville Grosvenor's top lieutenants viewed both *Finland Waters* and *Lapland Adventure*. All three of them were not only generous—but definitely lavish—in their praise of both productions. All three of them sent recommendations to Grosvenor that I be booked for the following season. The choice of film was left open. As a result of their praise, Melville Grosvenor wrote a letter of recommendation to George Pierrot, director of the world's largest travel and adventure series, in Detroit, Michigan.

We were at least three steps up the ladder.

Barbara's little red wagon, with which we had started our motion picture career, aided by a twenty-five dollar motion picture camera, was carrying us into a new world of experiences.

CHAPTER 11

Circle of Fire

The Finland film's initial success was due in large part to its intense timeliness. We needed another timely film.

Every spare moment, especially during the free hours while traveling by train to engagements in Michigan, I was reading, studying, exploring and mentally reaching out in search of a new vital film topic.

My eyes and concerns, more and more, turned westward—so far westward that the area I was thinking of is called the "Far East."

Europe, of course, was already deep in World War II but most of the Pacific areas and we in America were still clinging to a fragile peace. From my intense studies, I believed that peace in the Pacific was desperately unstable. Japan, in fact, was already engaged in a conflict with China which, for propaganda purposes, she referred to simply as the "China incident."

Here, throughout the Pacific, was an area for the making of another motion picture which might well become as timely as our film on Finland. I determined to produce a major epic which would include Japan, China, Singapore, the Dutch East Indies, the Philippines, Guam, Wake, Midway, and Hawaii. A few of those places, such as Wake and Midway, had at that time never been heard of by the average American, but they were on my itinerary.

Before setting out in May of 1940, I arranged to write regular reports of my experiences and observations for a number of newspapers in California and Michigan. The chapters which follow, through and including my experiences in Java and Bali, are—except for grammatical editing and a few omissions for the obvious sake of brevity—exactly as I wrote them for those newspaper reports. This was a year-and-a-half before the United States became embroiled in World War II.

Bordering the Pacific Ocean are some of the greatest volcanic regions of the earth. Extending in a vast circle from South and Central America, through Mexico, California, Alaska and the Aleutians, then on through Japan, the Philippines, and Java are thousands of volcanic peaks and islands. Many of the volcanoes are extinct, others dormant, but strewn throughout this area are scores which never cease to steam, which threaten violent and deadly eruption at any time. The most ominous are in Java and the Dutch East Indies, though the Philippines, Hawaii and Japan have craters and cones of awful power.

Within this same Pacific area, also, there smoulder other forces, which parallel in intensity the terrific hidden push of the volcanoes. I speak of the forces of economic need, national aggrandizement, racial tensions, imperialism, and armaments. Literally and figuratively, the Pacific area is a vast circle of fire.

Circle of Fire is the name of the motion picture which I am on my way to the Orient to film—a picture designed to portray and interpret these vast volcanic forces, both actual and symbolic. With the head having already been blown off the mountaintop in the other direction, over in Europe, I set off for my journey in May (1940) on the Empress of Russia from Vancouver, British Columbia.

The times were disturbed. In selling me a ticket, the Canadian Pacific company's representative in Los Angeles had not been permitted to reveal the exact date of sailing. No schedules were printed. "But," he had said, "it is good that you are going on a Canadian ship. If the United States and Japan suddenly got into war over the Dutch East Indies, it could be nasty enough to be caught on an American vessel."

Perhaps he was right. But he had neglected to tell me that the Empress of Russia had been turned into an auxiliary naval cruiser.

Fourteen years before, from Manila to Japan, I had taken passage on the same vessel, when my brother and I, between our sophomore and junior years in college, were completing a year's adventure journey around the world. At that time the ship had been white and lovely. So my first view of her at the wharf in Vancouver led me to rub my eyes. The entire exterior had been painted gray. The glass in every porthole and window was likewise coated over. At the stern was a cannon, turret-mounted, and with an antiaircraft gun above it. On the first day out, antiaircraft practice was engaged in by the crew. Canada, of course, as a part of the British Empire, was actually at war.

Throughout the voyage, a complete blackout was maintained. I had paid extra for an outside cabin, but the porthole window was painted over, inside and out. Special blinds were fitted to the windows of the dining salon and lounge. All navigation lights were doused but, as the purser explained: "So few vessels take this route, there is little chance for collision."

Even cigarette smoking was prohibited on deck after dark. But I doubt if anyone went to the decks at night—after the first time.

It had always been a habit with me on shipboard to take an evening walk. When I went out the first night, all was black as midnight. The wisdom of returning to the inside soon became apparent. So I sought the door. But where was it? There was nothing to guide me. Strange shapes seemed to be everywhere, with any number of obstructions to trip over. The wind was howling, making calling out of no avail. I envisioned a cold sleep on deck. After a desperate five minutes I blundered across an entrance. That was my last night walk of the voyage.

The passenger list of the Empress of Russia is small—some sixteen in the first class, twenty-eight in second, and three hundred Chinese in third. All of the Caucasian passengers are business executives, missionaries, or government attachés with urgent business abroad.

It was the third day out before we had world news from shore. Now we get brief bulletins daily. Radios for the passengers are not permitted. Messages cannot be sent from the ship, but the radio officer picks up dispatches and issues daily summarizations.

Last night as we all sat about the piano in the lounge, singing American plantation melodies, word came in that the Germans had taken the French seaport of Calais, with England just twenty miles across the channel.

I shall not soon forget that moment. No one said much, but the room vibrated with unspoken thoughts. At last a man spoke—a businessman from Shanghai. "I never thought," he said, "that I'd live to see a day like this."

These were nearly all English people. A threat to England was a threat to their empire. British defeat on the English Channel would rock the world. We had passengers from Shanghai, Hong Kong, Singapore, Malaya—all dependent for their existence on the stability and strength of the crown. If England fell, Hong Kong would be in danger, and so would extraterritoriality in Shanghai. Japan would see to that. Trouble in the Pacific might take ships of the United States fleet away from Manila; the American girl, who had a lover in the navy, was thinking of that. Trouble in the Pacific

would disrupt my plans. And the Germans had taken Calais, just twenty miles from England.

The importance and stabilizing power of the British Empire could never have been more eloquently revealed than in the minds of those ten or fifteen passengers sitting about the piano in the lounge of the Empress of Russia. Calais had been taken. Our vessel, in complete blackout, plowed on through the Pacific.

Through sea-lanes swarming with fishing boats and sampans, with great ocean liners, freighters, and warships crossing before and behind us, our Empress of Russia edged her way gingerly into Yokohama harbor. Three giant bombers roared out to meet us. All foreign ships are thus greeted and a careful watch kept for contraband which might be cast overboard before reaching shore. Doctors, immigration inspectors, and reporters boarded the ship at various points and I spent an hour running from one group to another, delivering the eleven different forms which it was necessary to fill out before landing. These ranged from currency declarations and a statement of all books I possessed, to vaccination certificates and a detailed list of my baggage.

And then to shore, and to Yokohama station. A swift electric train took me, in just forty minutes, to Tokyo. There were three stops en route and it was just by chance that I ascertained the correct station. Fourteen years before, when last visiting the city, I had found Japan to be almost a bilingual nation. Japanese signs and street names were accompanied almost invariably with their translation in English. But since then, Japan and Britain have had difficulties. An over-patriotic minister decreed that all English signs should come down. Now the foreign visitor sees only unreadable Japanese characters for station names, street signs, and notices of various kinds. No wonder John Gunther remarked that Tokyo is one of the world's most difficult cities in which to get about unaided.

A taxi, a 1936 Plymouth, took me to the luxurious Imperial Hotel. The fare was the equivalent of about six cents. My spacious room at the Imperial cost one dollar. Due to the disastrous exchange rate for the yen, I was in an inexpensive country.

Color Motion Pictures, or None at All

For the fifth consecutive day I sat in the office of Mr. Iwao Yokota, promotion chief of the government Board of Tourist

Industry, and bit my nails. On the first day, after an exchange of genuinely pleasant formalities, he had told me how sorry it made him feel that I could not take colored pictures in Japan. There were now no facilities for developing them in the country, and undeveloped film could not be taken out. So sorry.

At that announcement I had raised heaven and earth. True, this had not been entirely unexpected. The Eastman people in Los Angeles had warned me that it would be useless to take colored film into the country. And nearly every day during my Pacific crossing, the officers of the Empress of Russia had cautioned against even carrying a camera into Japan. The chief steward had told me it would be playing with fire. The master-at-arms had stated bluntly that I would end up in jail. Every day during the voyage, they trotted out fresh stories of arrests, confiscations of equipment, and spy scares. It became my regular diet.

Still, I had entertained hopes. I would take colored pictures or none at all. For that reason, I did not even possess any black-and-white film.

Securing a reporter's interview and a glowing write-up in the anglicized *Japan Advertiser,* marshalling every ounce of bravado at my command, I forced the issue. On the third day Mr. Yokota announced that, provided I was supervised at all times by a government agent, I might go ahead with some limited shots. They would be developed in America and censored by the Los Angeles consul—something unprecedented and "most unusual."

This was more to the point. I commenced to make pictures, with an interpreter and a government agent always at my side like overconscientious nursemaids. It was necessary for me to work fast, for the rainy season was close at hand with its weary weeks of overcast skies. For each movie view filmed by me, the agent would make a black-and-white "still," to be developed that night. By this neat method a continual check could be kept on my work. All was progressing well. Then suddenly, word came from the head office—we must report at once.

I made my fourth visit to Mr. Yokota. So sorry. A terrible mistake. He had exceeded his authority. The police had made a report. If I wanted more pictures, it would be necessary to draw up a complete list of every shot I desired, then submit it for review and censorship to the State Board of Tourist Industry and the Department of Home Affairs. He was adamant. There was no alternative.

In a daze, as depressed as a church budget, I left the office with my interpreter.

"Just why," I plied him, "have things turned out this way?"

Slowly he shook his head. "No one will take the responsibility. They are booting it from one department to another like a football. As you Americans would put it—how does it go?—too many cooks burn the eggs."

That it not precisely the way we Americans would have said it but, to quote another saying of my interpreter, he had certainly "hit the nail on the hammer."

I had to realize, of course, that red tape is a part of government, particularly when that government is directing a war. Of course, the Japanese refer to their three-year-old conflict in China, not as a war, but always as the "China incident." But that deadly and expensive—and seemingly never ending—"incident," combined with strained relations with my own country, was no doubt at the root of my difficulties in securing a permit to film.

All I could do was to try to unravel the red tape and doggedly pursue my goal.

CHAPTER 12

When Fires Threaten Tokyo

For a full day I feverishly toured Tokyo by taxi, penetrating every corner and listing all conceivable shots which would suit my purpose.

Buddhist temples, fish and vegetable markets, parks, rivers, alleys, and native hotels were inspected.

The Earthquake Memorial told a mighty story. My brother and I had been in Tokyo just three years after the great quake and fire of 1923. Now new buildings have been erected throughout the city to take the place of those which burned. But the memorial brings to mind the 200,000 persons who lost their lives in that day of horror. It is raised on the spot where, in a poor section of town, 32,000 persons perished in one group. I tried to picture the hell and confusion of that bygone day. But a few minutes later we were to have a realistic, if tiny, sample of what must have taken place.

We were walking through Asakusa Park, the Coney Island of Japan. Shops, theaters, stalls, had changed little here since I had seen them last. Incongruous to the Western eye, at the center of the amusement zone stood a great Buddhist temple where it would be easy to leave the theaters or merry-go-rounds for a brief moment of worship. Perhaps the Japanese have the right idea in this, after all.

Just back of the stalls and shops the wooden houses were packed together in a maze of tiny streets and alleys. The crowds of people were dense. We were standing before the temple listening to the deep soft booming of a bell as some high priest inside swung his mallet in a call to worship. Quite suddenly the tone of the bell changed. It was now harsh, raucous, insistent. But no, it was coming from another direction. A fire engine streaked through the midway of the amusement zone. We looked up. Black smoke was darkening the sky.

Following the mad rush toward the fire—for such it was—we soon stood before one of those wooden houses, a large three-storied structure, burning furiously.

Cinders and sparks were creating a rainstorm of firebrands. Frightened shopkeepers began scurrying for pails and started to throw water frantically on their stalls and wares. Women were wailing. People in the whole neighborhood were moving out their goods. From the third floor of the burning house several men crawled out of windows and down jutting roofs to the ground.

There was the confusion of a battlefield. My interpreter, my government agent, and I were caught in the thick of it and for a time could not get out. Our heads were dusted with falling cinders; we were liberally soused with water. We ran in and out of several houses, from front to back, trying to get away, and it was not until police had formed lines and established some sort of order that we made an exit.

An inspection several days later revealed that the blaze had been brought under control after a block of houses had burned. But it served as a succinct summary of what must have happened on a tragically greater scale during that earthquake day in 1923. Millions of people crowded hopelessly together in cardboard-like structures create a grim hazard.

It afforded me a horoscopic view, too, of what would happen in case of an incendiary air raid over Tokyo. A hundred bombs, strategically dropped, on a windy day, might have the whole city in flames, threatening six million lives. No great capital of the world is so perilously constructed, with respect to air raids, as is the capital of Japan.

We finished our tour with an inspection of the Imperial Palace grounds and a view of the government buildings. Nearly all work at the palace is done by school children, each group proudly parading its banner, and all busy with pushcarts, spades, and baskets, learning in this early fashion the importance of serving their emperor.

There were many imposing government buildings but the grandest was the new Parliament structure, a modern pile of dignified granite overlooking the city. It will make a tremendous picture.

Over iced tea in the Imperial Hotel lounge that night my interpreter and I drew up the list of pictures which I wanted, then poured through guidebooks in order to construct a hypothetical list for the rest of Japan.

A meeting was set for ten o'clock next day. List in hand, at the appointed time I was ushered into a private office. Six men were seated at a table.

This was the original board of censors—the first hurdle. Following a prolonged session of bowing and the exchanging of innocuous platitudes we got down to work.

May my guiding star be forever praised that I made my list voluminously long. Under the knife-like eyes of that group it shriveled and melted away like a savings fund at Christmas time. First one person then another would shake his head and the black pencil would get in its deadly work on view after view.

I must have shown actual genius at picking the wrong shots. Off went a superb scene of the great new Insurance Building, to have been taken from the moat surrounding the Imperial Palace. Off went all views of the moat itself (how beautiful those would have been). Off went the Imperial Palace. The Mitsui Bank (owned by the "Rothchilds" of Japan) and the Bank of Japan were both eliminated. Views which I wanted showing houses along the river all were overtaken by the fate of the black pencil. That pencil became a scourge.

So on for half an hour. But my list had been constructed on a generous and magnanimous scale. An adequate number of shots remained.

But time to take the shots, before rain set in, was fleeting. While one set of government officials commenced making a triplicate transcript of the residue of my list (accomplishing this on a Japanese typewriter, which resembles a huge electric mangle) the chief film man started preparing a schedule for presentation to the police throughout the city. All this was rushed through on the double-quick.

Then, grabbing a taxi, and accompanied by my entourage of interpreter and government agent, I sped across town, past stately blocks of great government buildings, to the Department of Home Affairs. This would be the real hurdle—the final test.

Stopping before one of the finest office buildings in the city, we at once penetrated its maze of halls. There was infinite questioning, presenting of cards, long sallies through corridors, led by one orderly after another. At last we were conducted into a great office filled with industrious clerks. At one end, separated from the others by a ponderous railing, sat a man alone.

He was of the military type, with short crisp black hair, skin like sallow leather, and with high cheekbones. Fortunately I had not had to deal with many of this type before. No one needed to tell me that this was the chief. He was the person who was to determine the final fate of my film.

Already the advertising for it had been released back home. Even now it was probably being booked. Looking at this man who sat there at his desk still ignoring us, I felt that in attempting colored movies of Japan I had perhaps taken too big a chance. It seemed my words froze in my mouth and I couldn't speak. To me, just then, this official before me was the human counterpart of a European blackout.

The Military Holy of Holies

My interpreter and government agent carried on the negotiations with the chief of the Home Affairs Department. The whole ceremony was conducted in Japanese. The chief scanned my list of proposed "shots," pondered, questioned, shook his head, asked more questions, pointed out one item after another, shook his head some more. Then we all bowed deep and left the room. I presume we resembled a funeral procession. I was crestfallen.

"What did he say?" I asked.

And my interpreter replied: "Perfect. He says O.K."

I jumped for joy and almost wanted to give cheers for the emperor. It seems the chief had explained that some Americans had recently tried to take pictures without a permit and that (to quote my interpreter) "had made an awful mess" which was injurious to my case. Certain restrictions had been stipulated about taking pictures at Fujiyama but otherwise, if the Board of Tourist Industry would take complete responsibility and have me watched at all times, then "it's O.K."

I left the building on the run. The sky was sunny. "And now," I shouted, "let's get started with the pictures."

My interpreter hesitated. "Well, there is just one more place. You see, there are many strategic locations in the city. We first have to get the permission of the War Department."

I suppose one gets inured to things like this. I stopped, gurgled baby-like three or four times, then simply said: "Well, let's get going."

A taxi sped us through the outer grounds of the Imperial Palace until we came to a great government building—the very nerve center of the Japanese Army. As we went in, and followed through one corridor after another, interesting sights were revealed. Down in the courtyard were soldiers stripped to the waist, drilling under the staccato commands of an officer. I was all eyes.

Probably if I had asked permission to view all this, it wouldn't have been granted without days of negotiation. Even if I never

obtained any pictures I was using my mental photography to the greatest advantage. As my interpreter would have said, "I was getting my eyes filled."

An army orderly was assigned to us and we went through more halls. Finally a ponderous door was shoved open. I missed a couple of breaths. But at the same time I began to get a highly important opinion of myself. For this room into which we were ushered had all the appearance of the council room of the general staff. It was like a Wall Street boardroom, with a great oak table, fifteen huge expensive chairs, and fine trimmings. From the window was the best view of the city, palace grounds, and army buildings which I had had. Motioning us to be seated, the orderly disappeared. We occupied just three seats; there were a dozen still vacant. I wondered how many would take part in the inquisition.

The door opened. We three sprang to our feet. An army officer—complete in uniform even to cap—came in and we all bowed low. He motioned us into our chairs. We presented our list.

Carefully the officer studied it, not saying a word. Then he arose. We did likewise, and he left the room. We sat down. Of course he was going to summon the rest of the board.

He returned. A servant was with him—bearing a tray with four cups of tea. He laid the papers aside; we sat down and stirred in our sugar, two lumps apiece. Sugar is being rationed; this was the first I had seen in Japan. The tea was excellent.

Then the document once more. All I can say is that the original board of censors who had gone over that list must have done a good task. It remained intact.

The officer began to speak. My interpreter translated. "Go ahead" he said, "and take the pictures. Make a good film of Japan and go back to America and say a good word for us."

He regretted that he couldn't speak English and I expressed my sorrow that I could understand no Japanese. Then, when we all arose, I bowed low and said, "Arigato gozaima." The officer roared. We all roared. He returned my "thank you" in English and we roared some more. Thus laughing, my permit signed and in my pocket, we left the room. The tracks were clear. *I could start taking my color motion pictures.*

And I really did. My interpreter and government agent had never known what hurry was. The sun had come out; the sky was clear and blue. I had a film to make. I had ground to cover. We used a taxi if we had to go more than a block. But even in the short spaces we walked I would sometimes be a hundred yards ahead of my two companions. If the government agent saw what I took it

93

was a marvel. But he was supposed to be accompanying me; not vice versa. It was no fault of mine if he couldn't keep up.

I carried two cameras, a tripod, meter, and quantities of extra film. That is to say, I and my government agent and interpreter carried them. They came in handy.

On the main streets, when policemen would come up to object, I would just sic my government agent on them. While he would be pulling out the permit and going over it with all the frills, I would be off and away getting more pictures. He would only later be able to locate me because of the great crowds gathered about me and my tripod. Once I swung around and got a picture of such a crowd— probably 150 people all massed to watch me work.

And so it went. In the space of the afternoon I covered Ginza Street, the Japanese theater, the stone temple, and obtained shots of strange signs, street life, subway signs, and of costumed girls crossing thoroughfares.

We made a three-mile trip out to Asakasa Park and photographed the park stalls, the wooden temple, the pagoda, and the main theater street. I obtained good close-up views of women carrying babies strapped to their backs.

The rainy season was fast approaching, but my camera's appetite for colorful sunlit scenes was being satisfied.

It was my desire to obtain close-ups of the women and geisha girls. But my companions said that the girls would not think of posing for me. Even my interpreter refused to ask them. So I had a try myself.

Going up to an attractive young geisha girl, I made some motions, and in no time she was posing sweetly for me. It worked. As soon as my companions saw what was happening they fell to and lent help with a vengeance.

One geisha girl whom I stopped in a park and who smiled charmingly while her picture was being taken was, according to my government agent, the most ravishingly beautiful thing he had ever seen. No sooner had she walked away through the crowds than he was seized with a mad desire for her address. So he started running after her.

Thousands of people were in the park. It was impossible to locate the government agent, so I sent my interpreter looking for him. While they were both gone I took pictures unaccompanied and unmolested.

Fifteen minutes later we found one another again. Poor government agent—he had failed to locate the girl. But my interpreter had caught up with her and had her address. Later a special

party was arranged for me, with this same geisha girl as the honored dancer.

By 5:00 P.M. we quit for the day. I was dead tired. My companions were in the last stages of exhaustion. But we had really made a start.

Thus the crowded street life, the color, the beauty and severity and immutable orientalism of Tokyo was fed into my camera lens and recorded in color on celluloid. Never had I gone through such difficulties and suffered such mental strain to obtain pictures, but they were worth it. After taking time to collect my thoughts and make a written record of my observations, I would be ready to head into rural Japan, to film the farm people, backbone of the Japanese nation.

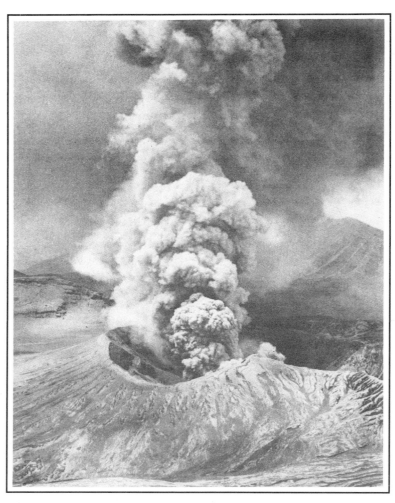

Japan's largest active volcano, Mt. Aso. Photo from Tourist Board.

CHAPTER 13

Symbolism on the Fuji Express

The Fuji Express, roaring through rural Japan, was like an ugly foreign intruder disturbing the peace of a primitive existence. The views which I had from the car window, as well as the surroundings and episodes within the car itself, were like a review of my stay in this strange land. They provided, in fact, a capsulized summary of this tiny nation. I was surrounded by the five major elements in Japanese life.

In the seat right opposite me was one of Japan's most noted actors, Umpei Yokayama. As a personality, he was not outstanding. Removing his shoes, he spent most of the day curled up in his seat, asleep. But, in the language of symbolism, he represented the arts of Japan. I thought of the operas I had seen in Tokyo—a strange intermixture of the East and the West. I recalled the Noe plays and Kabuki dramas I had attended in Kyoto, and the examples of silk weaving, ceramic art, and flower arrangement which I had enjoyed—all part of the artistic expression of this nation.

Just two seats down from me was Tokyo's most famous geisha girl. She might be taken to symbolize pleasure.

The status of the geisha girl is undergoing change. In former times, she had a higher education in the classics, dancing, etiquette, flower decoration, and music than almost any other class in Japan. She was an entertainer, but of the highest type, and her strict training often took years to acquire. When an individual or a group wanted to engage a geisha girl, she charged four or five dollars an hour to grace the party with her dances, her music, and her charm. Because of her superior education, she lived an aristocratic life, far removed from that of the ordinary girl.

Then dancing by couples was introduced to Japan. And the flapper made her appearance. Men found they enjoyed the entertainment of a flapper more than that of a geisha. And the flapper wasn't under the necessity of spending nearly so much on her education. With her superior position being undermined by less

97

exacting competition, the geisha's status is changing. Even deteriorating.

Visible out the windows as we roared through the cities were examples of the growing industrial might of this nation. This third symbol of Japanese life I had not been able to photograph, due to the extreme security restrictions.

But out the windows, also, I saw the fourth symbol—scenes of some of the most painstaking agricultural development on earth. I had previously recorded many of those agricultural scenes on film in my camera as I had forayed—along with my interpreter and government agent—out into the rural areas, especially in the region of Fujiyama. Whatever one may think of Japan as a nation, it would be hard not to register admiration for the Japanese farmers.

In a country no larger than California, with one-fifth of its area arable at all, they raise the food for seventy-five million persons. The answer to such an apparent paradox is intensive agriculture.

Terraces everywhere. For the one-fifth of the land that is arable is not conveniently located or ready for the plow. Much of it is on mountainsides.

From the car window I located the general area—near Mt. Fuji—where I had done some of my filming, and these scenes and experiences passed in review through my mind.

It was harvest time and the workers had been busy with the wheat. Their fields were like toy farms. The larger wheat fields in the lowlands were the size of tennis courts. From that they dwindled down to plots containing only three rows, crowded in, perhaps, along a ditch. Step on step, such fields as these marched up the mountainsides. The average terrace was but a few feet wide, which thus became the width of the field in those places.

Intensive agriculture. That wheat had all been planted by hand. The rows were as symmetrical as lines on a writing tablet. Each row was cultivated many times by hand. Soil and space were too precious to allow weeds to spring up. Manpower—and womanpower—was cheap, but space for growing wheat was more precious than life itself.

Planted by hand, now in harvest time it was being sickled by hand. The women mainly did this, while men would carry the bundles of felled grain over to the threshing device—scarcely larger than a sewing machine—which was treaded by foot as the stalks of grain were fed in.

Few farmers possessed modern threshers such as this. Most of them flailed the grain with a heavy wooden mallet, or a wooden rod swung from the end of a rope.

Intensive agriculture. Wherever I went on my picture-taking expeditions in the countryside, the signs of it never escaped me. Japan is a land of abundant rain but, with a whole nation to feed, the farmer cannot depend on caprices of nature. He irrigates in case nature fails. Small ditches and streams of water were trickling down the terraces, each drop of water being used many times.

One might think that erosion would result, especially on those steep mountainsides. But erosion is too expensive a luxury. The terraces were sodded, or in places even built with stone. The more gentle slopes were bedded down with straw to stop washout. Heavy baskets of soil were being carried up some of the hillsides. It all represents grueling labor but, as a result, the Japanese farmer has retrieved many acres from the mountainsides. And, doing all his work by hand, he produces fifty bushels of wheat to the equivalent of an acre. Unbelievable as it seems, the nation exports more food than it imports and cannot be starved in event of war.

Intensive agriculture. Midst the scenes of the wheat harvest, I saw dozens of other crops in various stages from planting to harvest. For there must be constant crop rotation if soil is to remain virile after two thousand years of use. Constant fertilization too—which was all too obvious to the passerby with a sensitive nose.

I had photographed a scene of a husband and wife planting an oily bean. Trenches were made with a stick, then filled with fertilizer. After the seeds were dropped, the two of them would cover them up, and tamp each seed by foot. But their perspiring leathery faces glowed as they worked. All this was a labor of love; they were producing food for the nation.

Art, pleasure, industry, intensive agriculture—all of these important ingredients of Japanese life were symbolized by my surroundings, both inside and outside the train.

And the fifth ingredient, now beginning to overshadow all the others—there it was, exemplified by an army officer sitting just across the aisle of my Fuji railroad car.

He was the MILITARY, spelled not with a capital "M" alone, but with capitals throughout. The MILITARY has that relative relationship in Japan's present-day scheme of things.

Several officers, in fact, were riding in our car. As the train had departed from Tokyo there had been great cheering and profuse bowing of those who had come to say good-bye. This officer across the aisle was accompanied by his family, going to Shimonoseke, port of embarkation for the "China incident."

There were his wife and three small children, one a little baby. This soldier had the stern features of the true military type, so different from the faces of many of the Japanese. In a few days he would be in China, facing death. Or at least directing his soldiers in the spread of death among the Chinese.

All of that would come next week. But now he was just a father. The baby fell from the car seat and bumped its head. Naturally the wee one began crying. Gently the army officer picked it up and bounced it affectionately on his knee. Soon it was laughing once more.

Removing his coat and shoes, loosening his collar, hanging his shining sword on the hat hook, the officer began playing with the child in earnest. Again the infant fell, but this time only onto the seat. Struggling to get up, the baby reached for the dangling sword and bit its brilliant sheath between its tender gums. Both baby and father laughed.

Thus soothed and amused, the child soon fell asleep. Gently the officer took it in his arms and made a bed on an adjoining seat. Then he began to play with his other youngsters. The Japanese love for children and for family life is excelled by that of few other peoples.

My attention was on that sword which the officer had hung from the hat hook. Every Japanese officer has one.

"How useless in modern warfare!" Such is the casual verdict of the foreigner. But how wrong that casual foreigner proves to be.

For that sword is a symbol. A symbol of honor and of the military spirit. The samurai of old carried swords. The shimmering steel of its blade reflects all the past glory and greatness of Japan. The importance to the soldier of such historical connotation is incalculable.

The clank and rattle of its chain signify the strength of the modern military machine. What comforting power in such a thought. And that razor edge—that needlelike point. These are to be used as a means of voluntary exit from life, in case the soldier faces capture or feels that otherwise he might die of dishonor.

Therein lies the secret of the Japanese soldier's hideous fighting ability. He prefers death to the slightest hint of dishonor. And that sword always at his side is constant reminder that his choice is easy to obtain.

The father continued to play with the youngsters while the sword rattled and swayed from the hat hook. Soon the baby would waken again and could play with it once more. That sword is a

symbol. The language of symbolism never spoke to me more clearly than when I watched the baby use it for a teething ring.

My experiences and observations in Japan convinced me that, beyond much doubt, this little nation and my own would eventually be at war. Japan is spending half of her budget for the military. If each country could only understand the other's problems, aspirations, and needs, hostilities might possibly be averted. I was seized with an intense desire to go back at once to the United States, and see if I could not make contact with President Roosevelt or some other high officials, asking them to try to head off the conflict.

I guess it seemed useless. At Kyoto, I transferred to another train, bound for Shimonoseki's port of Moji, for departure to Shanghai, Hong Kong, and Singapore.

Japan's 2600th Birthday

Italy's entry into the war caught me on a Japanese ship in the dirty little coaling city of Moji, the port of Shimonoseki, Japan.

After having boarded the vessel, for take off to Shanghai, we had been anchored in Moji's hot, congested harbor for half a day, much of the time watching the endless chain of Japanese laborers—both men and women—passing up the coal in tiny reed baskets from the lighters to the ship. Four thousand tons of the black fuel they handed up in that fashion.

It was revealing, too, while we waited, to watch the troop ships set off for China, and to see the hospital ships returning with their human cargoes of crippled and wounded. For the Moji-Shimonoseki harbor is the port of entry and departure for the war in China. Ambulances were at the wharves to receive the most urgent hospital cases.

At 11:00 A.M., while our ship was being coaled, every whistle of ship and factory in harbor and port began to blow. Bells rang. Even the swarms of tiny tugs lent their bombastic blasts to the din. We knew that the Japanese emperor was at that instant praying at the sacred shrine of Ise, far distant, off near Kyoto, and that he was even then reporting to the ancestors of the nation that Japan had reached her 2600th birthday. Every whistle in the land, we also knew, was being blasted at the moment the prayers were offered.

There were these things to do and hear in Moji, but little else, and all on board were glad when the coal barges pulled away and we prepared to weigh anchor at 2:00 P.M. Just then a rumor started to spread. Mussolini had taken the leap; Italy had come into the war.

101

It didn't seem possible that this could affect us—twelve thousand miles away. But at 3:00 P.M. our vessel did not move.

An American sea captain—an old timer, owner of the famous "Sea Captain's Shop" in Shanghai—was among our passengers. He and I had become good friends because I found that he had been born in Finland and had visited it last year. He knew some of my acquaintances there. The old captain came up to me and said: "Look at those winches. Look at that bridge. No activity. This ship isn't going to sail. I'll be damned if it is."

Four, five o'clock came, and no activity. The captain was right. Then we realized this vessel was bound for Liverpool via Mediterranean ports. A rumor spread around that the Japanese admiralty was issuing orders to our captain.

Next morning, before sunup, I was awakened by the sound of the winches. Peering out, I saw that boxes marked "Naples," "Port Said," etc., were being jerked out of the hold. All our Mediterranean cargo and mail was being unloaded. At breakfast, word passed around that our ship had been rerouted around Africa via the Cape of Good Hope. At 11:00 A.M. we finally put out through the Shimonoseki Straits for the Yellow Sea. The effects of war are far-reaching.

Repercussions were felt in other parts of the Orient as well. In Shanghai, a week later, I found a most awkward relationship existing between the French and the Italians in the International Settlement. The mother countries of these French and Italian emigrants were now at war with each other. The International Settlement belongs to neither one nation nor the other, and both nationalities have to live there without either having the upper hand.

Street signs bearing the name of Italy's king were pulled down in the night, but French authorities saw that they were replaced. The Italian consul decreed that no business relations should henceforth take place between the Italians and the French, and declared all Italian debts owing to French individuals and concerns to be null and void.

In Hong Kong I found the situation was different, this being a British colony. Immediately upon Italian declaration of war, all Italian firms had closed shop or been forcibly locked. The 22,000 British inhabitants in this tiny island colony of the Empire, with its 1,200,000 population of Chinese, were fully cognizant of the perils they were facing. Their fear is of Japan.

The women and children were being evacuated. The harbor was strung with mines. The verdant hills flanking the city were studded with forts and guns.

Hong Kong, within fishing pole reach of Japanese-threatened West China, is Britain's most perilously located Pacific possession. She is strong for Empire.

It was in Hong Kong that I received news of the probability of French surrender to Germany. During the next week, while steaming down to Singapore on a Japanese vessel, snatches of news and bits of rumor reached us from various sources. An element of interest was added by the fact that an armed cruiser was following us, just visible on the horizon. The first officer told me he didn't know its nationality.

It is a travesty of civilization to realize that, although we aren't supposed to have a complete World War as yet, every inch of the seven thousand miles I have traveled thus far has been on ships or through territory of nations at war; Canada, Japan, China, Shanghai, Hong Kong—every one a belligerent. Next I go to Singapore, then on to the Dutch East Indies and by Dutch ship to Manila. And of course those Indies, as yet undefeated offspring of defeated Holland, are in a state of belligerency. Not until I reach the Philippines will there be any signs of peace.

CHAPTER 14

Security Dodging— and Jungle Hopping

And now—3345 miles after leaving Tokyo—I have reached Singapore, to settle down for a time before proceeding by air to Java.

This is the most strongly-fortified British colony east of Suez. It is the site of the Singapore Naval Base. But despite all of Britain's defenses, here and in Hong Kong and at other bases in this part of the world, the whole area is vulnerable to attack. Someone has said that the British lion is trying to show his teeth and it is all bridgework.

It is becoming increasingly obvious, to those who make a business of studying such matters, that the Empire is going to have need of a dentist.

Singapore is a leisurely, quiet metropolis of the tropics and the most beautiful spot in town is St. Andrew's Church of England Cathedral—in a spacious grass-cushioned central square. I attended vesper services last night and found the cathedral packed. I wonder if it was so, before the crisis? (World War II of course had already engulfed Europe. Singapore, as a British colony, was also technically at war.)

In the cathedral, the hymns were like a touch of home, and made me long for America. As the music filled the sanctuary and drifted through the open windows into the soft tropical twilight, the realization came to me that England's conquest of empire had spread not only her temporal power throughout the world, but had taken with it the religion represented by this church I was in. Of course her temporal power has not been lily-white, and neither has the religion she spreads.

Shaking empires. Like a paean which was intended to be heard not alone in heaven but in England as well, the final hymn rang out.

Following the service, I stood at the entrance and watched emerging from the church all the civil and military leaders of Singapore—men on whose shoulders in reality rests the defense and safety of the British Empire from Suez to New Zealand. The faces were grim. Few smiles.

The church service had been comforting, and like a touch of home. If I were in the colonial service and stationed thousands of miles away in the tropics, I too would belong to St. Andrew's and attend vespers each Sunday night. Especially in wartime. Empires don't seem to be shaking quite as much when hymns are being sung.

In the threatened cities of Shanghai, Hong Kong, and now Singapore, I have done all the filming required for my *Circle* of Fire documentary, but how I was able to accomplish it, I'll never really understand. In each city I had encountered roadblocks, not as difficult as those which dogged me in Japan, but irritating, nonetheless.

Restrictions on wartime photography were a constant problem but in Singapore a less well-defined difficulty developed, of an entirely different character. I was little more than one degree from the equator, in midsummer, and the area was experiencing a particularly severe heat wave. Personally I do not mind heat, and function well in any temperature.

But the emulsion on color film is another matter. It was actually melting, virtually starting to run. All film that I was not using went into the hotel refrigerator, but the film in my camera just had to take the heat. Whether the pictures would be ruined I would not know until I had them developed, back in the United States. The rather weird thought occurred to me: Oh, to be back in winter Lapland, where my camera froze from the cold. This old world, it was becoming clear, is built on extremes.

A different sort of experience in Singapore counterbalanced the heat problem—an example of the fortunate manner in which it was possible to weave in and out of the mesh of guards, security patrols, and officialdom with no real damage to my picture-taking project.

I had filmed everything I needed in Singapore, even having made a successful journey on the causeway over the Straits of Johore, to the mainland, where exotic tropical scenes opened for my lens.

I was ready for departure. Taxiing to the airport, I checked my luggage, camera, tripod, and film, and saw them go into the

baggage hold of the plane. Next came passport inspection as I boarded the plane.

"Wait. What is this?" It was the voice of a military official, checking my papers and credentials. "It says you are a writer."

In a gentle voice I replied in the affirmative.

The official commenced grilling me severely. All mail dispatched from Singapore is opened and censored and I assured him I had not sent out any classified information.

(I wouldn't dispatch any newspaper write-ups until I reached the Philippine Islands.)

He was performing his job thoroughly. "Did you take any pictures?" he asked.

I determined to be truthful. "Yes, I took some travel movies."

"You've been taking moving pictures in Singapore?" The official's voice was not gentle.

"Just some tourist scenes," I responded, my voice still soft.

"Picture-taking is forbidden. We're at war. Where are your films?"

Now my voice, though still gentle, was quavering just a trifle. "They've been loaded on the plane; they're in the cargo compartment."

It just happened that I was almost the last passenger in line. Nearly all the rest were aboard. The plane was ready to leave; already it was late.

The plane's second officer and the military official held a heated conference. No, the baggage could not be unloaded. Just too bad, but it would be impossible—take far too long.

I edged toward the boarding ramp. As the argument continued, I could see that the plane's second officer was winning the debate. I boarded; the second officer did likewise and we lifted off over the Straits and headed across the equator.

A Visual Smorgasbord

In "The Flying Dutchman" I was on my way by air from Singapore to Batavia, in Java, a distance of some six hundred miles.

Immediately after taking off, we headed out over the Malacca Straits and soon had a salt-and-pepper sprinkling of dozens of tiny islands spread below. Their concentric displays of color were almost intoxicating in their splendor. The islands were of various sizes, and forest-covered. Surrounding each one was a great irregular band of brown and yellow, denoting shallow water. This

merged into greens, which signified that the water was deepening. After the various hues of greens came the blues—the color of deep ocean. Sometimes the demarcation from green to blue was sharp, indicating sudden drop-offs. And always there was a white line of breaking waves between the browns and greens. The whole picture was as though a thousand great splotches of paint had been dropped on the waters below.

This was the Rhio Archipelago we were passing. Somewhere just below here extended the equator but, hard as I looked, it did not show up.

Now we headed out over several huge islands all heavily covered with jungle. Great brown river systems, with the tributaries and branches visible for miles, were the only break in the mass of jungle trees.

I watched those rivers sharply. Often we flew low. There—far down—were one or two thatched huts along the stream. And a tiny native boat. The signs of human beings. Dwellers in that isolation of forested jungle! We were miles from anywhere. And below, just dense jungle on an isolated island in the sea.

Perhaps the native in that boat had scarcely ever seen a white man. But every day he could look up at the great flying thunderbird which roared over his hut. By now he was resigned to it. But what must he have thought the first time this devil with wings had broken the solitude of his home? To him it must have been a very real terror. It was easy for me to feel the fear which certainly possessed his heart when he first saw the plane and went running to his hut to comfort his wailing wife and children.

For a time we caressed the tops of some soft tropical white cloud puffs. They were great pillows of sugar candy, tantalizing the wheels of our plane. I could look down into wide canyons of pure dainty white, billows built upon billows. It was luscious.

More open sea. A few tiny fishing boats. Then we plunged out over the jungles of the Sumatran mainland. A ridge of mountains rises like a backbone in western Sumatra, but this portion was a vast, flat, tangled wilderness. There was a sea of thick green forest with occasional reddish trees, some few forest giants rearing far above the main mass of growth, so that their gnarled gray limbs came into view.

And more river systems. Vast waterways. Small rivers. Tiny feeder streams. I could follow them all from my godlike seat on high. They ran golden brown with the rich silt of the tropics. This area receives some of the heaviest rainfall in the world. Those matted trees, these great rivers opulent with their brown mud, were

convincing proofs of this. When we approached the coast I could see that nearly every stream had a large delta. And one great river had two distinct mouths, miles apart.

Thousands of square miles of jungle, without break or open space. We were in a land plane, but since coming to Sumatra there had not been one place to land. It behooved the pilot to keep the ship up in the air.

As I was thinking of this, the plane started to glide low. I could make out the individual trees now, and the coconuts on the tallest palms. Lower and lower, I could see down through those trees; there was a sea of marsh and water to form the jungle floor. Another river came into view, bending in a great arc. We were just above the treetops, and there by the stream was a native village—half a hundred grass-thatched huts built on piles along the shore at the water's edge. That sight was a gem. It was a movie set in its perfection. But how far from Hollywood this was.

I feared we would clip the trees. I knew this was the vicinity of Palembang, our only stop en route. Without circling once, without deviating to north or south, we cut down and down, almost nipping the branches as we came to a landing strip and roared along to a well-braked stop. Clearings mean hard labor in a Sumatran jungle; this landing field was none too large.

All of us piled out of the plane and went into the modern, newly-built station. For the half hour we were here, I gave my eyes a couple of weeks of work. Oh, for that camera of mine which was sealed and locked in a special compartment of the plane.

Photography from the air over any country which is at war is as impossible as a flight to Mars. And these Dutch East Indies, possessions of Holland, definitely were at war. I couldn't even take pictures on the ground without first reporting to the authorities at Batavia. Otherwise I would have stayed at Palembang. And even so, the Dutch consul in Singapore had told me my trip would probably be useless; he didn't think I could get a permit to make a film during time of war. These are days of severe restrictions.

Where the forests had been pushed back, I could see banana trees and palms interspersed with the more numerous hardwood trees. A dusky Sumatran maiden, with a sarong about her body and a dull soft cerise-colored "selendant" or veil slung over her black hair, padded barefooted along the road. She was headed for a thatched hut—the only habitation in sight.

We took off easily because there was no wind; and now we had a change of scene. Almost immediately clearings and agricultural land came into sight; then we swung out over the city of

Palembang. It was a real metropolis stretched along both banks of the Musi River, its thousands of tiled roofs reminding me that this was a colony of Holland. Steam freighters were plying the river, wharves lined the stream, and down beyond the city was a great refinery, with oil storage tanks hugging the water.

Now there was no jungle, but mile on mile of rice lands, all flooded so only the raised edges of the fields were visible. Soon these areas merged with the jungles again but—looking back against the sun—I could see the glint and reflection of water. This whole region was damp and partly flooded.

Next, the Sunda Strait. And more islands, even more beautiful than those of the Rhio Archipelago, for these new ones are coral formations.

Sumatra receded on our right and in ten minutes Java was in view. Here was more rice—more than I had ever seen. Every inch of soil was cultivated in the flat plain surrounding Batavia. The fields were clearly delineated and small, and there seemed to be a million of them. Small wonder, for Java is one of the most densely populated land masses in the world, and needs rice for food.

We were passing now through clouds which obscured vision. There had been one great mass of black clouds and the plane had pitched violently. In fact, it hit pockets most of the way and we did much upping and downing. The unevenness of the tropical equatorial air, I presume.

The clouds broke and I could see roads down below, with cars. On the left was the harbor, with a ship just coming in—the one I had almost decided to take two days before from Singapore. Down below me was Batavia, with its thousands of red tile roofs, its neat patterns, the cathedral, the recreation ground. We swung down to the landing field eighteen miles from town and I was soon started on my adventures in Java.

CHAPTER 15

Dutch Treat

The Dutch East Indies, in all respects except actual fighting, are definitely at war. Troops, both native and Dutch, are everywhere. Bomb shelters are being thrown up in streets and public squares of Batavia, Surabaya, and Cherebon. Blackouts have been practiced. The airports are strewn with barbed wire entanglements.

Refugees are arriving from Holland—just a few who managed to escape the German conquest. Most of them, once rich, are now penniless and without proper clothing. Many of my Dutch friends in the East Indies have their families in Holland and do not know whether they are dead or alive.

Censorship is strict. In Java I was searched four different times. Technically the country is under military rule. Instructions have been issued to all police to immediately arrest anyone seen taking pictures. In all my time in Java, I never once saw a camera being used by natives, Dutch, or foreigners, except my own. Under such conditions, as I started out to make a motion picture film of the land, I soon became entangled in almost as much red tape as had snarled my efforts in Japan. From the office of the commander in chief I was eventually able to wrangle a limited permit but one of its provisions was that, in every city or locale where I wished to film, I would be required to report to headquarters and obtain a local permit, or a police escort. In Batavia I did this and all went well. So, too, at Buitenzorg.

But at Bandoeng, center of what I felt was the most marvelous area in all Java, trouble developed at once.

I arrived here on a Saturday, which was also a holiday. The police officials (I contacted the chiefs of four different departments) would not take the responsibility of giving me a permit. And the Resident and the high army officers were all at parties and banquets, celebrating the birthday of Prince Bernhardt, husband of Queen Juliana. They could not be reached.

At 10:00 P.M. Saturday night I finally contacted the colonel of the local forces who told me it would be necessary to go to Commander Spoor. And he could not be reached.

I had hired a car and driver for next day, at a cost of twenty dollars. I was working on a close schedule and couldn't be delayed. This was the most interesting part of Java. If I could not get the permit at once it would be disastrous to my film.

My native driver arrived early next morning. I routed out the landlady and told her she must help me telephone Commander Spoor.

What a grand time to be doing it! On Sunday morning at 7:15 A.M. after a huge holiday. I knew for certain that Spoor had been out most of the night for I had not been able to get him by telephone. But it had to be done.

The landlady swore he would be away in the mountains. Or if he wasn't, he would be jumping mad to be called at this hour. But she gritted her teeth and rang the number. There was what seemed like endless delay. During that moment I offered up a fervent prayer. Actually the success of filming this vital part of Java hung on Officer Spoor being home and upon my getting his permission for pictures.

Suspense. A voice responded. It was the commander's servant. There was another eon of waiting. Then my landlady began to talk. She was reading my permit from the office of the commander in chief. Her face did not look too good.

"Give me the phone," I said. I felt if I could plead my own case, I might be successful.

It was Commander Spoor on the line. He spoke perfect English. Every officer in the Dutch colonial service goes through stringent schooling and must be fluent in several languages.

I gave him everything I had—relating the interest of America in the Dutch East Indies and of the fervent necessity of my mission. I told him several hundred thousand persons would see my finished film and emphasized what it would mean. He pondered. Then:

"Yes," he said. "I will arrange the permit."

The morning was perfect. There had been a tropical cloudburst the day before. It was to storm next day. But this perfect Sunday was mine for success.

And what a day! My native barefooted driver gave excellent cooperation. If I asked him to stop the car once, I know I asked him a hundred times. Our goal was the great Panandajan Crater, 7600 feet high, fifty miles to the south in the very center of the wild

Preangor Mountains. But there was so much of interest en route I scarcely would have noticed if we ever reached our goal or not.

First the rice. The fields in the flats were interesting but when we started into the hills and could see the terraces step-on-step up the mountainsides—that was the material of which great motion pictures are made. The natives were out early, working the fields with their huge ponderous water buffaloes, which would sometimes be buried up to the stomach in the mud of the rice lands. Doggedly the workers clung to their plows as they plodded along in the seas of mud behind their animals. I obtained pictures of the rice planting, of the matured crop, of the harvest and of the stacked grain—all in one area and in a single day. The fact that there are virtually no seasons in Java makes it possible to keep crops maturing almost every month of the year.

Next the tapioca—both the slender cassava stalks or plants growing in great fields, and also the shallow trays or baskets in which it was being dried in front of the tapioca factories.

Then the quinine trees (more properly the cinchona trees, from the bark of which the quinine is extracted). Ninety-seven percent of the world's supply comes from Java, and most of that comes from the region of Bandoeng.

The tree is not native to this region but came originally from South America. Countess Chinchon, wife of the viceroy of Lima, was the first person to be cured of malaria by the strange drug from the trees which the natives called "quina, quina." Seeds were brought to Java after infinite trouble and its cultivation started here. I saw trees varying in size from the "plantation quinine," the young sprouts which had just been planted, up to mature trees fifteen feet tall. All were slender, and they were planted as close together as commuters packed in a subway. There are sometimes a thousand trees to the acre.

We stopped to try the bark of the cinnamon trees—their green leaves being beautifully intermingled with soft red leaves and flowers. The bark had perfect cinnamon taste. These trees grew along the roadsides, adding to the beauty of the way, and did not seem to be cultivated. Parts of Indonesia, of course, were the original "Spice Islands."

There were sweet potatoes, ordinary potatoes, bananas by the millions, sago palms, maize, coconuts, and my driver only knows what else, but I had all I could do to film the unusual, let alone the commonplace. Then we came to the tea.

This Was Java Supreme

Tea!

I have never dreamed of estates of such vastness. The bushes are about three or four feet high, and the shiny green leaves glisten in the sun—glisten for miles, for the estates extended as far as the eye could see. We were in the highlands—on a mountainside. These were not drab flat fields, but rolling hills of tea, steep inclines of tea, tea in every contour which a rough mountainside could offer. Acacia and cinchona trees were sometimes planted along with the tea bushes to provide partial shade. They added to the grandeur.

We came to the women and children picking the leaves. Of course I had to have pictures—lots of them. But I nearly forgot about the tea. For these women were *beautiful*.

And how happy! They sang as they worked, with their heads barely peeping above the tea bushes, which made it difficult for me to film their work. But I made them stand for close-ups and they would laugh, twitter, and talk to me constantly in their native tongue. When we left they all called good-bye. When we would pass groups of them they would invariably wave and call a greeting to us. A proper simile would be: "As happy as a Papandajan tea picker." These mirth-loving lighthearted workers on the great Pengalengan tea estates near Papandajan—I shall never forget them.

This trip was one of the few I made in Java on which I was not accompanied by a police escort. Once, while filming a group of the tea workers, I was approached by a Dutch planter and questioned severely. A few minutes later I was taking shots of one of the tea factories out in the center of a great estate. I had made a long shot and was working for a closeup. We were miles from any town or settlement but from somewhere appeared a Dutch official.

"Stop," he shouted. "That is prohibited. This is wartime."

And so I was put under arrest and led off to headquarters. There was nothing serious they could do to me personally, but I was quaking for the safety of my camera and especially all my film. A Dutch officer had already warned me that if I was caught taking military objectives of any kind, including railroads, stations, bridges, views from bridges, soldiers, etc., all my equipment would be confiscated and never returned. I wondered—was a tea factory out in the mountains a military objective? Perhaps so.

It was lucky I had gone to all the trouble of obtaining the permit from Commander Spoor. That was the thing which saved me and

the film. I was released. But the incident was upsetting and I felt uneasy for half an hour, missing a number of other shots in that vicinity that would have made excellent pictures.

Up, up, up. Our road was a narrow lane winding through the seas of tea. Finally we left the estates behind and plunged into virgin untouched forest—virtual jungle.

Up, up, up. The road became narrow and when we met a solitary car there was trouble in passing. The road became rougher, petering out to a trail of stone through the wilds. Then a rise near the top. A brief descent.

"There," said my driver, and I looked far across the valley to see the crater of the Papandajan.

The film I am making, *Circle of Fire,* brings out the fact that the Pacific area is not only a center of economic and political unrest, but also a literal circle of volcanic activity. Java is a focal point of the future strife which may engulf the Pacific; it is also the center of volcanic fire. Few other areas in the world are so thickly studded with active volcanoes.

And the Papandajan is one of the greatest. The last time it erupted, forty villages were buried and three thousand people killed. It is still active. Even as I stopped to look, great clouds of steam rose up from the crater floor.

We started to descend. Down, down, down, along a torturous road, right to the crater's edge. But that was not enough.

A steep path led on down into the very bed of fire. My driver made arrangements for a native to guide me. We passed through sulphur beds. The odors were vile, so bad I was thrown into violent fits of coughing. Steam, enormous white clouds of it, came out of the ground and fogged the lens of my camera. I was worried that the instrument would be ruined. But I could see, still farther on, something which would not let me stop. For there ahead was color—intriguing masses and blobs of color.

The whole area was a bed of churned-up sulphur, and the bubbling and steaming caldron was encased in a mass of encrusted yellow and orange hues. They were brilliant beyond belief. It is unusual to catch the Papandajan on a clear day. This day was not only clear but the sun actually came out, with a blue sky overhead. Cutting down my lens to the smallest stop, I let it drink in the whole scene. Here was a steaming rainbow of almost frightening beauty.

There were small rivers of hot water, bubbling springs of steaming water, sputtering and popping mud pots, and the weird yellow and orange formations of sulphur emitting their blasts of smoke. Above it all hung a plume of white clouds formed by the

volcano's steam. Circle of Fire! It was terrible, yet it was grand.

I hadn't realized it before but I suddenly saw that my native guide was barefooted! I now took a close look at the bottom of his feet. They were almost as hard as shoe leather. Without any apparent pain, he had been walking over hot boulders and jagged rocks.

All the way back up the steam-shrouded colorful trail, then all the way back to the lookout station high above, I kept my camera busy. When at last I reached the car and my driver and I started down over a different road until the steaming crater passed from view, I felt a loss. This was Java supreme.

CHAPTER 16

Bali Bound

I was on the plane bound for Bali.

Every portion of my Javanese trip had produced a thrill. At Jogjakarta (usually called "Jogja" and spelled six different ways) there had been the great bazaars, the dancers, artisans, conglomerate native life. On the Prambanan Plain there had been ancient temples over and about which herds of deer nosed and grazed as though they were sightseers. But these temples had been nothing compared to the sublime Borobudur—a thousand years old, and the greatest, most perfect stupa in the world.

There had been volcanoes and craters until I had actually lost count. I was coming back to Java later, to make the climb to the Bromo, greatest crater on the island; but now I was "Bali bound."

My train was late getting into Surabaya (also spelled six different ways) and it was necessary to make a close connection with the Bali plane. The airport lay far across town but the pilot, informed by telephone, courteously consented to wait for me, even though the plane was a through one, bound for Macassar in the Celebes.

The airport was a mass of tangled barbed wire, with only the runway left open. The buildings were camouflaged. Sentries stopped my taxi so often that progress was difficult. At the airport I was hastily questioned and searched, then bustled on the plane. We were off.

Bali. One hears about it in Hollywood and Havana and Harlem. There are Bali restaurants, Bali tearooms, Bali dance halls all over America. At the time I entered the island I even had on a "Bali shirt" purchased in Ontario, California. Of course no Balinese had ever seen or worn such an article.

My coming here was impelled more by curiosity than a sense of duty. Initially, I had built up the idea in my mind that the place would be entirely superficial—that all the glamour one hears about the island is nothing but "ballyhoo." In the second place, I felt I

117

would not dare make a motion picture for general audiences in America with the scantily-clothed Balinese women as subject matter. These were my preconceived notions.

Three hours after I had landed on the Enchanted Isle my whole conception had changed. I couldn't make a comprehensive photo study of the island; my plans had been made otherwise and I lacked film. But, freed from the constraints of having to do extensive filming, I found on Bali a respite from my worries over permits and security guards. This would be a brief vacation from strenuous work.

My holiday started at the airport, which was on a narrow neck of land surrounded by the breaking sea and by coconut groves, some ten miles from Denpasar, center of the island's native life. As I rode along the dusty road toward town, the life of Bali immediately began to unfold before me.

Temples lined the way, each one with its series of intricately carved gateways, for which Bali is famous. There were rice fields, with the men and women busy at work, and in many of these fields were temples. The walled-in compounds of the families hugged close to the road and we had ample views of the groups of thatched houses within each set of walls. All the descendants of one great-grandfather are supposed to live together within one of these large walled compounds. Each has its family temple or shrine.

In the streams along the way the Balinese were swimming and bathing, innocent of clothing. And along the country road they were walking by the hundreds, many of them carrying great laden baskets balanced on their heads, or suspended on bamboo poles over their shoulders.

The men were nearly all good specimens of healthy manhood. As to the women, perhaps only one out of eight was strikingly beautiful, but I was to find that even those who did not have beauty possessed what is far more valuable—happy personalities. Fully half the women, too, wore simple single-button blouses which covered their breasts. Obviously I could get pictures which could be shown to any type of American audience.

The Balinese, I found, were mainly farmers, working in the fields and appearing to get great joy from doing so.

Almost as important as their work was their means of relaxation and inner expression. Art is vital to the life of a Balinese. They dance because they love it. They create and play a music which cannot be equaled, because it is in them to create and play it. They carve fine objects of wood and make scrolls and employ infinite artistic skill in the continual building of their temples simply

because these things are a necessary form of expression in their lives.

I couldn't resist attempting to get some motion pictures of the native dances. Hearing of a "dancing club" at the edge of town, I made my way there in hopes of hiring some of the girls to perform for me. But no one was on hand; all members of the club were out working in the rice fields. A messenger was sent and in a few minutes five girls came in from the fields. They adorned themselves in dancing costumes, and for an hour presented for me dances which, to me at least, were as charming as a Russian ballet. There may have been more professional dancers on this island, but I am glad that the girls I chose to film came right out of the rice fields to perform. This was the true Bali.

Then, as to music. I was on my way up-country to see the sacred monkeys in the nutmeg groves. The scenes along the road were alive with interest. There were more temples with their intricate gateways. Small markets, filled with happy natives. Brown-skinned men and women riding bicycles or padding along on foot in the dust of the narrow roadway. From somewhere, music was filling the air—strange, beautiful music, not in any sense oriental, yet certainly not of the West. I stopped to search its source and soon, under a thatched roof back from the road, I discovered a native orchestra, with perhaps fifteen players, all responding to the directions of a leader. There was a definite arrangement of instruments—mainly gongs, xylophones, one-stringed pieces. Later, at a museum I saw a complete orchestral setup and had it explained to me.

The music was mysterious, with a tune impossible to remember. But it was soft and plaintive, and beautiful.

There is a sequel. After listening fifteen minutes I went on but, many hours later, returned this way. Those same soft strains. Again I stopped and went back to the thatched-roofed enclosure. The orchestra was still playing. No spectators. No one to listen. Probably they were practicing for some future event. But how charming to realize that simple rice-working men and women on a South Sea isle could create a music as beautiful as that, and had within them the artistic urge that would keep them practicing for half a day to achieve perfection. This was the real Bali.

Balinese religion is a study in itself. I do not pretend to comprehend it. But one thing I do know; the religion of the people of Bali is a definite everyday part of their lives.

We in America build a costly sanctuary and often keep it under lock and key except for an hour on prayer meeting night and a few

hours on Sunday. The Balinese put a simple temple in their rice fields, so it will be handy for a bit of worship during work hours. They build a small temple in every home. On all the earth there could be no more sacred place for it. They construct small temples by the hundreds along the roads and highways. There are elements which a foreigner may find hard to understand in connection with their religion, but it is a vital part of their everyday lives and has an underlying quality of happiness and joy.

The villages have their shops for tourists, where native artwork is for sale. But now there are no tourists. An American army captain, on leave, was the only other outsider I saw during my Balinese stay. The shopkeepers are facing ruin, but they have not lost their ability to laugh.

One family I shall never forget. The husband and wife—both happy natives—ran the shop and their two-year-old brown-skinned son ran naked. Balinese youngsters are as attractive as any I have seen.

Weighed down as I was with camera equipment and film, there was little room in my luggage for souvenirs. But those two shopkeepers—and their tiny son—were so bubbling over with charm and goodwill that I left their shop with two intricately carved wood Balinese heads, and a smiling wooden mask. Their joy and their smiles—even in the face of adversity—were completely disarming.

Before leaving Bali, I sent a cablegram to Helen, so she would know I was faring well. Such messages are priced by the word, including the address. I had told our hometown Western Union office in case they received a message addressed "Line, Ontario, Calif." to deliver it to my wife. My simple message was "Denpasar. Love. Francis." Helen had to go to the Ontario library to seek assistance in finding out in what part of the world Denpasar was located.

On the air journey back to Java we took a different route and flew over the entire island of Bali. It is small and I could see a great deal of it at one time. We crossed the Bali Strait at its narrowest part; a distance which seemed no greater than the length of two city blocks separated Bali from Java. Then we started out over a Javanese mountain range which was pockmarked with craters. One passed directly beneath us and contained an emerald lake.

Heading out over the Madura Strait, I could see to the north the great island from which the strait takes its name. Over the craters, the air had been disturbed and rough. But upon passing out over the water it suddenly became treacherous. This was some sort of a

freak tropical air storm. The plane dipped and tipped like a roller coaster. We fastened safety belts and braced our feet. We rocked and ducked and jumped and settled.

But Surabaya was not far off. Its sea of red-tiled roofs looked good; soon we were circling over the harbor and the airport. Before landing I looked off toward the south. Visible fifty miles in the distance were the piled mountains of the Tenggar, with their mysterious Sand Sea and the greatest crater in Java—the Bromo. This was my next objective.

Trip to the Bromo

Darkness had just crept up the mountainside to shroud Tosari, a little hill station high on the crest of the Tenggars in southeast Java. The weather on the plain below was warm, but Tosari is nearly seven thousand feet high and I shivered as I sat in my room writing a letter home.

There was a knock at the door. It was the head of the local police, a Javanese who spoke no English. But he had brought a man along to interpret. I was expecting this, for I had previously applied for permission to take pictures on my trip to the Bromo crater. This was just a formal call. Yes, I could take the pictures, but a native policeman would go along to check on my activities. I smiled. I would be leaving at two in the morning, on an all-day trip through an area as wild as the Rockies. No military objectives could possibly be lurking in that section, yet I must be watched nonetheless.

And, just as a formality, would I please fill out this paper. I proceeded to give answers to a set of questions more amazing than could be conceived by "Information Please." All the usual questions, of course. Then, what was my wife's name and age? The names and ages of my children. Had I ever fought in the German army? How recently had I been to Europe? And (crowning questions of all): Did I own my own home? And how many rooms did it have? I almost felt for a moment as though I were applying for a house loan.

A wild-appearing native knocked on my door at 2:00 A.M. He was a burly fellow (unlike the average Javanese) with hair askew and a scowl on his face. I rolled out in the cold to dress.

Everyone had told me that the Bromo was Java's greatest crater but I knew little else about the trip I was to take. Little English was spoken in Tosari. In arranging for the journey, I understood I could have a horse to ride, or some natives to carry my things. I chose the latter, thinking it would give me more freedom for photography.

The natives would serve as guides.

So I dressed hurriedly and went out into the night. Waiting in the darkness outside, lighted only by a flaming torch held by one of them, were *eight* natives carrying a sedan chair, with the scowling mounted policeman beside them.

I called on the ghosts of all my past adventures to bear witness against this humiliation. To think that I, who had climbed mountains and glaciers and hiked to every state in the Union, who had done more hill-scaling than these men ever thought of doing; to think that I should let myself be *carried* on an adventure trip. When I saw those eight Javanese stolidly and seriously supporting the chair in which I was to ride, I broke out laughing.

I rode in the contraption for about five minutes. The men, even under my weight, were shivering with cold. As for myself, dressed for the tropics, I was numb. Thereupon I got out, took the torch from the head bearer, and led the procession. For warmth, I wrapped myself in the blanket on which I had been sitting.

We were following a circuitous path, with steep pitches and drops, through a region of heavy forests. Teak trees were all about us; in the branches overhead I could dimly make out the great fern growths of chamur which clung parasitically in huge clumps to the trees.

Every time I think of the picture which this weird procession must have made, I smile inwardly. There I was, wrapped in a blanket, leading the way with a torch. Then followed eight Javanese bearing a sedan chair which contained nothing but my camera. I could have carried it easily in my hand. Behind, on horseback, rode a scowling, wild-lookng native policeman, dressed for the hills with wide-brimmed hat and heavy poncho. He was to see that I didn't take pictures of any "military objectives." We were a ridiculous parade. Ten people to do the work of two or three.

But the night trip was beautiful. Overhead was the Southern Cross, surrounded by other stars as brilliant as coals of fire. The Milky Way, just as in the northern heavens, lay in a wide path across the sky. There were strange sounds from the thick forest all about.

Once my torch, blown by a cold gust of wind, was suddenly extinguished. The path was narrow and just at that moment one of the bearers stepped off from an embankment at the edge and fell. Luckily he clung grimly to the sedan chair and the other men easily held his weight. He was rescued and suffered only a bruised leg.

Daylight found us trudging through the forests, displaying this same weird picture. Then I unlimbered my camera and began getting movies of the strange procession.

The sun was casting a golden glow over the world when we left the forest path and broke suddenly onto a ridge which gave view out over the objects of our journey—the expansive mysterious Sand Sea, the perfectly-shaped, blunt-top cone of Batok, and the ominous smoking crater of the Bromo. There it all was, before me.

My companions built a fire and cooked themselves some breakfast. I worked like a madman transposing all the glory of that early morning scene into my camera while the golden sun was still casting its six o'clock light and long shadows.

The Sand Sea has the appearance of a dry lake, extending flat and far along the bases of the two craters. But the sands of this "lake" are volcanic ash, fine soft black particles of ground up lava. One theory has it that this Sand Sea is the bottom of a crater of some former enormous volcano, and that the Batok and Bromo are two new volcanoes pushing out of an old one.

When the men had breakfasted and I had filmed, we started down the treacherous trail toward the "sea." It was steep and, even with me walking, the bearers had difficulty carrying their sedan chair. And behind, leading his pony (for the path was even too steep for horseback riding), came the "constabulary." The procession made marvelous filming. This would add a bit of comic relief to the serious aspects of my *Circle of Fire* production.

We reached the bottom and started out across the "sea." The rippling black sand, seen at close range, is a marvel of nature. Unfortunately, what would otherwise have been an unbroken expanse of such rippling beauty was interrupted by frequent growth of bunch grass. But the Sand Sea was all I could have hoped for. I filmed the chair-bearers wading in it, making tracks across its rippling expanse.

The sand in places was deep, easy walking for the barefooted natives but rather hard for me. So I made use of my luxuries and rode in the sedan chair for a ways. The final object of our journey was not far ahead. Circling the base of the sawed-off Batok, we soon had our first closeup view of the Bromo.

The outer appearance of the crater is not exciting, but its weathered, rain-cut volcanic slopes have taken on weird shapes and forms. The glory is in the great white puffs of steam which are forever shooting out above the rim.

Leaving the chair and my entourage, and taking a couple of the men for guides, I climbed the wicked path through the lava mud flows and finally came to the crater's edge.

There has always been a mystery as to the location of the gateway to hell. This was it. In a symmetrical cone the crater sloped down and inward with the regularity of an inverted funnel. And there at the bottom was the funnel's spout, a well or hole which disappeared on downward into eternity. Out of it were coming intermittent puffs of smoke and steam. The rims of that hellhole were vivid yellows and oranges and browns, and the steam was coming from the unseen bottom below and from jets and crevices along its sides. One could imagine the terrible power hidden there and could almost wish to be here to witness an eruption. Satan's breath seemed hot on my cheek.

While my helpers slept, I circled a portion of the knifelike rim. There was no regular path and I had to use care not to slip down the outer lava-mud slopes toward the Sand Sea, and more especially not to let the soft inner edges give way, which would plunge me down into the Bromo itself.

After filming every angle of the hellhole, I turned my lens on the outer slopes, then onto the Sand Sea stretching out from Bromo's base. Close at hand was the serrated cone of Batok. This was the literal portion of the *Circle of Fire* for which my film is named.

That night—back in Tosari—I stood on the brink of the mountain rim and surveyed the valley below me. The sun's last light was touching the waters of the Madura Strait, miles to the north. Then the sun went down. The great mountain peaks of the Penanggoengan, the Ardjoeno, and the Kawi were outlined against a reddish sky. Darkness crept up fast.

I was on top of the world. It was cold and the air was sharp. Down below me I could see the clustered blinking lights of fifteen different towns and villages, spread out on the plain over a distance of fifty miles. The most distant cluster to the north was probably Surabaya. Off beyond, somewhere, was the equator, then ten thousand miles of Pacific, and finally California.

Today's adventures marked the virtual conclusion of my Java filming. The country had been thrilling but the taking of pictures in a land at war had been a nightmare. I was thankful to be finished.

A native baby started crying in a hut somewhere back in Tosari village. It brought me back to reality.

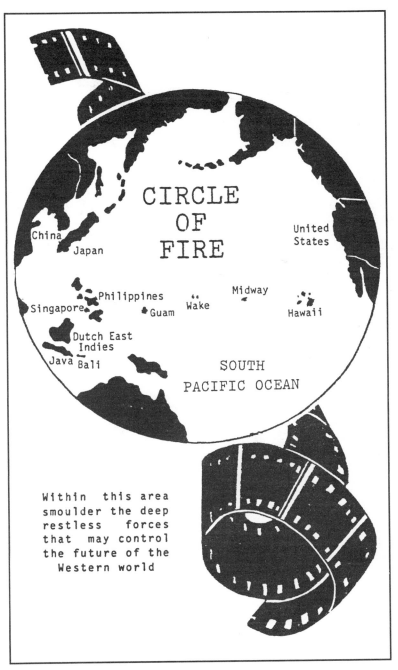

CIRCLE
OF
FIRE

China

Japan

United
States

Philippines

Midway

Singapore

Wake

Guam

Hawaii

Dutch East
Indies

Java Bali

SOUTH
PACIFIC OCEAN

Within this area
smoulder the deep
restless forces
that may control
the future of the
Western world

First page of Line's brochure of CIRCLE OF FIRE, showing areas covered by his prophetic film.

Even in Java's remote volcanic areas, filming had to be supervised by a police escort.

The cork hat was a protection from tropic sun.

An empty sedan chair. Line refused to be carried.

CHAPTER 17

Prophetic Prospects of War

This chapter and the one that follows, concerning my final adventures in the Pacific, were written from notes made on my journey through these areas.

All of the preceding chapters chronicling my Pacific journey— in Japan, China, Singapore, and the Dutch East Indies—were excerpted from articles, exactly as I had written them, except for grammatical editing, which I had sent to American newspapers.

My final dispatch to those papers was dated July 18, 1940 (one-and-a-half years before the Japanese attack on Pearl Harbor and America's entry into the war). In that dispatch, I emphasized that the Dutch were counting heavily on outside military aid, to help them retain possession of their East Indian empire. I wrote:

"Such help could be given only by Britain or America. The former would surely give it in normal times, because Australia, the British East Indies, and Malaya would be threatened by an enemy invasion of Java. But, at present, Great Britain has few resources for giving help. America (and perhaps Russia) are the great unknowns. If Japan were certain that America would not intervene, she would probably strike in the East Indies at once."

In my notebook at that time I jotted down this summary of the Pacific dilemma as I had assessed it during my journey.

"The U.S. has three courses open. (1) Let Japan have Pacific, which means loss of trade. (2) Make objections and not follow through, which means loss of face. (3) Fight, which means a long severe struggle in which Japan would win all the first moves and U.S. finally come out on top."

As I departed from Java, bound for the Philippines, on a sturdy Dutch merchant ship which steamed northward across the equator, then along the coast of Borneo, I tried to visualize the future of these vast equatorial colonial possessions of the Netherlands. Halfway around the world, in Europe, Holland had just fallen to

the Germans. Even now, Dutch evacuees were fleeing to these East Indies possessions.

Our vessel was bound directly for Manila, with no intermediate stops at any of the myriad islands of the Philippine archipelago that lay south of the capital city. In our trip around the world in 1925, my brother and I had wended our way, in a Japanese freighter, through these island-studded waters and had visited Davao, capital city of the Philippine's second-largest island, Mindanao.

In subsequent reading I learned that the city of Davao has 150 Japanese to one American. Seventy percent of Davao's roads are built by the Japanese. In 1934, ninety-eight Japanese vessels called at Davao, compared to four from the United States. Japan is reaching out.

Slowly the Dutch merchant ship carried me northward, through the eastern reaches of the China Sea. This chain of Filipino islands is enormous in length—extending a thousand miles from south to north.

Five days after leaving Batavia, when I wakened just at dawn, we were at last close to our goal, and by 9:30 A.M. were steaming through the narrow entrance to Manila Bay, with the bristling guns of Corregidor on our port side. Just beyond Corregidor lay the Bataan Peninsula, then the bay widened and it was nearly an hour before we dropped anchor outside Manila, having passed an aircraft carrier and many ships en route.

We lay at anchor two hours, waiting for a doctor to examine the 1,462 Chinese traveling in steerage, even though they were bound for Hong Kong and wouldn't be landing here. The ship is taking on two hundred more at Manila. The hatches were opened today and I saw how they lived—packed below decks nearly to the point of suffocation, or at least it seemed so to me. The Chinese as a race have had to undergo some extreme hardships. Someday, I wonder, will they be emancipated and rule the world? Who knows?

We had lunch on board. Then came our turn with the doctor, then customs, and the immigration. Lifting anchor, we moved up to Pier 7, largest in the Orient.

My baggage was soon in the hands of the customs officials. While waiting, a young man who seemed to be an inspector, asked me a number of pertinent questions, then sought my opinions on Java and the Dutch Indies, which I gave him. A photographer snapped my picture. Only then did I learn that this had been a newspaper interview. I had voiced opinions to him (thinking he was an inspector) which I would not have expressed to a reporter.

When the article and picture appeared in Manila's "Philippines Herald," my statement was played up above everything else, even though there had been more prestigious passengers aboard.

Hundreds of British women and children, evacuees from Hong Kong, had landed recently and we feared all hotel space in town would be taken. But I located a suitable room at the Y.M.C.A. for seventy-five cents a day.

It was Sunday. Also staying at the Y as his permanent home, I discovered, was a clerk from the Pan American Airways line of the "China Clipper" seaplanes which had recently begun service between Hong Kong and the United States.

Two men from my Batavia ship, who had clipper reservations for America, had told me that, with hundreds of government officials and business bigwigs flying back and forth because of the war hysteria, clipper passage was overbooked.

Perhaps my newly-made Pan American acquaintance at the Y could help me out. Almost the first thing I did was to enlist his aid. It was essential that my return to Hawaii and California be by plane rather than by leisurely surface vessel. Helen and our two daughters had already arrived in Hawaii where we would do some filming together before returning home to California. Already this *Circle of Fire* film of mine was being booked in America, and we still had to edit it. Manila is eight thousand miles from Los Angeles, a third of the distance around the world. Ship travel would be just too slow.

World's Smallest Volcano

My first evening in Manila was made luminous by one of her best summer sunsets. Early next morning I was out to inspect the city. I strolled across the Jones Bridge over the Pasig River to the modern shopping center. I walked through the walled city, with its St. Augustine Church dating from 1599, and its university, founded two years later—the oldest under the America flag.

Then I dropped in at the Philippine Tourist Bureau and told the young man in charge, Mr. Arturo Zamora, of my need to get color motion pictures of Manila and Luzon. Within an hour he had turned his duties over to an assistant and, for the rest of my stay, he became my guide, as well as the driver of the car I rented.

We saw—and filmed—the fine Luneta park, the Manila Hotel, Dewey Avenue which skirts the bay, the High Commissioner's new residence just being completed, the old fort where the

American flag was first raised, Rizal Stadium, and Taft Avenue leading down to the new legislative buildings.

Taking time to visit a tailor shop and order myself a linen suit, we then headed for Malacañan Palace, former home of the governor general, but now the residence of the new commonwealth president, Manuel Quezon. My guide's uncle is social secretary to the president, so we had no trouble obtaining permission to photograph the beautiful palace on the banks of the Pasig River, with well-kept gardens, lawns, flowers, arbors, and trees.

Next day, a thirty-five mile drive south of Manila took us to Taal Lake, a great irregular body of water, with an island volcano rearing out of its center. It is said to be the smallest volcano in the world. In Java I had explored some of the world's largest burning mountains. Now I wanted to visit the smallest. The whole area made good pictures.

Driving back to Manila, I explained to my guide the nature of my *Circle of Fire* documentary, with its literal and figurative connotations.

"I've been in volcanic regions almost this entire trip," I explained, "All the way from Japan to Java. And now your Philippines have some of the most explosive fire-pots of all."

We fell into a discussion of the other kind of explosion which was building up beneath the surface, ready to erupt at any time.

Young Zamora was well-informed, from a well-educated family. We touched on the matter of Philippine independence.

"We Filipinos want it, yes; but really, we are not quite ready for it yet."

Almost as an afterthought, he added: "Probably Japan will have this whole country inside of ten years."

That night my linen suit was ready at the tailor shop. I needed it desperately, for the humidity was high and the temperature even higher. Even with the lighter attire I became soaked with perspiration. Ten minutes after getting back to the Y.M.C.A. a deluge of rain poured down upon Manila which seemed to fill the whole world with pounding waves of water.

Baguio, in the mountains nearly a mile high, is Manila's resort city, named for the aromatic pines which form its setting.

Next morning, as we started a two-day trip there, our road for a ways skirted the Lingayen Gulf. (Without in any way realizing the significance of what I was accomplishing, I made motion picture studies of the spot which—several years in the future—would become historic. As General Douglas MacArthur had escaped the

Philippines just before its capture by Japan, he had said: "I shall return." When the American and allied forces finally started repossessing all the islands, extending into the South Pacific, which the Japanese had seized, MacArthur had waded ashore at Lingayen Gulf. He had returned!)

More interesting to me than the resort city of Baguio was an Igorot village, not too far distant from it. Baguio itself was distinctly non-Filipino. Of course, the Igorot village was not typical, either. The Philippine Islands are a heterogeneous group.

Our Baguio hotel was overflowing with the British women and children refugees, evacuated from Hong Kong. I had had to quit filming because of another torrent of rain and, after dinner, going into the hotel's lounge, I found it filled with eight or ten refugee mothers, and more than twice as many children, gathered about the fireplace, trying to amuse themselves.

Somehow, I had always thought of refugees in terms of such persons as those Chinese who, in our ship's steerage, were fleeing their Dutch East Indies homes to seek precarious safety in their beleaguered China. But these women and children were British—English speaking middle class whites such as myself. All races, it seems, can be upset by the stalking giant of war.

The mothers were wondering, wistfully, where they would go next, for Baguio was only a temporary refuge. Would it be Australia? The British Isles? Canada? And would their husbands, still in Hong Kong, be able to join them?

When I was in Hong Kong I had come to the conclusion that, left to itself, it was as susceptible to attack and capture as a fort built by boys at play. The large natural harbor was strung with a chain of mines and two ships, steam always up, were ready to pull the mine chain completely across the entrance on a moment's notice.

The fire in the hearth of the hotel lounge felt good, in contrast to the wind and storm outside. But the fires of war were threatening ominously day by day. They were casting their heat even up to the resort city of Baguio.

My Y.M.C.A. acquaintance—the Pan American clerk—had helped me successfully in getting passage on the Honolulu Clipper for Hawaii.

I thanked him for this but I did not fully realize, until years later, the historic significance of this journey he had arranged for me. In crossing the Pacific on one of the China Clippers I would be participating in an important chapter of early aviation history. These great flying boats, which took off and "landed" on water

rather than land, were making the first passenger flights over any ocean. With the start of World War II such flights would cease. By that war's end, long-range land planes would have taken over. I was at the right place at the right time, enabling me to cross the Pacific on one of the pioneering China Clippers.

On my last night in Manila I was treated to the most photogenic sunset of my entire circuit of the Pacific. Since I would be arising at 2:30 A.M. I retired early—about 9:30. But in a warm and humid room, under the mosquito-netting tent erected over my bed, and with thoughts of my reunion with Helen and our children, I had probably the most restless sleep of my trip. But this didn't really matter.

In the dim light of early dawn the Honolulu Clipper lifted off from Manila Bay and I was homeward bound. While over Luzon on our first day's journey to the American island possession of Guam, great mountains appeared below—high mountains, with grand yet threatening volcanic peaks lifting their heads skyward. The symbolism of our *Circle of Fire* film, encompassing all those war torn or war threatened lands through which my camera and I had made our precarious way—that symbolism was reaching up from these Philippine mountains, almost scraping the belly of the plane.

Now that my trip was nearly over, the thought of what might happen in this volcanic circle of turmoil about which I'd journeyed, almost frightened me. This Pacific—the word means "peace"—was threatening to belie its name.

CHAPTER 18

Guam, Wake, and Midway

Guam, Wake, Midway. We would be stopping at those three islands, two of them no larger than flyspecks in the 6500 mile sheet of salt water which lay between us and Hawaii.

This clipper was not like ordinary passenger planes. We had no assigned seats but were free to sit in the lounge, which was as large as a living room, or in comfortable chairs in the main cabin. Berths were available for those who wanted a nap. The meals, served on tables in the lounge, were elaborate and delicious. The difficulty in obtaining reservations on these clippers, I learned, was not related to space in the planes themselves, but to available sleeping facilities for the overnight stops at Wake and Midway.

Normally I hug the windows, to observe any possible sights down below. But the endless ocean—from two miles up—was a placid desert, while the plane's library had a stack of American magazines and newspapers, some of which were scarcely a week old. Providentially, some of the news magazines were older. For the first time in nearly a quarter of a year—one of the most crucial periods in world history—I caught up on news of the German blitzkrieg across the Low Countries, the fall of France, the evacuation of Dunkirk, and even of the Roosevelt-Wilke election campaign in the United States.

Much of my news, for months, had come in one paragraph bulletins which were printed—sometimes in a foreign language—from the wireless dispatches received by the ships on which I traveled.

It was back to a window seat just in time to see our approach to Guam and a great churning of water as we "landed" off Sumay Point. A launch transported us to shore where dinner awaited us at Pan American's hotel.

Guam's capital, Agaña, lay seven or eight miles across the island and, even though darkness had come, I persuaded one of the clipper passengers—a middle-aged woman—to share the cost of a

taxi for an exploratory trip around Guam. Next day I learned that my share-the-ride acquaintance was a Mrs. Archibald, daughter of the man who, along with John D. Rockefeller, Sr., founded Standard Oil Company. She had once sponsored a National Geographic Society expedition in New Guinea, and had participated in part of it.

A nearly full moon came up just as our taxi trip started and we had a strange, highly-satisfying introduction to an island paradise. It was nearly midnight when I tiptoed into my hotel room where my Pan American roommate, Mr. E. W. Hopper, manager of Manila's Insular Sugar Company, was sound asleep.

The 4:00 A.M. breakfast call came all too soon and long before daylight we had assembled at the pier. Seven more passengers were to join us, and a dozen people, mostly young American wives of naval and marine officers, were down to see them off. Eight native girls, dressed in hula skirts, danced rhythmically to the strains of guitars. It was before daylight; the moon hung low in the west and the morning star gleamed like a brilliant lantern above the low mountain to the east. Those going away were garlanded with leis. We boarded our launch and pushed off into the darkness for the plane. There were good-byes, as soft music floated across the water. Dawn was just creeping in as we reached the clipper; off over the headland a rosy glow of rising sun touched the clouds banked above. Light crept up fast now. For several miles our great clipper taxied close to the coral studded beach, then swung around and started back on our takeoff. It was warm, cloudy, and the atmosphere was heavy. For eighty seconds we rushed and roared through the water, rising a fraction, then settling back. Almost at the end of the bay we were finally airborne. Later I was told that because of the heavy atmosphere we had barely made it. One time a plane had to make five attempts before getting away and on one occasion a clipper had to wait for better weather the following day.

Circling the harbor we started out over the whole island of Guam itself. We were low. I saw Agaña with its tin-roofed governor's palace. The island extended for perhaps twenty miles farther. There were grand views of the shore with the coral reef and the brilliant colors of the coral beneath the water. Thick clumps of coco palms covered much of the land, with clean open spaces between. Someday I'd like to return to Guam.

Our passenger contingent—now numbering forty-five—included some of the more influential business executives and government officials of the Far East, and the day's flight to Wake did not provide enough time to become acquainted with all of them and

hear their stories and concerns about the threats hurtling like cannonballs toward this part of the world.

There was a Chinese general on a diplomatic mission to Washington, a Dutch delegation from Java on similar business to our state department, and a code and cipher expert just returning from Chungking.

One passenger was on a mission completely unrelated to international tensions. Dr. Ross was transporting a rare and valuable plant from the Philippines to Hawaii. In Manila, I had seen him carrying and guarding it carefully and, just as our clipper began making ready for its glide into the harbor at Wake, Dr. Ross showed me a copy of the cablegram in which he had notified Honolulu parties of the plant's arrival.

All of Wake's three islands are no larger than a dozen city blocks. They are twelve hundred miles from any other islands in the Pacific but, being approximately half way between Guam and Midway, they are vital for transpacific flights. The whole group was not visible until we had nearly reached the water; then the coral lagoon could be seen as we glided down. Just offshore, the surrounding ocean was essentially bottomless; these tiny specks of land are the tops of steep mountains. Ours was a perfect splash down. We taxied up to the pier on shore and saw anchored a few feet from us our sister ship, the California Clipper. She had come in from the other direction with fourteen passengers. This trip seems to be an incubator for superlatives. The meeting of these two planes will increase Wake's population tonight to the greatest figure she has ever had. All crews have to sleep on board and the passengers must be crowded three to a room.

From the pier we walked through an avenue of trees to the hotel close at hand. It was a beautiful afternoon and a couple of hours before nightfall, but the first thing I learned was that picture taking of any kind was strictly "out." This was final. For a nature lover, however, Wake is a tiny box of jewels. This I discovered on a walk about the principal island. It is only a quarter of a mile wide by a mile long.

The three islands of the Wake group are separated by narrow channels, with a coral reef connecting the ends to make a perfect water enclosure. It is no harbor for ships, for there is no entrance, but for a seaplane it is ideal. Its waters were crystal clear, alive with multicolored fish.

A Walk across Wake

Starting my walk, I met one of the clipper's officers, going out to inspect the radio station and direction finder. He invited me along. We cut across the island and found them, enclosed in unlocked buildings. The instruments were intricate. "We are under Guam control the first half of the journey," he explained to me carefully, "then we switch to Wake. Our ship follows the direction finder in landing."

After making these inspections we started out exploring, for he had never walked around the island either. In four minutes we had crossed it, and were soon on the coral beach. I haven't had much experience with coral beaches and this was the most interesting stretch I had ever visited. He had spent several months on other Pacific isles, helping to install radio stations preparatory to the clipper's New Zealand flights, so was well acquainted with the various marvels we found. Loose pieces of coral and shells almost completely covered the shore. But mixed in amongst the coral wonders were hundreds of hermit crabs. They are born without shells but soon acquire discarded ones to fit them. As they grow they discard those for larger ones. We saw them of every size from that of a dime up to that of a baseball. They were brilliant red and could make good speed across the sand. As we picked some up they objected strenuously. But I carried one with me, to exhibit to Dr. Ross.

The beach, on the island's outer side, was almost solid coral. Coming to the channel separating our island from the next one, we circled and were soon on the lagoon side. Here was sandy beach which we followed back to the hotel. Our tour, including the radio stations, the coral, and the crabs, had taken just over an hour. Wake is a tiny pinpoint in the world's greatest ocean. That planes can zero in on it unerringly speaks well for aerial navigation.

At dinner I ate with three of the officials of the Wake port, including the airport manager who is in charge of the island, and from them learned much of interest. Wake is at the end of the world's longest milk route, all fresh milk as well as vegetables being brought by clipper from Honolulu. Most of the staples, including frozen meat, eggs, etc., come in by steamer twice a year.

"It is cheaper to import eggs than to import chicken feed and care for the chickens," the manager explained.

But there are several hens on the island as an experiment, and a few vegetables are grown in a little garden. The place boasts one

car and about two miles of travelable road or trail. All water has to be distilled from the sea.

Some of us had a short walk along the beach by moonlight, perfect in all its beauty, and then early to bed.

Next day, traveling on, there was the crossing of the International Date Line, where tomorrow becomes today. There was a moon-sprinkled night at Midway, following a before-dinner "stage show" of gooney birds. I learned that top soil for this island had to be imported from Hawaii. Only those trees are planted which can grow in sand.

Midway had some of the same interesting aspects as Wake, although she boasted two automobiles instead of one. One day, so I was told, those two cars had a head-on collision. Traffic hazards even on a two-car Pacific Island.

Again, before daylight, we took off from Midway. More exchange of experiences with passengers and crew. More reading. Then below, one after another of the tiny islands of the Hawaiian chain began appearing, some of them coral reefs, some volcanic. The city limits of Honolulu extended out more than a thousand miles to meet us. Soon we were gliding above Kauai, and then over Oahu. Our Honolulu Clipper settled majestically down onto the surface of Pearl Harbor and a launch carried us ashore.

There, back of a set of guard ropes, and waving to me frantically, were Helen and our two young daughters. Frantically—and joyously—I waved in return. Of course it would probably be an hour before I could clear customs and inspections and be in their arms. So I thought.

Our two-and-a-half-year-old Adrienne, with a huge lei in her hands, pulled loose from Helen and ducked under the ropes.

"Daddy, Daddy." In an instant she was out to me, had the lei over my head, and her arms around my neck.

It was only for an instant. A furious inspector jerked her loose. Helen, with Barbara, rushed out to retrieve her and I had a chance to give them huge embraces before the inspector angrily herded them back beyond the ropes.

In the confusion, I had dropped the cork helmet I was wearing and Adrienne had joyfully picked it up. Seeing this, the inspector became even more upset.

"A hat like that could conceal contraband," he muttered, as he had jerked it from her.

In half an hour I was embracing my whole family legally and unmolested—without benefit of inspectors.

You Don't Know Hawaii

Among the first things we filmed in Hawaii were Pearl Harbor and the defenses at Hickam Field and Schofield Barracks. We felt these would be vital if war erupted in the Pacific, so exerted considerable efforts to obtain official permits which would make the adequate coverage of these places possible.

We also decided to do a complete motion picture on the peaceful aspects of Hawaii and in this the girls played an important and interesting part. It would be called *You Don't Know Hawaii*.

We journeyed out to the Blowhole, which soaked us with its spray as we filmed it; we discovered a dozen rainbows—some even two at a time—in the rain-drenched beauty of Manoa Valley and we found floral magic as we filmed orchids and leis and night blooming cereus; we spent sunny days and moonlit evenings on Waikiki's sandy beach.

The girls stayed with close friends in Honolulu as Helen and I flew down to the big island—Hawaii—and made an automobile circuit around it. Our camera drank in scenes of half a dozen beautiful waterfalls, the sugar cane harvest and—soon to become history—cattle being loaded by rope and derrick onto ships off shore at the Parker Ranch, second largest cattle ranch on American soil.

As a culmination of my *Circle of Fire* sequences we also filmed Hawaii's active volcanoes.

Back to Honolulu. A crisis had developed. War scares were prompting an exodus from the Pacific area. All planes, clippers, and ocean steamers were booked solid. No chance for passage. Our only hope was to be put on a waiting list.

We waited, and while doing so made the trip around Oahu in a rented car. We waited some more, and took another such trip. More waiting, more trips. Probably a dozen times we circled the island.

There was time to get my *Circle of Fire* film footage developed at the Eastman lab in Honolulu, and from Eastman we obtained use of a projection room. Scene after scene, episode after episode, drama after drama of Asian or East Indies life came alive on the screen. Helen gasped for breath as the literal and figurative volcanic portrayal unwound from the reels of film. I shivered a bit myself, as the scenes stirred memories. Even the footage which had been nearly melted by equatorial heat was well-nigh perfect. This was more than I had dared hope for. Hawaii has been called the paradise of the Pacific. We were in seventh heaven as we left the Eastman lab.

For several weeks we waited for some form of passage to the mainland. There were opportunities to take long afternoons of swimming, wading, and playing in the sand at Waikiki Beach. Barbara and Adrienne loved it. They played with the Hawaiian youngsters. We explored floral gardens and museums. Barbara's great love was Manoa Valley, with its frequent rainbows. We went there often, and tried to get to the end of some of those colorful areas. Our enforced weeks of waiting gave us opportunities to relax together as we had never done before.

Then, quite suddenly, due to a cancellation, a four-berth cabin on a Matson Liner for Los Angeles became available—if we could be on board in two hours. We had been packed for weeks. Dispatching a cable to friends at home, by evening we were waving farewell to Waikiki and Diamond Head. Five days later three carloads of our closest friends met us at Los Angeles Harbor.

That night I began wading through stacks of letters which my part-time secretary had arranged on my desk. Dozens of them contained inquiries about bookings for *Circle of Fire,* others contained signed contracts for such showings.

Next day Helen started editing the film. Our first showing, a few weeks later, was in the thousand seat Merton E. Hill auditorium of Chaffey Junior College, in our home town. The house was packed. We received a standing ovation.

Circle of Fire had been launched.

*Upper: One of the historic CHINA CLIPPER ships carried Line to Guam,
Wake, Midway, and Hawaii.
Lower: Barbara in a Hawaiian pineapple field.*

605 Passengers Arrive From Coast on Mariposa

Vacationists, returning residents and businessmen headed the 605 passengers arriving on the Mariposa this morning. The ship will return to San Francisco at 5 this afternoon. She docked at Pier 11 at 9:15 a. m., with 69 returning residents aboard. She carried 237 bags of mail.

One passenger who was "praying that the volcano will erupt" is Mrs. Francis R. Line, traveling with her daughters, Adrienne, 3, and Barbara, 7. They are here to meet Mr. Line, a lecturer, who is expected to return aboard the clipper from Manila the second week of August.

Mrs. Line

Mr. Line is making pictures of Shanghai, Japan, Singapore and the Dutch East Indies. He was making pictures of resorts in Finland when Russia invaded that country and made a pictorial record of the invasion.

Mr. Line took up camera work as a hobby a few years ago and has since made it his profession.

Mrs. Line, whose home is in Ontario, Calif., says this is her first trip to Hawaii and that she is hoping they will be able to make pictures of the volcano if it becomes active.

Mariposa Arrivals

Passengers who arrived on the Mariposa this morning were:

A

H. Aaron, George Archer. Mrs. Harry Alexander, Mrs. C. G. Alling, Thomas Ames, Miss Geraldine Anderson, John Anderson, Mrs. Thelma Antaya, Mrs. Frances Arias, Mr. and Mrs. Ernest C. Arnold, Mr. and Mrs. Earl H. Arthur.

B

Miss Mary Alice Barnes, Mrs. Charles W. Bartlett, Mrs. Leroy Bickel, Mr. and Mrs. G. S. Bilheimer, Miss Mary E. Black, Miss Vivian Borrmann, Mrs. L. A. Bower, Andred I. Bright Jr., Simeon K. Bright, John B. Brown, Miss Eloise C. Brownell, Mrs. Lillian Burgess, Miss Amy T. Butterfield.

Mrs. Jessie H. Backer, Mrs. Milton Bailey, Mrs. John Baird, Miss Florence Baird, Miss Gladys M. Barnhart, Miss Avelyn Beames, Mrs. Frances Bechelman, Mrs. Albert L. Becker, Miss Gail Becker, Nelson Behling, Mrs. Ciena M. Beichler, Mrs. Frank Bernoski, Master Louis Blows, Mrs. M. E. Blows, Miss F. Estelle Bogardus, Miss Frances Bohannon, Miss Barbara Bohannon, Mrs. M. Bolts, David Bourland, Mrs. Andrew Bright Jr., Mrs. Helen Bunting, Stanley W. Burke Jr., Miss Doris M. Burnett, Miss Nell M. Burns, Mrs. Florence M. Butler.

C

Mrs. C. G. Cambron, Rowland Carr, Miss June Carrothers, Capt. Clarence Cobb, USMC; Mrs. Clarence O. Cobb, Frank Cockett, Mrs. Mildred Coe.

Mrs. Louise Campbell, Mrs. George Carbinier, Mrs. E. W. Carlson, Miss Frances Carmichael, Miss Audrey Carson, Donald M. Carson, Robert Carson.

Eckley B. Coxe IV, Mrs. Marcus Clark, Miss Mary Coleman, Mr. Cooper, Mrs. P. S. Creasor, Master Phillip Creasor, L. F. Crofoot, Mrs. Katharine B. Crofoot, Miss Martha J. Currier.

Miss Dot Chappuis, Miss Rosalind H. Chilton, Miss Hazel N. Y. Chong, Wah Jan Chong, John B. Christie, Maynard L. Cobb, Mrs. Thomas F. Coleman,

Adrienne

Barbara

Helen Line and daughters made the headlines in Hawaii.

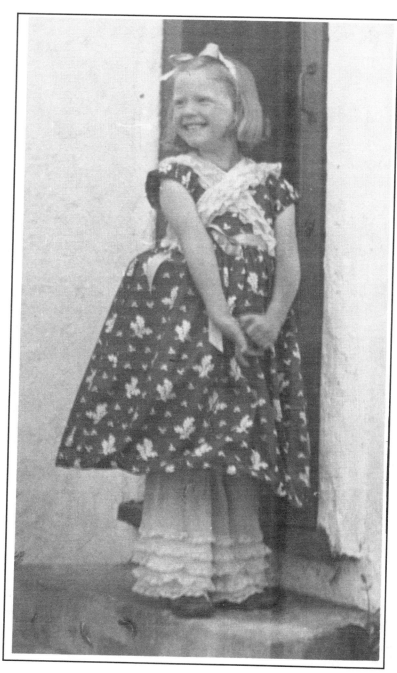

Barbara loved her school play costume.

CHAPTER 19

The Soul of a Traveler

During the late autumn days, following our return from Hawaii, we had as many film showings as we could handle. But, we discovered, Christmas is the season when auditoriums and club stages are "dark," so far as illustrated lectures are concerned. During the December of 1940, Helen and I were eternally thankful that we had few engagements.

Shortly after her eighth birthday—November 28—our daughter Barbara began to feel poorly. On December 6, the diagnosis was acute leukemia. The condition resulted—we discovered much later—from x-ray radiation which the doctor had prescribed for her at birth to correct some ailment at that time.

For nearly six weeks, before and after the Christmas season, we were with Barbara almost constantly. Throwing all other cares aside we read together, played games, took pictures, and celebrated a Christmas, a New Years, and her daddy's and grandpa's birthdays.

Most of the time Barbara was very happy. But there were periods of extreme trial and suffering. We have never seen any one braver than she. Except for one or two occasions she went through the whole six weeks without a tear. When asked how she was feeling Barbara always answered, "I'm just fine."

Barbara passed away in the wee early morning hours of January 19, 1941—a Sunday. Her last words were, "Where is Adrienne?"

That evening an engagement was scheduled for the showing of our Hawaiian film at the First Congregational Church, in our hometown of Ontario.

"Of course you will want to cancel," the minister phoned us. Helen and I had discussed this prayerfully and thoroughly.

"No," I replied. "That Hawaii film features Barbara and her sister Adrienne. It is a part of their lives. She wouldn't want us to forego showing it now."

As the film was projected that night, Helen and I, to narrate it, sat with a microphone in a room adjacent to the sanctuary, where we could still see the screen.

That showing was hard. But the beautiful memories it evoked, the love for Barbara that it generated with the congregation assembled in the sanctuary—these things mattered a great deal. A freewill offering was taken, the entire amount—we suggested—to be used for youth activities in the church. Instead, the collection, which was sizable, became the nucleus of a special fund. When the church was remodeled several years later a Children's Chapel was built, in memory of Barbara.

Our own church was in neighboring Upland. At the memorial services, both the minister and I spoke. On its editorial page, *The Upland News* printed the tribute that I gave, prefacing it with this introduction by the editor, Vernon Paine.

The Upland News
Established in 1894

Enjoying Today What We Have Today— A Tribute to Barbara

"Too many great occasions are dulled in the belief that many more such joys are coming."

Beauty, joy and thrills are about us daily—if we would only look for them and recognize them. Our daily lives may be clouded with worry, troubles and a yearning for something we might get sometime in the future. Thus, we often times fail to appreciate what we have today and fail to share fully in the joys and blessings of the present.

In recent weeks, several children have been taken away from their families by death. In at least three cases, the parents knew there was no hope for their little ones; that it was only a matter of time until the end.

Francis Line, one of the bereaved fathers, delivered a brief tribute at the memorial service for his little Barbara. This was included in the tribute:

"Too many great occasions are dulled in the belief that many more such joys are coming. This last Christmas of ours was precious beyond anything which had ever been, because it would be the last of its kind."

Other bereaved parents, no doubt, have the same feeling. And now we give the complete text of Mr. Line's tribute:

Soul of a Traveler
By Francis R. Line

Barbara has the soul of a traveler, and her spirit lives today in the lives of hundreds of boys and girls and men and women whom she met in all parts of the world.

Barbara would hate a funeral service as much as do her mother and I. This is not a funeral in any sense of the word, but a happy "bon voyage" for a beautiful little traveler who has lived eight splendid years of adventure and joy and friendship.

We are profoundly thankful for these eight years. To bring a little girl up to her eighth birthday, to lead her into new paths of life, to see the development of her love for music and poetry and beauty—all of these represent the greatest privileges of living.

Barbara loved beauty. The principal profession of our whole family in recent years has been the making of travel motion pictures. Wherever we went we have been in search of fine scenes for filming. As we journeyed by auto along the highways of America, or traveled by train through the fields of foreign scenes, Barbara's eyes were alert every second to the beauty which was unfolding. Each few moments she would cry excitedly: "There's a picture, Daddy!" Her judgment of beauty was good, and when she exclaimed over the charm of a landscape or the vividness of a rural scene, we usually stopped to take it. Some of the finest shots in our pictures have been of Barbara's choosing. Much of her life has been spent in searching out beauty and in exclaiming: "There's a picture, Daddy."

Barbara loved people. When she was two, and again when she was four, she journeyed with us to eastern America. One summer was spent in Boston. Barbara entered eagerly into the life about her. She became the inseparable pal of two little Boston boys who lived next door to our apartment. So eagerly and earnestly did she enter into their lives that for months after returning home she clung to a quaint Boston accent.

During the summer in New England we took her out to Walden

147

Pond to visit the quiet woodland spot where Thoreau lived so closely in touch with nature. She went to the Old Manse—where Emerson lived near the rude bridge in Concord; she became acquainted with the "Orchards"—farm home of Louisa Alcott's "Little Women." She saw the Great Stone Face, and the Maine coast, and the Old Oaken Bucket. And she loved them all.

While Europe was yet peaceful—before the machines of war began to smirch the sky—Barbara traveled with us across the Atlantic. The tulip fields in Holland were like glorious carpets of life; Kew Gardens in London was filling the world with sunshine.

As she traveled across the channel on her first trip to Holland, Barbara became pals with a fine Dutch youth of 22. They became inseparable. He told her about his country; pointed out to her as we neared the coast the dikes and windmills. Throughout Holland she met and played with the Dutch youngsters in the fields. Their play was an unconscious exchange; a seed of internationalism. As they touched her life with beauty, so did she touch theirs. And Barbara lives today in the hearts of these friends of hers across the sea.

There was a nursery school in London; then later, a glorious two months spent at Kittiwake—a children's school on the English south coast near Bexhill. Those two months were perhaps the climax of Barbara's life. The whole glorious English countryside to romp over; excursions to the south coast beaches; most important of all, an individual garden plot which it was her duty to tend each day.

But as always it was the people that counted most. There were sweet little refugee children from Germany and Czechoslovakia. There was an upstanding young boy from India. There were fine little English youngsters. And among this group Barbara was the happy little girl from America. While we were gone, Barbara acted as a mother to her little sister, Adrienne.

Mrs. Silcock, owner of the school, was the loveliest woman whom Barbara ever met. At Kittiwake Barbara's spirit soared high. Again there was beauty to give and to receive. And today Barbara is living in the hearts of these friends of hers across the sea.

Her last big trip was to Hawaii, and we can never forget the joy of our weeks at Waikiki. Swims three times a day in the soft semi-tropic Pacific; excursions to the pineapple fields and through the pineapple factory; grand trips around the island. Best of all, Manoa valley, with rainbows—arcs of promise—hanging constantly above it. This was her favorite spot. But as always, her greatest joy was with the friends she met—little Hawaiian youngsters, or Chinese, or Germans, or American boys and girls.

This past Christmas we spent with Barbara in a Hollywood

apartment where she was taking treatments. It was the most transcendentally beautiful Christmas which any of us has ever spent. Too many great occasions are dulled in the belief that many more such joys are coming. This Christmas of ours was precious beyond anything which had ever been, because it would be the last of its kind.

A window of our Hollywood apartment looked out toward a high hill to the north. Barbara often looked up at that hill and would say: "Mommy, I wish I knew what was on the other side. Can we go up it some day?"

On the morning that we left to bring her home, the rain was falling hard from an overcast sky. Barbara was bundled into the car. "Mommy," she said, "can't we go to the top of the hill now?"

And we went. Following steep, crooked, slippery roads, we wound our way up and around, until we could look out and see what lay on the other side. That yearning of hers came from the soul of a traveler. No greater adventure can there be than to see what lies on the other side.

The fullness of life is not measured in terms of years. There are those who might say that Barbara experienced just eight short years of life. No. Barbara experienced an English spring, a soft Hawaiian summer, a June in the Michigan woods, and an August by blue New Hampshire lakes. Her calendar of time was marked off, not by days, but by experiences. She had gained an appreciation of poetry such as is given to few adults, she was peeping into the mysteries of music, she had learned to read, and was beginning to express her thoughts on paper. And she had friends—international friends—for every day in the year. Her calendar was not of years, but of poems and friends and beauty.

Barbara knew and repeated two prayers. One was a prayer of thanks which she learned during her recent illness. It was simple and beautiful:

"We thank you, dear God, for fun and for friends.

We thank you for music and pictures and stories.

We thank you for people who show us Your Love,

And for work which makes us happy and strong."

The other prayer was one which she learned at Kittiwake in England—a prayer taught to her by Mrs. Silcock. Every night for two years she has repeated it. It has been our prayer, too. Each day during my recent trip in the Orient, I made this prayer a constant part of my thoughts. And this prayer shall forever be our certain assurance that our little daughter Barbara shall be with us always and that her shining spirit shall go on with God forever. This is it:

"Gentle Jesus, meek and mild,
Look upon a little child.
Bless Auntie Silcock and all the little children.
Keep them safe and sound.
Bless Barbara and Adrienne.
Bless Mommy and Daddy, and everybody in the world.
Amen."

Each evening, after saying this prayer, we would kiss Barbara good night and she would always say. "Good night, Mommy. Good night, Daddy. I'll be seeing you in the morning." And we would reply: "Good night, Barbara. We'll be seeing you in the morning, too."

And so we shall.

Barbara had a feeling for good art. She had accompanied us as we visited art galleries in Chicago, New York, Boston, and London, and had thrilled at some of the great paintings we had shown her, just as my own father had pointed out those same paintings to my brother and me when I was a child, such as Millet's *Angeles* and *Gleaners,* and Rosa Bonhur's enormous *Horse Fair.* Helen and I started a Chaffey Community Art Association in her memory and donated a dozen paintings that would become the nucleus of an important permanent collection. There would be an annual purchase prize exhibit.

For several years Helen directed that exhibit and together we scoured the art studios and galleries of California for suitable entries. On my semi-annual lecture trips east I would select paintings from New York galleries to be exhibited in the annual show.

The summer of 1991 heralds the half century mark in which this association has been serving Southern California. Its outreach and activities are expanding constantly, as hundreds of dedicated individuals foster a love of fine art among students and adults. The permanent collection has grown into one of the important art treasures of its kind in the West. Exhibits, lectures, workshops, student art classes, and an annual hanging of the permanent collection, all take place throughout the community but especially in the beautiful Spanish-style Museum of History and Art, now home for the Association.

Helen and I have had our lives enriched by the scores of great artists who have become our lifelong friends—Millard Sheets, Phil Dike, Conrad Buff, Phil Paradise, the Rex Brandts, Emil Kosa, Jr., Jean Goodwin Ames, Anders Aldrin, and many others. Through Anders we met his nephew, Buzz Aldrin, second man to walk on the moon.

Before it was moved to the new art gallery, the painting of Barbara, by Marion Olds, hung in the library of Chaffey College and High School. One girl student told us, "That painting of your daughter, looking down on us through the years, has inspired and permanently affected our lives."

BARBARA *By Marion Olds*

FIRST INVITATIONAL
PURCHASE PRIZE
ART EXHIBIT
CHAFFEY - - ONTARIO, CALIFORNIA

Exhibit catalog of Art Association founded by the Lines in memory of their daughter, Barbara.

THE ART THRILL OF THE WEEK

By the Art Critic—

Arthur Millier

PURCHASE prize art exhibits in public schools have made history in several Southland communities. They have aroused community enthusiasm but their educational value, for students or citizens, often has been low. They have too often swamped a few good paintings in a mass of mediocre ones.

Chaffey Community Art Association, which last Friday opened its first purchase prize exhibit of contemporary American painting in Chaffey Junior College, Ontario, has taken the needed next step. Its showing consists of 55 carefully selected oils and water colors by 10 eastern and 35 California artists. And with few exceptions every artist is represented at his best. In this show Ontarians can see what the better sorts of current painting are like.

Ontarians Francis R. Line and Mrs. Line saw the chance to do this fine thing and organized the Chaffey Community Arts Association, of which Line is president. It grew from 5 to 117 paying members in six months.

The Lines also have presented to the college seven good paintings by Southland artists in memory of their daughter Barbara. Purchase prizes, secured by members' fees, will buy two more pictures from the current show.

The exhibition, hung in the spacious women's gymnasium, is on view free to the public from 10 a.m. to 9 p.m. daily and Sundays through Nov. 2. It is well worth any art lover's time. A. M.

LOS ANGELES TIMES art critic spoke highly of Chaffey Community Art Association's first "Purchase Prize Exhibit."

Along El Camino Real

With Ed Ainsworth

Francis R. Line has come back from the "great Babel" of the Far East with a new colored picture record of what is happening around "The Circle of Fire"—the Pacific Ocean. Francis Line is one of the most distinguished of modern cinematographers. Editors of the National Geographic Magazine, for whom he is going to preview his new motion pictures in Washington in a few days, think he is in the top rank of those few cameramen who know just what to take in a teeming foreign country to get the "feel" of it all for American audiences .

First portion of Ed Ainsworth's column in LOS ANGELES TIMES.

CHAPTER 20

Plaudits from the Geographic

In the first year of its life, *Circle of Fire,* although highly acclaimed wherever shown, was less successful than *Finland Waters* or *Lapland Adventure.* Japan, Java, Singapore, and the Philippines were far away, inaccessible to tourists because of backlash from the European conflict. Wake and Midway had scarcely been heard of by most persons and this even applied to Pearl Harbor.

Ed Ainsworth devoted his full *Los Angeles Times* column, *Along El Camino Real* to our Pacific film, which served as excellent publicity in Southern California.

I had arranged for the New York Feakins Lecture Agency to handle bookings for me in the Midwest and East but they were unsuccessful in obtaining many showings for our new film.

We dealt with the National Geographic Society largely on our own and they decided to present our *Circle of Fire* rather than either of the two which we had personally previewed for them the year before.

After Barbara's passing, it was decided that Helen and I would take Adrienne—not yet old enough for school—and drive east together. In addition to our luggage, two projectors and a large public address system, we carried the heavy reels of our five color motion picture programs in the car.

In my head, I had to carry the commentary for each of these one-hour-twenty-minute films. Sometimes we would present all five of them in as many days, and it required a bit of mental gymnastics to remember correctly every fact and detail. I began to appreciate the skills of concert and opera artists who carry the music and lyrics of half a dozen pieces in their memories.

It was good to have Helen in the audience at Constitution Hall, in Washington. She had never attended one of our shows in an auditorium that large. Despite horrendous weather, the huge hall was packed. Over 3500 people were there. Mason Sutherland and Jack

Rideout, two of Melville Bell Grosvenor's chief lieutenants, told me scores of people in the audience were in high government positions and knew the Pacific area well—generals and admirals, state department executives, ambassadors and personnel from the foreign embassies.

National Geographic programs start precisely on time—not two seconds early or two seconds late. Melville Grosvenor is a rigid disciplinarian and taskmaster. A liveried chauffeur had been sent to transport Helen and me to the hall. The early April weather had—unseasonably—suddenly turned fierce; a snowstorm was biting the air, windblown drifts were two feet high, and streets were slick with ice. We were staying with friends three miles outside Washington. So carefully did the chauffeur have to negotiate his limousine to avoid accidents that we reached the stage door at Constitution Hall just moments before the deadline established by Grosvenor.

I was led at once into my dressing room although I had changed into tuxedo back at our friends. That afternoon I had tried out the podium, the microphone, and the electric signal by which I could make contact with the projectionist.

National Geographic speakers are not introduced; that was another of Grosvenor's innovations, with results both good and bad. The printed program, put in the hands of the audience as they take their seats, gives a sketch of the speaker's life. That is adequate, says Grosvenor.

Sutherland and Rideout, who handle the myriad of details in connection with the program, confided to me that the lack of an introduction is hard; it helps to "break the ice." Rideout told me that some speakers, even seasoned lecturers on occasion, were so frightened at the prospect of walking out on the stage—unintroduced—before that huge and prestigious Constitution Hall audience, that they almost froze. Several times, so he said, he and Sutherland had to open the door and physically push the speaker onto the stage.

It was one minute until 8:30 P.M. Sutherland had a watch in his hand; Rideout had the doorknob in his. 8:30. Rideout opened the door. I didn't need a push; stage fright is one thing which has never concerned me, and an audience of thousands is ten times easier to address than a small gathering of thirty or forty. This audience began to applaud—deafeningly so, it seemed to me.

Walking across the huge stage, I stepped up onto the temporary low stool which had been placed behind the podium.

"Good evening, ladies and gentlemen of the National Geographic Society," I began. Those were the words with which—again according to Melville Grosvenor's directions—every speaker must commence.

With that salutation out of the way, I forgot Grosvenor and was on my own. "This afternoon I came here to try out this podium and I couldn't see over it," I began. "So the custodian and I rummaged around in the basement until we found a small stool. That's what I'm standing on now."

The audience broke into hearty applause and laughter.

"Those of you who are historically minded," I continued, "may be interested to know that your present speaker is just five feet, two inches tall. That is exactly the same height as was Napoleon Bonaparte."

Again, 7000 hands applauded, and 3500 throats emitted spontaneous laughter.

"And they do say," I added, "that Napoleon was good too."

The applause became as wild as the storm outside, which all these people had braved to get here. Applause is psychologically important to anyone who is standing on a stage, whether to speak, or sing, or perform. Audiences, if they only realized it, can do as much to make an evening successful as the person up front.

This audience apparently realized that fact. When I signaled the projectionist far up in his booth, and the huge color pictures—twenty-four feet wide—started flowing onto the screen, the audience began applauding every minute or so, as some particularly fine scene appeared, or even one which had cost me enormous effort to obtain. The entire one-hour-twenty-minute presentation was punctuated with spontaneous handclapping. A skilled National Geographic secretary (this was long before the age of recording tapes) took down in shorthand every word I said, indicating each time there was either laughter, applause, or both. A typed copy of this, given to us by Melville Grosvenor, became extremely valuable, since it enabled us to study the exact parts of the film and commentary which brought significant audience reaction.

As soon as the program was over, dozens of those from the audience, including Helen, streamed backstage to my dressing room. My great regret was that so many crowded around me to talk I could not even catch the names of all who were there. More than once I heard the words "congressman" and "ambassador."

One person, however, made all the others stand back—Gilbert Grosvenor, venerable editor of the Geographic, and its ruling voice. He introduced me to his wife, who was the daughter of

157

Alexander Graham Bell, inventor of the telephone. As their special guest, the Grosvenors had invited a woman whose husband had once been governor general of the Philippines, and who knew the whole Pacific area well. Mrs. Grosvenor introduced me to her— Mrs. William Howard Taft. She was a gracious lady. I had even shown Manila's Taft Avenue in my motion picture; she spared no words in telling me how much our film had meant to her—carrying her memories back to scenes she had loved, before the time that her husband became president of the United States.

On behalf of The National Geographic Society, Melville Bell Grosvenor wrote me a lauditory letter praising my showing of *Circle of Fire*.

A Date with Destiny

December 7, 1941. We had been showing our Pacific film for over a year before that December 7th date when Japan made its sneak attack on Pearl Harbor, bringing America into World War II. In that instant, *Circle of Fire* became an entirely new program, in the truest sense of the word. No longer did the Pacific area remain abstract. No longer did people, as formerly, have only confused ideas of what and where Pearl Harbor was. The terrible eruption had taken place. The figurative volcanoes were belching steam. *Circle of Fire* came alive.

Our engagement calendar also came to life as it never had before. The day after the Pearl Harbor attack, audiences across the land wanted to see our film, in order to get some idea of what the potential war area was all about. As the Japanese Pacific invasion swept southward, through the Philippines, Hong Kong, Singapore, the East Indies, those same audiences, plus dozens more, wanted to view the film again. As American troops finally began gaining the upper hand, pushing the Japanese back through this same chain of islands and outposts, the audiences needed to observe it once more. Wives, parents, children and friends of servicemen came up to me after the programs to express their thanks at being able to see pictures of the places where their loved ones were serving.

With each new phase of the Pacific conflict, *Circle of Fire* became a new film. When the war was over and the boys came home, *they* wanted to get a look at some of the places where they had been. Two, three, four, and even five times, I gave repeat showings—season after season—in halls across the land. It became difficult to find time for *new* engagements.

Then there was the military. George Pierrot of the Detroit World Adventure Series, with my permission, had arranged a courtesy showing for, as he said, "some army people" in Detroit. The showing was to be in a spacious hotel lounge. Upon my arrival there, I found the place littered with generals and admirals. In those days America's War Department had no satisfactory films, either motion pictures or stills, of many of those places included in our documentary, which were so important in war strategy planning. Later, I presented the film before other groups of the military and eventually furnished them with a copy of its strategic portions, so they could study it at leisure.

Most gratifying of all my *Circle of Fire* showings—perhaps next only to the National Geographic appearance—was the film's reception at Pierrot's World Adventure Series in Detroit, the world's largest, in point of national reputation and the number of noted speakers and illustrated lecture personalities presented each year. The film definitely sparked enormous spontaneous audience reaction. Although I didn't know it at the time, that showing resulted in something even more significant. Each year Pierrot conducts an audience poll, asking all his regular ticket subscribers to list the five programs, in order of preference, that they considered best, of the twenty presented throughout that season. *Circle of Fire,* in competition with them all, took first place.

This film on the Pacific became my passport to every major illustrated lecture course in America, with presentations at Town Hall, Columbia University, the Brooklyn Institute of Arts and the American Museum of Natural History in New York City, Carnegie Hall in Pittsburgh, Philadelphia Geographic Society, the Taft Theater in Cincinnati, Orchestra Hall and the Field Museum in Chicago, Kiel Auditorium in St. Louis, the Denver Museum of Natural History, Pasadena's Civic Auditorium, Los Angeles's Ebell Theater, Shrine Auditorium, Royce Hall—and hundreds of places in between.

The timeliness of *Circle of Fire* had been slow to assert itself, but that timeliness was also slow to wear off; it remained a vigorous part of our lecture repertoire for nearly a decade. Thinking back on my bittersweet journey through all those countries of volcanic upheaval, I was glad that my camera and I had made it.

"This is Your America"

is a Cameraman's Report to the Nation

America is at war today, not alone with guns but with every aspect of her national life. Here is the first film to give full portrayal to this all-out effort which our country is making. It is a war film without the horrors of war. It shows CONstruction, not DEstruction. Much of it was made with special War Department permits; it contains defense scenes never before filmed in color. It is as vital as America itself.

FOOD Line spent the spring of 1943 in Arizona, filming the great roundups of beef cattle. He portrays young boys and girls leaving school and "riding the range" to help produce the nation's meat supply. Also great wheat combines on the western plains, full granaries, bulging elevators, are pictured here.

TIMBER Men topping trees at dizzy heights. Great Douglas firs crashing earthward. Lumbermen shown in their leisure hours after work. From lumber comes plywood for planes. It's vital. You see it made; you see its uses. It may largely replace aluminum, which is scarce.

MINING Tungsten from Idaho; lead from the Coeur d' Alenes, copper from Arizona. Line has worked in mines himself; he knows the life. This film shows a colorful phase of America which is of life-and-death importance to our war effort. Without minerals we lose.

INDIANS The film portrays the unusual patriotism of the Southwest Indians and shows the important contribution which these redskinned brothers of ours are making to the war effort. This is one of the most colorful and dramatic sections of the entire picture. There are also sections revealing much of America's folk lore and folk music and these portions have special musical accompaniments.

DETROIT Detroit's conversion to War is symbolic of the nation. It is an American epic. This film pictures it. You see jeeps turned out by Ford; planes manufactured on the assembly lines of Willow Run. The great factories and the War Department both co-operated with Line in the making of this Detroit sequence.

Front page of Line's brochure for color motion picture, THIS IS YOUR AMERICA.

CHAPTER 21

This is Your America

On the thousands of miles of train travel, back and forth and up and down across America which it was necessary for me to make each year to arrive at my illustrated lecture engagements, I often carried motion picture camera and tripod—in addition to all the required projection paraphernalia. We were beginning the process of filming episodes for a new program, and I would obtain parts of it while traveling to lecture engagements.

The nation was at war. Factory workers across the land were bending every effort toward production of materials with which to help win that war. Farmers were producing foods and grains in record quantities, not alone for American consumption, but for our allies and our servicemen overseas.

Unsung men and women, in out-of-the-way and little-known areas of the country, were working heroically at essential jobs. The native American Indians on the western reservations were helping; the Navajos, with their indecipherable language, were becoming valuable members of the Signal Corps.

Some of the pictorial and historic spots of the nation were taking on new significance—or at least they could, if properly heralded. The Lincoln Memorial in Washington, and what its deep meaning was to the country; the carved faces of the presidents on Mt. Rushmore, in South Dakota; the folklore and folk music of isolated pockets of our population, tucked away where few knew they existed.

We decided to try to film all of that, in a production which we would call *This Is Your America.*

Filming in wartime is hard, hard, hard—in ways we'd never even dreamed of. At first, Helen and I did some traveling by car to obtain shots we needed. In the remote and isolated town of Jerome, Arizona we wanted to film some of the mines that had come back into operation because of war needs. Jerome had been a ghost town until new life had been breathed into these mines. For an

establishing shot I set up my tripod at the edge of the main street, to obtain an overall view.

"Stop. Wait. What are you doing there?"

It was the town's only police officer.

"What are you up to?" the angry voice continued. "Don't you know we're at war? This city is strategic. Photography is forbidden."

Helen and I were both put under technical arrest. Providently, I had a wallet full of special recommendations and we were soon released—though rather reluctantly—on the part of the police chief. This had perhaps been the only "spy" case in his entire career.

Up in the remote High Sierra we were filming scenes of a mountain river, roaring and tumbling down through a great stand of timber. Some of that timber would be cut for war use.

"Stop. What are you doing?" The voice we heard calling out was almost the echo of that Jerome officer's raspy warning.

A patrolman, apparently following us, had seen our car stop. As I set up my tripod, he accosted us. It seems that farther down that roaring mountain stream a dam was converting the plunging waters into electric power. Power for the war. Pictures were forbidden.

It had never even remotely occurred to us that the former ghost town of Jerome, Arizona, or a few wilderness scenes in California's High Sierra, would be off limits for photography. Where there was any question at all about restrictions, we always spared no effort to get official permits.

In order to film bomber production at the Willow Run plant near Detroit, I spent months seeking permission from the War Department. (Their name was later changed to the Department of Defense.) The plant manager grinned a bit wistfully when, camera and tripod in hand, I entered the factory for the filming and handed him the permit.

"Look's like we don't have any say about what happens in our own plant," he complained. "Everything is up to Washington. But go ahead," he added. "If you don't interrupt the workers, it's OK by me."

Those workers were important, especially some of the petite women who had been hired because they were small enough to crawl, with their riveting machines, into the cramped tail sections of the planes.

Some of the largest bombers were constructed of plywood, made from Washington State Douglas firs.

The Willow Run permit worked wonders. With similar documents issued by the War Department, I gathered footage of other vital industrial production, in Wichita, Kansas and at the Ford Motor Company River Rouge plant.

In pursuit of other important materials for our new film, Helen and I went to the Intertribal Indian ceremonies in Gallup, New Mexico, traveling there by train. I hitchhiked (from a distant lecture date) to Mt. Rushmore, in South Dakota. We filmed California's central valley fruit pickers, and migrants picking and hauling tons of tomatoes and other produce in the Coachella Valley near the Salton Sea.

In the grain belt of the Midwest I depicted the harvesting, the storage, and the shipping of wheat—golden scenes which would eventually constitute the opening sequence of this new film production. In my commentary accompanying these scenes, as I lectured with them later, I made statements and prophecies which foretold the Marshall Plan:

"After this war is won—and we may as well become used to the idea now—America must feed the world. The products of our factories are today going to every continent of the globe to help put down tyranny. The results of that tyranny have been, and will be, starvation for millions.

"America's grain bins must not only be filled but they must stay full. The armies of the allied nations will need millions of bushels of wheat in this war. When the war is over we must have an immediate supply on hand to rush to a dozen nations where people are already starving. The social and economic safety of the world is dependent on it. America is the only country which can do it. Furthermore, we must broadcast this fact to the world now. The hungry of France, the starving of Greece and Yugoslavia, knowing that we intend not only to liberate them, but to feed them after the war as well, will be all the more ready to rise against their oppressors when the first sign of help arrives. Full granaries in America today, through proper use of propaganda, can be actual and effective weapons to help us win the war."

"Give Me Men to Match My Mountains"

Making sweeping reference to millions of bushels of wheat is dealing in abstractions. To personalize my message, I went out into the field of J.J. Ridder, on his farm a few miles from Wichita, Kansas. His was not a large spread, and he had none of the huge combines or threshers which I had photographed elsewhere. But he had

163

six sturdy sons and daughters, ranging in age from six to sixteen. With the father as the kindly generalissimo of this family army, the harvest was accomplished.

I visited the tiny mining town of Burke, Idaho, high in the Coeur d'Alenes, where—between high school and college—my brother and I had worked for three months mining silver and lead, far below ground, during our year's hiking trip to the forty-eight states of the Union. Mining was important in the war effort.

Across the facade of a government office building next to California's capitol building in Sacramento is inscribed in stone the motto: "Give me men to match my mountains." We filmed that statement, which became an introduction to the grandeur of the High Sierra, Yosemite, and the Sequoias.

We tried to be pragmatic, and included sequences of "What's wrong with America"—a cheapening of our nation's beauty through misplaced billboards and gaudy advertising, needless slaughter on the highways, unwarranted strife between management and labor, pockets of poverty and poor housing.

Journeying to Washington state, I captured in my camera the scenic story of America's lumber industry. Weeks had been required to obtain permits and clearances but, with that behind me, cooperation was the watchword as I visited the great timber operation of the Tacoma and St. Paul Lumber Company, on the foothill slopes of Mt. Rainier.

Ninety-five miles of their private railroads penetrate to all sections of their timber holdings and a speeder was made available to me for the rail trip into the camps.

Later, I transferred to an even tinier speeder which was handier for getting about in a hurry.

Most dramatic scene of all—and one of the highlights of the finished film—was high-climber Hewitt's ascent of a Douglas fir, as high as a twenty-story building, to cut off the top so that the tree might be used as a spar for further lumber operations. I held my breath as I filmed it, and the audiences to whom I showed it held theirs as they watched Hewitt at his precarious task.

With the vital but hazardous activities of the lumber operations transferred to film, I needed a change of pace. It came with the termination of the day's labors.

At suppertime, back in the camp, several hundred hardy lumbermen filed into the huge tin-roofed mess hall and filled every seat on the wood benches at the twenty long tables, which were smothered with bowls and dishes of food, and pots and pitchers of coffee and milk.

As each man sat down he started helping himself from the bowl nearest him, and reaching for those farther away. Those men were hungry! They ate! At the rate they were going I feared there would not be time to obtain adequate shots of the scene.

Trying to get good angles from the end of a table, I realized I was not tall enough. Unceremoniously pushing several bowls and dishes aside on the tabletop itself, I stepped up onto the cleared space, set up my tripod in the midst of their eating, and began grinding the film through the camera.

The men paid me almost no heed whatever. To have done so would have meant they'd have missed part of their supper. Those men were *really* hungry! They *really* ate! It made a sparkling human interest sequence.

On some of these American safaris, particularly if we would travel by train, Helen accompanied me. On one such occasion, an event occurred which helped greatly to overcome a fear which she had always had of high places. When we had ascended the Eifel Tower in Paris she had trembled with concern, at the top. When we had ascended a series of narrow stairs to explore the intricate details of architecture on the expansive roof of the Milan Cathedral in Italy, she had had touches of fear.

It was understandable, then, that she said "No" when I asked if she wanted to ride with me out over the whirlpool rapids, just below Niagara Falls. A large metal "cage" transported passengers on suspended cables out over the rapids, the metal straps forming the floor of the conveyance were separated from each other enough that I could project the lens of my camera straight down between them and get excellent shots of the foaming river below.

I went up to pay my dollar. The day was cold and windy; no other passengers were on board.

"Isn't the lady going?" asked the ticket-taker. Helen answered firmly in the negative.

For a moment the man hesitated. Then: "She can go along for the same price," he added.

Helen's thriftiness got the upper hand. She went with me. So interested was she in helping me obtain those unusual shots of the tumbling water down below, she did not have time to be afraid.

Ever since, she has been less concerned about heights.

Sheep Help Win the War

Helen accompanied me to Phoenix, Arizona for some lecture engagements, and we visited her cousin in nearby Chandler. The

annual sheep drive was just beginning—moving the herds from the unbearable summer heat of the Salt River Valley up to cool summer pasture in northern mountains. Those sheep meant mutton and wool for America's war effort. Helen's cousin, owner of two of the herds, described to us the dangers and grueling hardships of the forty-day trek.

"That Heber-Reno sheep trail is really wicked," he said. "Those sheep go through some of the wildest country in America."

"Yes," agreed his wife, "and those Mexican herders are heroes in the truest sense."

Helen and I exchanged deep glances. It would be a week before my next lecture, back in California. We spent six days chronicling some of the hazards—and also the rare desert beauty—of the first portions of the Arizona sheep trek.

To get the sheep pictures, we walked. When it was necessary, back home, to drive our car for filming, we employed every possible effort to conserve scarce gasoline. Someone, however, reported us to our local gas rationing board and, in a stern letter, I was called before them, to explain what someone had reported was "unnecessary driving."

Carefully I outlined the problem, and even showed them unedited scenes of the story of America's war effort, which we were attempting to catch on film. After reviewing and listening attentively, the board adjourned. Next day I was summoned to return. What would be their verdict? Instead of punishing us, I soon discovered that they had voted unanimously to grant us a "C" ration card, nearly doubling our allotment of gas. Even though only half finished, and still unedited, *This Is Your America* had passed its first test.

Some of the scenes we needed were far too distant for driving, even with a "C" card, and were not near any of the lecture engagements to which I traveled by train. With camera and tripod I began hitchhiking to reach such required places. Accumulating scenes and episodes through a two-year period, with Helen editing it all, as only she could, our production on America's war effort was at last completed.

We called it "A war film without the horrors of war, showing construction rather than destruction." It became one more film which I carried with me—this time by train—on my eastern lecture trips, and one more hour-and-twenty-minute commentary which needed to be stored in my memory.

166

Carnegie Hall in Pittsburgh is an ideal spot for the premiere of any film. The auditorium is large, the projection—with a carbon-arc machine casting a crisp colorful image on the huge twenty-foot screen—is professional, and the audience, sponsored by the Pittsburgh Academy of Arts, is receptive to programs of quality.

This Is Your America, in its initial presentation at Pittsburgh's Carnegie Hall, was applauded more than I could even remotely have imagined. People swarmed around me backstage when the show was over. After most of them had finally departed, the head usher came back to see me.

"Line," he said, "if you want to get an evaluation of a film you only need to ask me."

The usher explained himself. "If a show's no good, people start leaving, and I hear what they say. When a show is good, I catch all the comments as the people are on the way out, after it's all over."

He paused, then continued, "Tonight, after I'd heard what the people said, I knew you had given us the best film that Carnegie Hall has ever had."

I was going to write Helen at once for I knew she would be as interested as I, in the program's reception. She had helped in parts of the filming and had done all the editing, which can be responsible for much of a motion picture's success or failure.

"But no," I thought to myself. "Three more important shows are coming up in the next two days. Perhaps the Carnegie Hall audience was not typical. I better give the film a couple more tryouts."

Members of the Nomad Club, next night in Dayton, Ohio, were as enthusiastic as the Pittsburghers had been. My only disappointment was that Wilbur Wright, coinventor of the airplane, who had planned to attend, could not do so because of last minute illness.

Time was lacking to write Helen after the Nomad show; I had to get up to Detroit to make ready for two huge presentations of our new film for George Pierrot's World Adventure Series. As mentioned before, this was the world's largest illustrated lecture course.

There was an afternoon and an evening showing. Late that night, after the evening show was completed, I wrote my letter to Helen:

"It was another of those applauding audiences," I began, "or else this is an applauding film. They started clapping at the first

scene, applauded five shots in the opening sequence, then kept it up quite regularly throughout the film."

This Is Your America, it became clear as my tour continued, was indeed "an applauding film." Two fellow lecturers who made a semiprofessional business of evaluating illustrated lecture programs, rated it on their score sheets as the best film in America. The Pittsburgh Academy, as a result of the showing there, selected me, out of all they had presented during the year, to give their bonus or "dividend" extra film lecture. Of greater significance, the Detroit World Adventure Series audience—as I learned much later—in their balloting for best program of the year, gave our new America film first place. If a film did well at the World Adventure Series—so great was that organization's reputation—program chairpersons across the country would book it, sight unseen.

This Is Your America was on its way.

CHAPTER 22

I Travel by Train

Now that America had entered the war, our timely *Circle of Fire* film strained our calendar capacity to the limit. Also, war conditions put an unforeseen and almost unbelievable strain on travel, to get to lecture engagements.

Gasoline was rationed; long-distance driving was a complete impossibility.

Desiring to establish some sort of a foothold in the Northwest, I had unwisely accepted a single engagement in Seattle, Washington, at a fee of $150, and journeyed there by train.

Never have I traveled by plane to fill lecture engagements. In the 1940s and 50s planes were not sufficiently reliable. Many of my confreres in this field depended on them and, because of plane delays, sometimes failed to fill dates for which they had contracted. In more than a quarter of a century in this business I never missed nor was late for an engagement.

So off to Seattle I went—by train. America had just entered the war. Movements of troops and supplies for the Pacific war zone were being pushed on a twenty-four hour basis; they had priority over everything else.

Our passenger train was put on a siding to allow a troop carrier to pass. Another siding and an interminable wait, while a freight train of military supplies overtook and passed us. More troop trains. More waiting.

As we were approaching Dunsmuir in northern California, I began to realize this train would never get me to Seattle in time for my program. It was 9:00 P.M. I had a bus schedule and decided to switch to a bus that was due to pass through Dunsmuir at this time.

I left the train. The bus had been delayed. In desperation, I hired a taxi. We drove through the night—all night—to Portland, Oregon, where I caught a train that got me to Seattle, with fifteen minutes to spare before my program was to start. My fee was $150;

my expenses came to $178. Long distance travel by taxi is expensive. But I kept my record intact.

There were a few similar train delays in the Midwest, but war conditions affected western trains the most. As the conflict progressed, and railroads adjusted to the new strains they had to bear, train travel—except in isolated instances—became more reliable. Between large cities, after the war ended, it often approached the ideal. Concluding an evening lecture in Chicago, as an example, I would go to bed in a Pullman car at the station. At midnight, my sleeper would be attached to a departing train and by daylight that same car would be switched to a siding in Cincinnati. Or Indianapolis. Or Detroit. Or St. Louis or Minneapolis.

Often, on lecture tours, more than half of my nights would be spent on trains. It was soothing, in the middle of the night, to hear the jingle of the warning bell at crossings as we rumbled through tiny Midwestern towns. Sometimes I would waken and look out at the quiet streets, the houses with an occasional bedroom light still burning, an automobile waiting at a crossing as we steamed past. I thought about the people—in their houses, and in those cars. Who were they? What were their lives like? They were so far from my home in California. But they were part of America. I loved to travel by train.

Twice a year—autumn and midwinter—I would go to the Santa Fe passenger agent in Pasadena and reserve train travel, together with Pullman berths, for an entire transcontinental trip, with a couple of dozen backtracks and transfers and detours to places all over the map. My ticket, all the various sections and segments pasted together in one serpentine streamer, was long, very long. On one tour, at the beginning of each of my programs, I'd take that ticket from my pocket, hold it high in the air, and let it unfold for its entire length. It was eight feet long! The audience would emit a collective gasp.

My longer trips by train twice each year provided opportunities for other types of activity that had metamorphic effects on my life. In the Pullman diners—but more particularly in the lounge cars—there were opportunities for contacts with other passengers. These were strangers; we would never see each other again. Many of them were lonely; nearly all of them, seemingly, had problems. Some of those men and women, finding that I had a sympathetic ear, would pour out their life stories to me as they could never have done to personal acquaintances. I was a good listener and that is what they often needed most—someone to whom they could give uninhibited expression to their deepest feelings and needs. I

learned much concerning human nature; hopefully I was able to help some of those who confided in me as our train flashed through the American countryside.

At other times in those lounge cars—and always in my own Pullman berth—there was isolation and solitude. There was opportunity to write and to read, with ideal conditions for concentration. The clicking of the rails, the low musical moan of the train whistle at road crossings, created an almost mesmerized background conductive to inspired thought.

I knew almost every major secondhand bookstore in the large cities all over the land. Always, I had half a dozen volumes with me as I traveled. I shipped many books ahead, to pick up at later stops. Much of Helen's and my library of some 2500 books was accumulated in this way. I devoured books not only on the trains but often in lonely hotel rooms, while awaiting my evening lectures. That reading, which I could never have done except for those lonely hotel bedrooms and those long journeys by train, changed the content and makeup of my life. My horizons widened in the fields of philosophy, history, religion, and literature.

Audience sizes, in the war days, varied enormously. The average was a thousand for lecture series, a few hundred for clubs. At the large gymnasium of Michigan State College (later, Michigan State University) in East Lansing, where the illustrated lecture series was held, an audience of five thousand almost always greeted my appearance. My largest audience, ever, was sixty-two hundred, in Flint. Another Michigan engagement, at the Grosse Point Yacht Club, out of Detroit, favored me with my smallest attendance. It was on the Sunday, near the war's beginning, when prohibition on Sunday automobile travel first went into effect. Most of the members lived far from the clubhouse. Only those within walking distance showed up—a total of twelve. At my fee of $150, my services cost them more than twelve dollars each. They could afford it. As I discovered the following year, the club has wealthy members.

For my showing that next year, the clubhouse lounge was filled nearly to capacity. I was carrying a small phonograph and a record, for background music with the film I was showing. Ten minutes before show time, I discovered that the phonograph would not run.

"Wait just a minute," said the chairman who was going to introduce me. "I'll get a couple of mechanics who can fix it in a jiffy."

He summoned two young men from the audience. They were, indeed, skilled mechanics and in three or four minutes had the phonograph working.

With the emergency taken care of, the chairman took time to introduce me. "Mr. Line," he said, "this is Henry Ford II, and his brother, Benson Ford."

Their grandfather was a skilled mechanic. I had proof that they were, too.

Mechanical problems in connection with projection facilities were among the most disturbing hazards of illustrated lecture presentations. Whether traveling by car or by train, I nearly always carried two large, heavy 1200 watt projectors, for use in clubs or small school auditoriums. It was necessary, however, unless Helen was with me, to depend on amateurs to do the projection, which often presented problems.

The largest auditoriums had carbon arc projectors, with professional operators. In Washington D.C.'s Constitution Hall, for example, such a machine would enlarge each less than half-inch wide frame of my movie film into a glowing twenty-four-foot wide color picture on the screen.

In the adolescent years of the film-lecture business nearly all of us who took color motion pictures always used our original film exclusively. Copies did not have the high color quality and sharpness. The National Geographic, which paid a five hundred dollar fee—tops for those days—would permit only original film to be shown, which entailed great risks to film footage that could never be replaced. Several lecturers, including ourselves, had severe damage done to original film, in some of the places where we showed.

Gradually the quality of film copies improved, and we were able to safeguard our originals. But projection difficulties continued to present severe problems.

One of our later productions was concerned largely with nature and wildlife, but had one sequence portraying the people of an isolated pioneer settlement. A professional projectionist in St. Louis, in loading the film, inadvertently got it twisted, so that every scene showed in reverse. At once I recognized the difficulty but, as long as no signs or printing were shown, or no people were involved, the audience could not distinguish the error.

"But the scenes in that isolated town—they are coming up soon," I said to myself. To have ordered the show to be stopped, while the projectionist unloaded the film and put it back properly, even if I could have gotten word to him, would not only have

172

caused great delay, but would have broken the continuity and the intense audience concentration which I had been able to achieve.

The episodes of the pioneer town began flowing onto the screen—men chopping wood, building a church, pounding with hammers, women sewing and ironing. With the film turned over as it ran through the projector, every person in that village appeared to be left-handed.

May I be forgiven for what I did. I simply said: "This is probably the only completely left-handed town in the land."

And the show went on.

Columbia University in New York City, except for one occasion, provided excellent projection. On that occasion, as the Japanese scenes of my *Circle of Fire* were on the screen, the loud noise of an explosion came from the projection booth. At once the picture stopped. I launched into a vivid word portrayal, hoping the trouble might soon be corrected. It wasn't. I asked for questions from the audience, and fielded all kinds of queries about conditions in Japan. Still no picture. Hoping the show would soon go on, and not wanting to cover material that might presently appear on the screen, I began describing events that had occurred in Japan when my brother and I had spent a month in Tokyo fifteen years earlier, in 1925. The country had been much less developed then. Groping for sufficiently interesting material to make sure the audience stayed with me, I began to describe—too vividly perhaps—the early bathing customs. At that point, the chairman, Dr. Russell Potter, came on stage. "The projector has blown up. It cannot be repaired," was his announcement. He told the audience he would rebook me for a later appearance. That ended the evening.

One other experience had the potential for even more serious consequences. My pictures were being projected from the front of a balcony. Everything was going well. As the show ended and the lights came on I saw, to my horror, that the entire film had gone through the projector but then—instead of feeding onto the takeup reel—had dropped down onto the floor below. I practically yelled for the entire audience to freeze in their tracks. As they did so, I rushed back to protect the film. It was rewound successfully and, after cleaning, was as good as new. One person stepping on it could have ruined the entire footage.

What's in a Name?

One of the great bonuses of the lecture business is the almost miraculous opportunities it provides for meeting friends from the past.

Following a showing in Cincinnati, Ohio, I was greeted by the superintendent of schools of that city, Mr. C. V. Courter, and Mrs. Courter. Our last previous meeting had been thirty years before, when he was superintendent of schools in the small town of Howell, Michigan, where I had graduated from high school, and where he had been my brother's and my debating coach.

Following a film showing at South Bend, Indiana, (and after an equally long passage of time) I met Mr. Francis Sanford, former principal of that same Howell school.

Agnes Cansfield was my favorite teacher in high school. Years later I was delighted when she attended one of my film showings in Detroit. A few months after that she came to one of my Orchestra Hall presentations in Chicago. In one place or another she attended probably a dozen of my programs throughout the years.

Distant relatives, usually cousins once or twice removed, and some of whom I had never heard of before, sometimes came backstage after a lecture, to introduce themselves. Such surprises were pleasant.

Following a program at the First Congregational Church Forum in Toledo, Ohio, a middle-aged couple greeted me.

"Don't you remember us?" the man asked, and I was honest enough to admit my inability to do so.

"We are Gene and Ivy Smith."

At that point I was proud of my memory, for the names clicked instantly, although I had not seen nor heard of Gene and Ivy—they were brother and sister—for half a century. When I was four years old, in my birthplace town of New London, Ohio, they had been the little kids next door.

When my brother Winfield and I had made our hike to every state of the Union, following graduation from high school, we had worked during the winter months half a mile below ground, in the silver-lead mines of Burke, Idaho, "batching it" in a tiny one-room cabin. On Halloween night, several young boys, sons of some of the miners, had attempted to overturn our privy. We apprehended them, grabbed and herded them into our cabin, and had a fine Halloween evening, feasting on candy which our parents had sent us from Michigan. We formed a club and met weekly during the time we were in Burke.

Thirty years later I was filling an engagement at the University of Washington in Seattle. The affair had been well publicized in the city papers. Following the show, two young men came backstage to meet me.

"Did you once live in Burke, Idaho?" they asked me, and at my surprised reply—in the affirmative—they explained excitedly:

"When we saw your picture in the paper we almost knew it was you. We were members of that club you and your brother formed that Halloween night."

They had both graduated with degrees in engineering from the University of Washington and had responsible jobs with the Boeing Company. A couple of years later, after another of my Seattle showings, they greeted me backstage again, with their wives. In the two year interval, both had become married.

One year I had a series of lectures across Canada, starting in Toronto and ending in Vancouver, British Columbia, with engagements along the way at Winnipeg, Manitoba; Regina, Saskatchewan; and Calgary and Edmonton, in Alberta.

At the beginning of that trans-Canadian tour, one sleet-filled midwinter night following my appearance in Toronto, a blond-haired woman came backstage.

"Mr. Line," she greeted me, "It's so good to see your film and to see you, again."

My mind went searching, but came up with a blank.

"Of course you wouldn't remember," she continued. "That was another world. Before the war. Finland. I drove you to the Great Arctic Highway from Inari."

Through the icy Toronto night the two of us went together to a nearby cafe for some hot chocolate. Memories flooded in on me. Lapland. Recalcitrant reindeer. A pulka episode that left my arm sore for a week. The welcome hospitality at the Inari Inn. (See Chapter 5.)

"Russia attacked Finland," she explained, "shortly after you were there. I escaped, and came here. But I miss Inari."

Her eyes seemed to have a faraway look. "This weather tonight reminds me of it. Perhaps someday I can go back. Finland is a land I love."

It was always a surprising thing to me that people who had seen some previous program of mine—perhaps in some distant part of the United States—would often greet me, not only to tell me they had remembered one of my former programs, but they had remembered the joke I told during my introduction. I would nearly always

open an evening with some bit of humor about myself, often pertaining either to my short stature, or to my name.

Sometimes I would open a program with a true story about my last name.

"Line—it is such a simple surname." I would say, "L-I-N-E. But you would be amazed how often that simple name gets mixed up. Once it even confused my mother. In high school I played left halfback on the football team. My mother wasn't interested in football—had never attended a game. But I persuaded her to take in the final contest of the year. As it happened she took her seat up along with the rooters of the opposing team. When it was all over she came down to the field."

"How did you like it?" I asked.

"It was wonderful," was her response. "And you were just about the whole team."

When I interjected modestly, she continued:

"Yes, you were. All afternoon I sat up there with those opposing rooters. And all afternoon they kept yelling: 'Hold that Line. Hold that Line.' "

I really hated to disillusion her.

On one occasion the chairperson at one of my lectures apparently used the "association" method for remembering names. "And now," he began, "I want to present to you our speaker, Mr. String."

The surname "Line" lends itself to a dozen humorous twists but my first name provided the most telling bit of authentic humor.

A month or so before entering the University of Michigan, my brother and I went down to nearby Ann Arbor to register. Soon, through the mail, came a letter in a blue envelope, sweetly scented. Opening it, I found it was signed by a "Miss Edna Kadow."

"Dear Frances," it began, (spelling my name with an 'e') "if I may be bold enough to address you by your first name. This year the university has adopted a new policy, and has assigned a senior girl to assist every girl entering the university as a freshman. I have been assigned as your senior advisor and want to help you in any way that I can. Please do write and let me know if there is any information I can give you about classes, clothes you should bring, etc. Edna Kadow."

Tongue in cheek, I at once wrote back:

"Dear Edna: I don't mind at all about your using my first name. In fact, I rather like it. Yes, there is so much I need to know, especially about the matter of proper clothing. Your freshman friend, Francis."

In the ensuing correspondence, I learned more interesting details about girl's clothing than I had ever imagined before. Then came the final letter:

"Dear Frances: University classes commence next week. Please let me know when your train will arrive at the station and I'll plan to meet you. Your senior friend, Edna."

I let her know, and she met me as promised. There was a moment of shock when she discovered I was a boy and not a girl, but she recognized the humor of the deception, and we both had a good laugh. She was a senior, and I was a freshman. Among 10,000 students, we soon lost track of each other, and I scarcely ever saw her again.

Almost thirty-five years later, in introducing my program at Horace Bushnell Memorial Hall in Hartford, Connecticut, I began:

"Ladies and gentlemen, it is good to be back in Horace Bushnell Hall. Last year I told you a joke about my last name, so you would never be able to forget it. Tonight I want to tell you a true episode about my first name, so you will also remember that forever." I proceeded to relate the mix-up regarding my name of "Francis."

After the program a woman came backstage, waited until all the others had gone, then addressed me rather timidly.

"Mr. Line," she began. "I'm Mrs. Crawford. I've never been to one of these film lectures before in my life. A neighbor couldn't use her ticket, and gave it to me. I didn't even know what the program was going to be. But I'll never be able to thank her enough. I am Edna Kadow Crawford. I was once your senior advisor."

The next time I appeared in Hartford I had her come onto the stage, and introduced her to the audience—midst wild applause.

That "Francis" joke was my leadoff one year, in all of my lecture showings on the Hawaiian Islands. One afternoon, as Helen and I were strolling along Kuhio Avenue in Waikiki, a bus came to the curb, stopped, the door opened, and the Hawaiian driver politely addressed me: "Hello, Francis, wouldn't you like a ride?"

A few days later, in a rented car, we had driven up to a great canyon view on the island of Kauai. A car filled with Japanese school girls parked beside us. As soon as they saw me, as though with one voice, they exclaimed: "Hello, Fran-cees."

Apparently, nearly everybody on the Islands had heard the story of my multigendered name.

"THIS IS YOUR AMERICA"
by
Francis Raymond Line

Upper: Brochure for a program at Horace Bushnell Memorial Hall, Hartford.
Lower: Audiences at Carnegie Hall, Pittsburgh, were among the finest on Line's circuit.

HERALD

For Over Half a Century

FEBRUARY 2, 1949. **PRICE 5c**

FRANCIS R. LINE, noted photographer, no doubt considered the 52 days spent with sheep, stars and solitude in capturing a little-known phase of life in the southwest well rewarded when he found such a warm welcome Friday on arrival in Honolulu. Rose Kekuna is bestowing the islands' greetings to the world traveler who will present under Kiwanis sponsorship his full-length color movie, Sheep, Stars and Solitude, Thursday night at 8 in the Hilo high school auditorium. One of the Kiwanis World Adventure Tours Series, the film will be accompanied by a colored short of the Pasadena Tournament of Roses parade.

Front page picture in HILO TRIBUNE-HERALD, Hawaii.

FRANCIS RAYMOND LINE

77 PATRICIAN WAY
PASADENA 2, CALIFORNIA

MEMBER OF: THE NEW YORK EXPLORERS CLUB •
CIRCUMNAVIGATORS • NEW YORK AND
LOS ANGELES ADVENTURERS' CLUBS

FIFTEENTH CONSECUTIVE SEASON

BOOKINGS INCLUDE:

World Adventure Series, Detroit
(20 times)
National Geographic Society,
Constitution Hall, Wash.,D.C. (8)
Boston University (5)
Columbia University (13)
Carnegie Hall, Pittsburgh (9)
Toronto and Ottawa, Canada
Hawaiian World Adven. Tours
(40 showings through Islands)
Town Hall, New York (2)
Brooklyn Institute (6)
Amer. Museum Nat'l Hist., N.Y. (12)
Field Museum, Chicago (6)
Friends of Music, San Antonio (4)
Horace Bushnell Hall, Hartford (6)
University Club of Los Angeles (11)
Woman's Club of Evanston (2)
Michigan State College (7)
(Audience average 5000)
Pasadena Civic Auditorium (10)
Taft Theatre, Cincinnati (5)
Town Hall, San Francisco (4)
So. Shore Country Club, Chicago (7)
University of California (9)
City Club of Milwaukee (6)
North Park College, Chicago (4)
Shorewood Lecture Series, Milw. (8)
Oak Park Community Lectures
Kiel Auditorium, St. Louis (2)
Dayton "Y" Lecture Series (7)
University of Minneapolis
Woman's City Club, Kansas City (4)
World Cavalcade, Seattle (2)
Fullerton Forum of Calif (13)
I.M.A., Flint, Michigan
(Largest audience, 6200)
Ebell Club, Los Angeles (4)
Hyde Park Travel Club (7)
Orchestra Hall, Chicago (6)
So. Miss. College, Chattanooga (4)
Moline After Dinner Club (2)

World Geog. Society, L.A. (4)
Nomad Club, Dayton (3)
Men's Dinner Club, Okla. City
Shrine Auditorium, Los Angeles (3)
Occidental College, L.A. (11)
Lyric Theatre, Baltimore
Atlan. Union Coll., Mass.
Kellogg Hall, Battle Creek (7)
Richmond, Va. Woman's Club
Military Academy, Staunton, Va.
Grosse Pointe Yacht Club (4)
Cent. Meth. Church, Detroit (3)
Flint, Mich. Town Hall
Sunset Club Seattle
Kiwanis Lecture Series, Mich. (3)
Akron "Y" Series, (5)
Minneapolis Woman's Club
Toledo "Y.M.C.A." Series (3)
Women's Club, Louisville, Ky.
La Sierra College, Riverside (2)
Stockton College (2)
Toledo Rotary Club (6)
University of Cincinnati
Woman's Club of Cent. Ky. (4)
Hollywood Woman's Club (4)
Geog. Soc. of Phila. (5)
Des Moines Forum (4)
Beverly Hills Woman's Club (3)
Wash. Miss. Coll., Wash. D.C. (4)
Chaffey College, Calif. (12)
Cong. Church Forum, Fresno (4)
Pomona Eve. High School (12)
St. Louis "Y" Series (27)
Century Club of San Fran. (2)
Santa Barbara Museum (8)
Cong. Church Forum, Waterbury (8)
Idaho Artists Series, Boise
Chicago Woman's Club
Grosse Pointe Lectures (3)
Chicago University Club
The Athenaeum, Summit, N.J.
Acad. Natural Sciences, Phila. (2)
No. Shore Sun. Eve Club, Chi. (3)
Armchair Cruise, Sacramento (2)
"Y" Series, Springfield, Mass. (2)
Denver Museum Natural Hist. (14)

Some of the places and number of showings on Line's regular circuit during early years of his career.

FOR YEARS THE SPACIOUS LINE HOME ATOP THE FAMED EAGLE ROCK OVERLOOKING HOLLYWOOD AND THE PACIFIC, HAS BEEN THE GATHERING PLACE FOR ADVENTURERS, EXPLORERS AND LUMINARIES OF THE FILM AND LECTURE WORLD.

"JAM SESSIONS IN FILM" BY THE WORLD'S GREATEST TRAVELERS FEATURE THEIR PERSONALLY PRODUCED FILM RECORDS OF ADVENTURE, TRAVEL, STRANGE AND EXOTIC CUSTOMS OF ALL THE WORLD.

Detail of brochure for a TV series planned by the Lines. At the time, they

CHAPTER 23

Clothes Make the Man

Packing for an extended lecture journey by train across America is a meticulous and exacting undertaking—two heavy projectors, a cumbersome public address system, often a phonograph (or later a wire recorder; still later a tape recorder), five or six cartons of films, a huge suitcase, sometimes a camera and tripod, plus a folder of contracts, a small folding typewriter, with stationery, envelopes, stamps. Helen and I spent days checking and assembling every necessity before each lecture trip which I took.

One season, my first engagement after leaving home was in San Antonio, Texas, where I was to appear before the First Nighter's Club at the St. Anthony Hotel. Preceding the program there was to be a receiving line, with the mayor of San Antonio and other city and club dignitaries. I was asked to be in the ballroom promptly at 7:00 P.M. to be a part of that line.

Twenty minutes after six. Finishing bathing I started to dress in my hotel room on the seventh floor. 6:30 P.M. Into my tux. 6:35 P.M. Dress shirt on, adjusting of cuff links. 6:40 P.M. Black tie, out of its special box in my suitcase. . . but where is the box? Where is the tie? 6:45 P.M. Entire contents of the suitcase on the bed and floor. 6:50 P.M. I arrive at the realization that my black tie is still back home in California. We had somehow neglected to pack it.

Within one minute I had the hotel's social director, Sally Frampton, on the phone.

"No time to explain," I blurted, "but I have no black tie. What shall I do?"

That social director was sharp—and fast. "Go to the end of the hall," she told me, without wasting a second in questions or recriminations. "Ring for the freight elevator. Take it down to the main floor. I'll meet you there, immediately."

She met me, at the freight elevator's entrance to a baggage room off the main floor.

"This way," she motioned, and I followed. In thirty seconds

183

we were at the stage door leading into the ballroom. She opened the door, and our ears were blasted by the din of an orchestra playing on stage. Quickly she darted behind the musicians, over to the drummer, who was at the back, almost concealed by the players in front.

I saw her as she whispered in his ear, then reached up and removed his black tie, so deftly that the drummer did not miss a single beat. In an instant she was back to me.

"He won't need it. No one will notice," she explained, as though this was an ordinary procedure.

In fifteen seconds she had helped me put on that tie and adjust it. At exactly 7:00 P.M.—even though I was still a trifle dizzy—I heard her say: "Mr. Mayor, I'd like you to meet tonight's speaker, Mr. Francis Line."

Clothes make the man. Or wreck him. The scene was a high school near Schofield Barracks on the Island of Oahu, in Hawaii. Hawaii's usual climate is so balmy the walls of the auditorium stage had been constructed of bricks, laid with large spaces between them, allowing the cooling breezes to flow through.

On the night of my appearance, Hawaii's climate, at least in the elevated areas near Schofield Barracks, was less usual than usual. The air flowing between those bricks was not just cool; it was freezing. On stage, making my preparations before the show started, I was freezing also. My teeth actually chattered.

Those in the audience were not affected by the wind whistling onto the stage. Borrowing a topcoat—a couple of sizes too large for me—from a friend in the audience, I arranged it and my hat on a chair backstage. After my introduction, the lights went out and the film began. Quickly, between sentences, I reached for the coat and hat backstage, donned them, and stood in the darkness at the edge of the screen, narrating the scenes as they appeared. With the benefit of coat and hat my teeth were no longer chattering.

Once in a great while, during a lecture, the film breaks. It happened that night. An expert operator would have reloaded it at once while I kept talking. This operator was not an expert. When the film trouble developed, instantly he turned on the lights. There, in what was supposed to be balmy Hawaii, I stood before a thousand spectators, swathed in an oversized overcoat and a hat.

The audience gasped. I gasped.

"You'll have to forgive me," I blurted. "I'm still not used to Hawaii's balmy climate."

They laughed. I laughed. And the show went on.

Weather plays tricks, with great frequency, on lecturers who tour America at all seasons of the year.

The scene was another high school auditorium—this time in a suburb of Detroit, Michigan, in midwinter. But this time, the stage, rather than being cold, was hot and stifling. All the warm air from the large overheated hall was flowing up and being trapped by the heavy stage curtains behind which the chairman and I were standing.

Making ready to go on stage to introduce me, he wiped his forehead with a handkerchief.

"It's freezing outside, but this place is like a furnace," he exclaimed.

Behind us was a door leading outside. "Maybe we could prop that open and give us a little breeze," I suggested.

We did so, and a welcome surge of air, cooled by the winter snows, drifted in.

Stepping onto the stage, the chairman launched into some announcements, leading up to his introduction of the evening program. I was still perspiring. Opening the outside door still wider, I stepped out onto a platform to inhale one good breath of the sharp, crisp air.

The door prop slipped, suddenly the door slammed shut, and automatically locked. I twisted the knob. Useless. I pulled and jerked. A waste of effort. I pounded, but even as I did so I knew that the chairman could not hear me.

The snow was ankle deep and in places had drifted against the building to a depth of two or three feet. All was dark, except for the glow of a distant streetlight.

Inside, on the stage, I had been perspiring greatly. Now, out on the snow, I was *sweating* heavily. Not from heat, but from something akin to terror. I was locked out of my own lecture. Not once in my professional career had I been late for an engagement. To think that it would happen like this.

Like an enraged polar bear, I began running and plowing through the snow, around the building toward the front entrance. Drenched with slush and perspiration, I burst into the building. A large fellow was taking tickets. I rushed past him.

"Wait," he accosted me.

"I don't have any ticket. I'm the speaker," I yelled.

"The _____ you are," he swore, but by this time I was halfway down the aisle.

Long-winded chairmen are anathema to lecturers. But never

could I have been more thankful that this man had pulled out all the stops.

"And now," I heard him saying, "I want to present to you one of the great adventure personalities on the American lecture circuit today, Mr. Francis Raymond Line."

I mounted the steps to the stage and took a bow as the audience applauded. As I dusted snow from my tuxedo, I proceeded to relate to them what, for me at least, had been one of the most nerve-wracking adventures of my lecture career.

It made a wonderful beginning. That was one of my most successful showings.

Weather dominates a photographer-lecturer's life almost as sternly as it once dominated the lives of sailors before the mast.

In the filming portion of our activities, it is sometimes possible to "sit out" poor weather conditions. In America's Northwest we once waited ten days for storms to pass in order to catch tulip fields, against a Mt. Rainier background, bathed in ideal sunlight. Another occasion required a return trip—three thousand miles there and back—to Glacier National Park in order to film its grandeur under suitable conditions.

When lecturing, one is deprived of this luxury of waiting out a storm, or returning later. For a quarter of a century, my motto was more rigid than that of the postal service: "Neither snow, nor rain, nor heat, nor gloom of night, stays these couriers from the swift completion of their appointed rounds."

Severest weather conditions of my lecture career swept in upon me during an unseasonable post-Thanksgiving storm which suddenly buried the Ohio River Valley under four feet of snow, with an accompaniment of freezing temperatures which glazed the world in ice.

Cincinnati's spacious Taft Theater was packed for my annual appearance there, on a Sunday afternoon. Snow had been falling all day but not in quantities to hamper traffic severely. But as the audience (and I) left the auditorium, we were hit with a blinding fury of swirling whiteness. It was a winter cloudburst. Approaching darkness found the city smothered in drifts.

My night train for Huntington, West Virginia—next lecture stop on my route—was to leave at 10:00 P.M. The train was called, and a hundred passengers assembled at the departure gate.

No train.

"There will be a short delay, due to the weather," came the announcer's voice.

10:30 P.M. 11:00 P.M. No train.

Almost none of us left the gate, since the announcer kept assuring us the delay would probably be brief.

Someone in the waiting crowd recognized Senator Robert Taft, for whose family the Taft Theater had been named.

"I've got to get back to Washington for the special session," he explained to some of us. "It starts tomorrow."

"Seems like a senator could get a little action," a woman remarked. Her tone was humorless, her voice as cold as the storm.

"Even congress can't control the weather," Taft smiled. Unassuming and patient, the senator waited with the rest of us until half an hour after midnight, when we went aboard.

Next morning, hours late, as the train pulled slowly into Huntington, I saw city scenes of winter that were out of some book of horror stories. From the train windows, and later as a taxi tried to battle the drifts and get me to a hotel, I saw icicles twelve and fifteen feet long, as thick as an elephant's trunk, extending from second story eaves. Freak conditions of thawing and freezing had created a thousand deadly weapons suspended like dangling swords above the sidewalks. Crews were soon out to start knocking them loose. A passerby, pierced by an icicle, was killed.

A few hundred brave patrons endured real hardships to fill the college auditorium to a third of its capacity for my evening showing. My night train, with a snowplow scattering the drifts, landed me in Pittsburgh the next day.

The snowbound city was paralyzed. This was chapter two of that horror story. Only a handful attended my evening showing at Carnegie Music Hall. No space of any kind was available for parking; every lot, and the sides of every street, were piled deep with drifts. The Institute of Arts rebooked me with the same program later in the season.

They were generous. Another organization, for whom I was scheduled to appear in Pittsburgh the next day, not only cancelled the show, but felt it was not necessary even to pay me expense money.

Two days later I arrived in Cleveland, in time for the horror story's conclusion. The world was beginning to dig out of its avalanche of white. A car was uncovered from beneath a drift on a Cleveland street. Inside was an unconscious man. He had been buried in snow for six days. He lived.

The next year, in another Midwestern city, a different sort of storm created a different sort of nightmare. The barnlike

auditorium where my program was being presented, and where every sound made an echo, was almost shaking under blasts of thunder. It was impossible to make myself heard when the rolling currents of noise from the outside storm penetrated into the hall.

As we would recover from the thunder shocks, lightning flashes began playing tricks with the electrical system. The motion picture projector would sputter, and sometimes stop. The music of my phonograph records, which I was playing on stage, would sink into a sickening dirge.

As soon as projector and phonograph were functioning again, another bolt of lightning, another blast of thunder.

Somehow, a large bird had been blown by the wind through an open door, along with a paying customer. In fright, it swept around the cavernous hall, swirling down toward the lighted screen, almost striking me with each round it made.

A lightning bolt, a thunder blast drowning out my voice and startling some of the audience into near-panic, a sputtering projector, and wailing phonograph music; then, a swirling bird, causing me to stop speaking altogether as I dodged each onslaught.

The theme of my film-lecture that night concerned adventures in distant places. Both the audience and I had real life adventures— as dramatic as any movie—right there in the auditorium. When the bird almost collided with the lighted screen, at the same instant a crash of thunder shook the hall, one woman screamed in fright.

But the show must go on, weather or no.

On another occasion, in another auditorium, the entire rolled-up stage curtain suddenly fell from the ceiling with a thud, luckily missing me. As the audience started reacting in shock, I quieted them by saying: "For a long time I have suspected I was good, but I didn't know I would bring the house down." Not only did that quiet the audience, but it got the evening program off to an excellent start.

Getting one's program off to a good start is often the difference between a run-of-the-mill presentation or a really memorable occasion. This has to do with getting the audience with you at the beginning, after which they contribute as much to the evening's success as the speaker. It helps to use every available contrivance to accomplish this result. Kiel Auditorium in St. Louis provided a good example.

The stage at Kiel is huge and, as I discovered beforehand, it can actually be raised or lowered electrically. On that large stage, in that enormous hall, I seemed not only small, but almost

insignificant. I admitted as much to the audience, told them of my short stature, then added: "But I have a remedy for all that."

As I made a pre-arranged sign to the electrician in the wings, he pulled a lever and that enormous stage very slowly began to rise. Up. Up. Up. The audience burst into applause. It was a memorable evening.

In the breakfast-food city of Battle Creek, Michigan, where my mother had once taught kindergarten, my showing was at the luxurious W. K. Kellogg Auditorium. I started off the program by relating a true story about the Kellogg company's rival, the C. W. Post company.

"My mother's brother, my Uncle Albert," I began, "was once Mr. Post's only employee. They worked together in a small shed or building behind Post's home, making what was called 'Postum.' As a final step in the process, Mr. Post would go into a closet and secretly add some special ingredient to the formula. Then C. W. Post and my uncle would go up and down the streets of Battle Creek, selling that product house to house. That was the beginning of the great Post cereal empire."

Next day a front page story came out in the paper concerning this little-known historical episode. Officials of the Post Company contacted me and invited me out for a tour of their plant. What they most wanted to show me was the tiny structure, preserved and moved to its new location, in which the whole Post industry had begun as C. W. Post and my uncle mixed up that formula.

ROSE PARADE FILM PROVIDES HAPPY SURPRISE IN LINE'S CIVIC AUDITORIUM LECTURE

That was the headline of a story in a January 4th issue of the *Pasadena Star-News*.

During World War II Helen and I had moved from Ontario, California to a home which was situated exactly on the Eagle Rock-Pasadena city line, close to the starting point of the annual New Year's Rose Parade. During war years that spectacular event was cancelled. But, with peace, this most colorful of all American parades became grist for our movie cameras. We covered it from start to finish and rushed the film to Hollywood for special developing. Helen sat up all night to edit it, and a "Rose Parade Special" became part of the program we presented on January 3 to the 2000 people who jammed Pasadena's Civic Auditorium for one of my adventure films.

That became the first time, ever, that Rose Parade color motion pictures were shown professionally to an American audience. The footage became part of my presentations that winter, across America. Year after year we filmed the parade and I showed it, along with my regularly scheduled films, from Philadelphia to Hawaii. Today, color scenes of the event are broadcast on television worldwide. But until TV arrived, our films took the pageantry of the parade to people all over the United States.

CHAPTER 24

Sheep, Stars, and Solitude

Shortly after returning home from the filming of *Finland Waters,* Russia had attacked Finland, making our documentary on that country more timely than anything else we could have produced.

A year and three months after completing *Circle of Fire* Japan had attacked Pearl Harbor, and made this one of the most timely films in America.

In its own way, *This Is Your America,* was equally timely.

Timeliness. It is one of the important ingredients in a documentary's success.

Where now should we turn? What film could we now produce that would be aided by this ingredient?

The answer required an analysis that went far beyond surface factors.

Psychologically, America was being suffocated by war. Economically, she was reeling under its costs. Emotionally, she was worn out. Spiritually, she was groping, searching.

In *This Is Your America,* the short segment on the Arizona sheep—strange as it may seem—had received the highest praise of any sequence in that film. (See Chapter 21.)

Nothing could be more timely, now, than a program that would give audiences a respite from the stress of war. If that program could, in some way, also offer healing for the emotions, even provide spiritual uplift, then it would be serving a vital need. Such a film, in the truest sense, would be timely.

Helen and I planned and talked, and dreamed. It was decided that I should follow the herd of her cousin's sheep throughout its entire forty-day grueling trek from Arizona's hot Salt River Valley to the cool summer pastures in the northern mountains. The film would be titled *Sheep, Stars, and Solitude.*

I have since written a complete book by the same name concerning that journey with the sheep, describing every important

191

episode, trying to catch the mystic flavor of star-studded Arizona nights and the soothing solitude of lonely deserts and silent forests. The third generation Arizonan, Dan Genung, says of the book in its Foreword:

> *When you open the pages of this book, plan to live for several hours with life at its simplest, harshest, and yet strangely its most gloriously beautiful. You will be living with history on the hoof.*
>
> *You must be willing to march with the planet Jupiter as it leads the parade of night across Arizona skies. You learn to seek sleep in thin blankets while the stars brush your hair and the Milky Way nestles on your shoulders.*
>
> *Here is your challenge to trudge through searing sands and on rocks that shred your shoes. You will be trapped on a mountain slope which has become a "rock-ribbed refrigerator" by the freezing impact of a storm "like a Paul Bunyan gone mad in the forest."*
>
> *Here is your invitation to dine on beans and pan-brown bread, to share the misery of a shivering sheepdog and the rain-sodden woes of burros who "document their sorrow with their ears at half-mast."*
>
> *Here is your introduction to Rosalio Lucero, whose last name means "Morning Star," a sheepherder whose profession predates Moses by thousands of years, and whose unfolding odyssey seems to translate the scenes of the Twenty-third Psalm into a setting of the Arizona wilds. You can share his heartaches and joys as he nurses 2,000 "sheepsies" over 200 treacherous miles "with the tender care of a mother with a colicky child."*

Actually, I made the trek twice, the second time (this was a fifty-two day odyssey) to obtain still photographs and write an article for *The National Geographic Magazine.* I likewise did an illustrated article for *Arizona Highways.*

It would be repetitious to detail the sheep trek here. But it is important to chronicle the reception the film received.

Eventually, I would present it, personally, before more than a million persons across the United States, from New York to San Francisco, and across Canada, from Toronto to Vancouver.

Audience reaction in New York was representative of the reception which the film received. After my showing at Columbia University, Program Director Dr. Russell Potter wrote me a glowing letter, and at once scheduled the film for a repeat showing the following year. He eventually had me present it at Columbia University four times.

Of course I showed *Sheep, Stars, and Solitude* for the National Geographic in Washington, D.C. There were two presentations in Constitution Hall, one in the afternoon and the other in the evening, to a total of six thousand persons. Melville Grosvenor not only wrote me a letter of praise; his assessment of the film's impact was graphically measured by the fact that he at once commissioned me to make the sheep trek a second time, to obtain still photos and write an article for *National Geographic Magazine.*

At George Pierrot's World Adventure Series in Detroit, when the annual audience balloting was conducted for best film of the year, *Sheep, Stars, and Solitude* took first place, as had *Circle of Fire* and *This Is Your America* before it. No one else had ever won three such awards.

Sometime later, at the 21st anniversary celebration of the Detroit World Adventure Series—largest of its kind in the world— the seven persons still living, who had ranked highest in audience popularity during those twenty-one years, provided the program. The Series had presented almost all the top explorers and adventurers (as well as writers and public figures), such as Admiral Richard E. Byrd, Lowell Thomas, Lowell Thomas, Jr., Amelia Earhart, Burton Holmes, Dr. Will Durant, Count Felix Von Luckner, Thor Heyerdahl (Kon Tiki), John Gunther, Edwin Way Teale, Richard Halliburton, Fr. Bernard Hubbard, Frank (Bring 'em back alive) Buck, Sir Hubert Wilkins, Cmdr. Irving Johnson, Col. John (Danger Is My Business) Craig, Ellery Queen, Kermit Roosevelt, Cornelius Vanderbilt, Jr., Louis Untermeyer, Harrison Forman, Gutzon Borglum, and a couple of hundred others, through the twenty-one years.

The elaborate program booklet given out to the audience that day (we had to present shows both afternoon and evening to accommodate the overflow crowd) listed all 279 speakers who had been part of the World Adventure Series programs through the years. After my name was printed: "His all-time ballot rating tops all others. On our 21st birthday he makes (coincidentally) his 21st appearance for us."

It was gratifying to be ranked first on such a list, but I was sensible enough to realize that several special circumstances had been partly responsible. Audience voting had not started in the initial days of the World Adventure Series. Helen and I presented color motion pictures only; many of the others (particularly the earlier ones) used black-and-white films, or color slides. The films I showed had, in every case, been timely. A fellow lecturer summed it up for me: "You interject enough humor into your presentations

to keep the audience laughing, enough seriousness to keep them thinking, and an element of spirituality to raise their sights."

Sheep, Stars, and Solitude for several years was the leading film on the American lecture platform and never did lose its popularity. The St. Louis YMCA series used it two different years on all of their five citywide showings. I traveled to Hawaii for showings on all five of Hawaii's principal islands, under auspices of the Honolulu Kiwanis Club. For this purpose they provided a small private plane and pilot who "island hopped" from Oahu to Maui, Kauai, Lanai, and the Big Island. We even flew over to Molokai for a free showing at the leper colony.

The next year I made the same Hawaiian circuit again, with another film. But the year following that, they wanted a repeat of *Sheep, Stars, and Solitude*. This time Helen accompanied me and in the same private plane we again made the tour of all those islands, including Molokai, where a leper patient acted as our projectionist. We later gave him a handclasp of thanks. A bonus of that experience was learning that modern leprosy is not contagious.

The Fullerton, California Forum presented *Sheep, Stars, and Solitude* more than any other place—nine times in all, with each showing before a capacity audience of nearly two thousand.

Foreign rights to the film were purchased by the U.S. State Department. They translated a shorter version of my commentary into twenty-six foreign languages, for distribution worldwide through the United States Information Service.

We, ourselves, produced a short version with sound on the film, which we called *Morning Star* and arranged for its distribution through Encyclopaedia Britannica Films. Forty years after it was first made, the shorter version is still being sold to schools, libraries, universities and clubs throughout the land.

Sheep, Stars, and Solitude was a timely film when we produced it, because it provided healing from the scars of war.

It was *timely* then.

But it is *timeless* now. Sheep are enduring symbols of humanity's trek across the ages. Stars are eternal. Solitude is a basic ingredient of life.

Sheep, Stars, and Solitude, in its shorter version as an educational documentary, and in book form, will—we hope—go on long after Helen and I have departed. Of all our films, it was both timely and timeless.

Starting our travels with Barbara's little red wagon, we had taken a journey to the stars.

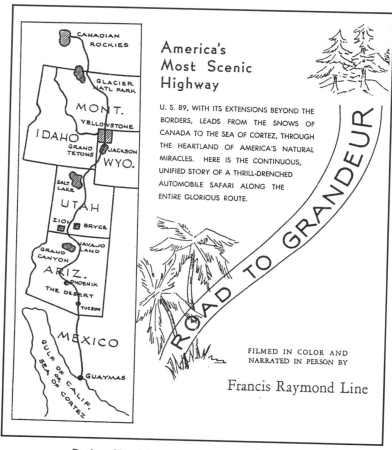

America's Most Scenic Highway

U. S. 89, WITH ITS EXTENSIONS BEYOND THE BORDERS, LEADS FROM THE SNOWS OF CANADA TO THE SEA OF CORTEZ, THROUGH THE HEARTLAND OF AMERICA'S NATURAL MIRACLES. HERE IS THE CONTINUOUS, UNIFIED STORY OF A THRILL-DRENCHED AUTOMOBILE SAFARI ALONG THE ENTIRE GLORIOUS ROUTE.

ROAD TO GRANDEUR

FILMED IN COLOR AND NARRATED IN PERSON BY

Francis Raymond Line

Portion of Line's brochure for ROAD TO GRANDEUR.

"After Words"

The success of our motion picture, *Sheep, Stars, and Solitude,* changed the entire course of our film-making activities. Why go to distant lands overseas when our own West had so much to offer?

Columbia River Country was the first of these western productions. This great river rises in a tiny spring in British Columbia seventy-five miles north of the state of Montana and heads— not westward towards its ultimate destination of the Pacific Ocean—but northward toward the Arctic wilderness. In a small canoe we journeyed north on the river until suddenly its course was blocked by mountains. Abruptly it veered southward, eventually entering the state of Washington. We filmed President Truman as he dedicated the Columbia's Grand Coulee Dam, which was upstaged by a herd of four thousand sheep, making their final crossing over the Grand Coulee. We filmed the river's progress as it sliced through the Cascade Range and flowed into the Pacific. By canoe, by stern-wheeler, by grain barge, by car, we followed and caught on film the drama and history of its 1400 mile course.

Next came *Road to Grandeur.* During two different years we journeyed from the Canadian Rockies to Mexico's Gulf of California along U.S. Highway 89, as that greatest of America's scenic roadways led us into explorations of Glacier National Park, Yellowstone, Bryce, Zion, Grand Canyon, and the little-known wonders of Utah and Arizona.

Road to Grandeur introduced us to the Navajo Reservation; later, we spent much of two years there, producing a film which enabled us to become lifelong friends with the Navajos and the Hopis. By four-wheel-drive Jeep, we traveled more than 10,000 miles on the Navajo and Hopi Reservations—which are as large as four eastern states—camping out most of the time, or living with our Indian friends. Some of the most meaningful experiences of our lives were spent in making that film.

For two summers, and late springs and early autumns, we lived in a small community in southern Utah, producing *Southwest Story.*

We traveled to every state west of the Great Plains, garnering the materials for *Seven Wonders of the West.*

With our daughter Adrienne as one of the cyclists, and with Helen and myself cycling by tandem, we made *Southern California on a Bike.*

One after another, film after film flowed from our cameras.

Our motion picture on the Navajos led eventually to another change in our film-making activities. Producing a shorter version of that film, with my voice recorded on the footage itself, we found a ready sale for *Navajo, A People Between Two Worlds* in schools, universities and film libraries across the land. From now on we would travel to *make* the films, but send them out on their own.

Three educational documentaries on the life of Abraham Lincoln followed, and two on the life of Walt Whitman.

Through our Lincoln films we became acquainted with Carl Sandberg and Allan Nevins, the leading authorities on Lincoln's life.

Being freed of having to travel to *show* the films gave us more time to travel in *making* them, so again we ventured abroad. In producing *Lincoln's Influence Around the World* we renewed our contacts with the English countryside, home of Lincoln's ancestors. I introduced Helen to areas of the Orient and the far Pacific, where Lincoln's influence had carried.

Having become deeply concerned about ecology and our environment, we made a documentary on Francis of Assisi called *Song of the Earth, Francis of Assisi's Message to America on Peace and Ecology.*

That production took us not only across America but twice to Assisi, Italy. But, most important, perhaps, it took us to Sweden, and back to our beloved Finland.

We were invited to present the film, personally, before the Forum of the First International Conference on the Human Environment, in Stockholm, in 1972. Finland was just across the Baltic. We went there, and found Hellin Heiskala, who had been our interpreter and guide in Tampere, Finland thirty-three years before. (See Chapter 6) Ever since our first meeting we had kept in touch by letter.

Her aviator husband had been killed on the first day of the Russo-Finnish war. In a subsequent re-marriage she had become

198

Hellin Ostring and had four more daughters—"my army of five girls" she called them in a letter to us.

One after another of these daughters became "Miss Finland" and one after another entered either the international beauty contest near us in Long Beach, California, or the Miss Universe contest in Florida. Maila Ostring placed among the top five in Long Beach; we had her as a guest in our home for a week. Satu, the fourth daughter, was chosen first runner-up to Miss Universe, and became a celebrity throughout the world.

These daughters had other attributes besides beauty. Heli, the first Miss Finland, studied to become a surgeon. Our close friend, Maila, was a chemist, and spoke six languages. (Her mother spoke seven.) Satu was as vivacious, and had as charming a personality, as any girl we had ever met.

On our visit to Finland, we renewed our acquaintance with Maila. Then Satu and her mother Hellin—whom we had not seen for thirty-three years—entertained us royally. Later Hellin flew to our home in California to spend a weekend with us. We were overjoyed when our youngest granddaughter, Krista, chose Finland as a place to work, teaching conversational English to Finnish young people, in the city of Kajaani which Helen and I had visited when making our film, *Finland Waters—A Story of Adventure in a New Nation.* Krista made a trip, north, across the Arctic Circle, to Lapland, where I had made our first professional motion picture almost half a century before.

Our story of adventure had gone full circle.

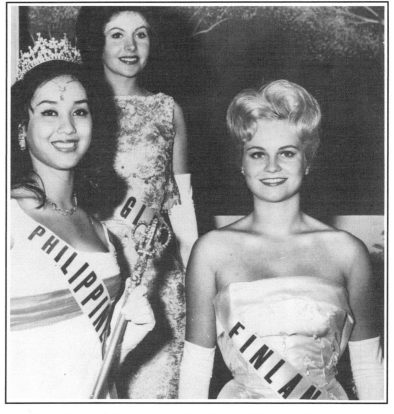

Upper: Filming the final crossing of four thousand sheep over Grand Coulee Dam.
Lower: Maila Ostring, Miss Finland, a runner-up in international beauty contest.

Francis Raymond Line in 1988.

About the Author

Francis Raymond Line, born in New London, Ohio, grew up in the small town of Howell, Michigan and started traveling in an important way at age eleven. With his twelve-year-old brother and his father, he journeyed round trip by bicycle to the ancestral home in Linesville, Pennsylvania, and the following year cycled through the Great Lakes states.

By age twenty-one he had hiked to every state in the Union and circled the globe, working his way as he went. He is a University of Michigan graduate, magna cum laude, a member of Phi Beta Kappa and The Los Angeles Adventurers Club.

Line has lectured with his travel-adventure films at Constitution Hall in Washington D.C.; Columbia University, Town Hall, Brooklyn Academy, and the American Museum of Natural History in New York; Carnegie Hall in Pittsburgh; Orchestra Hall and Field Museum in Chicago; Kiel Auditorium in St. Louis; the Denver Museum of Natural History; Shrine Auditorium in Los Angeles; Pasadena Civic Auditorium, and similar halls nationwide, as well as to hundreds of schools, clubs, and university groups. With his wife Helen he has also produced educational films which are used in schools, universities and libraries in every state of the Union.

Francis has written for *The National Geographic Magazine, Arizona Highways, Boys' Life, Wide World of England,* and is the author of the book, *SHEEP, STARS, AND SOLITUDE.* With Helen he coauthored *GRAND CANYON LOVE STORY, MAN WITH A SONG,* and *BLUEPRINT FOR LIVING.* With his brother Winfield he wrote *FOOT BY FOOT THROUGH THE USA.*

Helen and Francis Line celebrated their 60th wedding anniversary by hiking to the bottom of Grand Canyon. They have a daughter, three grandchildren and two great grandchildren.

Other books published by
WIDE HORIZONS PRESS
are listed on page 209.

INDEX

OTHER BOOKS FROM WIDE HORIZONS PRESS

Let
WIDE HORIZONS PRESS
FILL YOUR GIFT LISTS THROUGHOUT THE YEAR

We will package and mail the following books to any address in the USA:

Any two books	$16.50
Any three books	25.00
Any four books	30.00

See page 211 for full details and ordering information

GRAND CANYON LOVE STORY
by Francis and Helen Line

An absorbing true story with the suspense and drama of a novel—a portrayal of the Grand Canyon in such vivid writing you will feel you have known it forever. This adventure chronicle spans sixty years of intimate acquaintance with the Canyon. Officially approved for sale at the Park Visitor Center.

"The story they have told of their love affair with Grand Canyon is an absorbing and inspirational saga. The reader not only becomes acquainted with the Canyon, but with a couple who are in love with life—and each other. The Lines are contagious. You have a rare treat ahead of you." Mike Swartz, Interpretive Ranger, Grand Canyon National Park

300 pages, 65 photos, softcover, $8.95
ISBN: 0-938109-04-9 Library of Congress F788.L495 1988

see next page

FOOT BY FOOT THROUGH THE USA
by Winfield and Francis Line

A high adventure odyssey to every state in the Union. Two teenage brothers, in the adolescent years of America's highway travel, set out to learn about their country in the most intimate way possible—hiking, catching rides, and working their way for over a year. This true story takes you on a journey back in time through a historic and scenic USA. It's a combination of humor and history, geography and grit.

"A delightful account of that trip." Dick Kleiner, The Desert Sun, Palm Springs, California

"This book should be a 'must' reading for all Americans, especially students in high school." Mr. Yong Keun Cha, Federal Aviation Authority, Washington, D.C.

312 pages, 77 photos, 15 maps, softcover, $8.95
ISBN: 0-938109-03-0 Library of Congress: 86-28939

SHEEP, STARS, AND SOLITUDE
ADVENTURE SAGA OF A WILDERNESS TRAIL
by Francis Raymond Line

The experiences of following two thousand sheep over one of the wildest trails in America are recounted in this "Arizona Walden." Line first wrote up the trek for National Geographic Magazine and Arizona Highways. The book combines adventure, humor, philosophy, spirituality, nature, and ecology in a true story of unique beauty.

"A gentle classic which warms the soul while contributing to western literature." Stanley W. Paher, Southwest Bookshelf

"The U.S. Government and the National Geographic Magazine have recognized the simple wisdom of Line's story. It is enjoyable and rewarding." Small Press Book Review

165 pages, 45 photos, softcover, $8.95
ISBN: 0-938109-01-2 Library of Congress: 86-11154

see next page

Ordering Information

ADVENTURE UNLIMITED $8.95

GRAND CANYON LOVE STORY $8.95

FOOT BY FOOT THROUGH THE USA $8.95

SHEEP, STARS, AND SOLITUDE $8.95

Special Discounts

Any two books $16.50
Any three books $25.00
Any four books $30.00

Add $1.00 postage and handling for each book

California residents add 6% sales tax

These books can be mailed, together or separately, to any address in the USA. *PRINT* all names and addresses *clearly.* Tell us if we should include a gift card with your name.

SATISFACTION GUARANTEED
You may return any book for a full refund if not entirely pleased
Prices are subject to change without notice

Additional information and brochures available upon request to:

WIDE HORIZONS PRESS
13 Meadowsweet
Irvine, CA 92715

NOTES

NOTES